Weddings:
From
Snapshots to
Great Shots

Suzy Clement

**Peachpit
Press**

Weddings: From Snapshots to Great Shots
Suzy Clement

Peachpit Press
1249 Eighth Street
Berkeley, CA 94710
510/524-2178
510/524-2221 (fax)

Find us on the Web at www.peachpit.com
To report errors, please send a note to errata@peachpit.com
Peachpit Press is a division of Pearson Education.

Editor: Susan Rimerman
Production Editor: Lisa Brazieal
Developmental/Copy Editor: Elizabeth Kuball
Proofreader: Scout Festa
Composition: WolfsonDesign
Indexer: Karin Arrigoni
Cover Design: Aren Straiger
Cover Image: Suzy Clement
Interior Design: Riezebos Holzbaur Design Group

ISBN-13 978-0-321-79265-5
ISBN-10 0-321-79265-3

9 8 7 6 5 4 3 2 1
Printed and bound in the United States of America

DEDICATION

To my beautiful children. Brilliant Mielle, you inspire me every day with your strength, wisdom, and wit. There is no limit to what you can achieve, my dear. And Lucien, Mr. Delightful, your sweet and joyous spirit nourishes our family. I believe in you both, and I love you.

ACKNOWLEDGMENTS

Naturally, this book is the result of a team effort, and there are many, many people to whom I am so grateful. Just to name a few:

The beautiful and brilliant Lenny Gonzalez, who supported this effort in every way imaginable, from discussing shooting techniques to color-correcting images to cooking dinner. Thanks for walking every step of the way with me, on this project and in life. Love you, husband.

My wonderful friend and colleague Julie Caine, photographer, writer, and storyteller extraordinaire, who provided fierce brainstorming power at a critical moment and graciously (and seemingly effortlessly) offered up some great metaphors for the book.

The incredibly savvy, smart and just plain awe-inspiring Amy Stewart, whose boundless support and sound advice have never failed to inspire and uplift me during the writing of this book, and indeed over the past 20+ years.

The entire team at Peachpit Press—Lisa Brazieal, Elizabeth Kuball, Scout Festa, Owen Wolfson, Aren Howell, and especially Susan Rimerman—for guiding this newbie through the writing and production process and taking such care to make the work look its best.

Anne Schlatter and all the lovely folks at Pro Camera. Thanks for always sharing your knowledge and experience, and doing it with a smile.

My wonderfully talented friend Thayer Gowdy, whose early wedding work inspired me to turn a beloved hobby into a business that has given me so much.

The many incredibly gifted wedding planners, designers, stylists, florists, cake bakers, caterers, and lighting companies with whom I've had the honor to work. You create extraordinarily beautiful feasts for my camera with your amazing designs, florals, details, and event landscapes. Thank you for your brilliant work.

And most important, thank you to the many, many couples who have honored me with the privilege of capturing and preserving this singular moment in life. I am so grateful for the opportunity to fulfill my passion to create work that will endure and bring joy for many years to come.

Contents

Introduction

"Without the participation of intuition, sensibility, and understanding, photography is nothing."

—Henri Cartier-Bresson

Nothing quite matches the power of a photograph to preserve a moment in time. The shutter pressed at exactly the right instant both records the scene in broad strokes and captures the more subtle gestures of those pictured in a way that speaks volumes about their experience at that particular moment. Indeed, photography has the power not only to document an event, but to actually shape the nature of memory. As time passes, the moments that remain most vivid in memory are often the ones that were captured in photographs.

For a couple on their wedding day, everything is a blur. All the months of planning are gone in a heartbeat. The moment is fleeting when the couple, surrounded by the love and support of family and friends, declare their commitment and embark on a new stage of life together. It's our joy and privilege as wedding photographers to preserve the power and grace of this day for the couple and their loved ones, for generations. And of all the photographs taken at a wedding, the images that reflect the authenticity of this experience—the true and tender moments that could never be staged—are the ones that endure over time. Looking at these images years and even decades later, the viewers will actually feel everything—the joy, the excitement, the unexpected moments—that made the day so special. It's heady stuff!

And it's no easy task. Wedding photography encompasses a bit of nearly every photo specialty, including documentary, portraiture, group portraiture, still life, landscape, action, low light, fashion, party, and food. Just to add to the challenge, you get only one chance to nail the most important moments, you're always in a rush, and emotions around you may be running just a bit high. Wedding photography is definitely not for the faint of heart—and yet, if you thrive on the challenge and excitement of a pressure-filled moment, it offers amazing opportunities for creative expression, as well as the chance to provide something infinitely meaningful to your clients.

Over the 15 years that I've photographed weddings, I've experienced just about every type of situation imaginable. In this book, I share the skills and strategies that I've developed to help me consistently create a body of authentic, intimate, beautiful images that tell a story, reflect emotions, and truly capture the essence of that unique wedding day for each couple.

Chapters 1 through 3 lay the foundation, with discussions on equipment, shooting basics, and preparations that will help you manage each phase of the day smoothly and effectively. Chapters 4 through 8 cover the stages of the wedding day—from before the ceremony begins through the dancing and reception. Here, I address the unique demands of each stage and share my approach to many of the most typical challenges that occur so that you can confidently face whatever comes your way. I also offer techniques and exercises that will help you train your eye to capture the more subtle, sometimes small, often unexpected moments that are so crucial to telling the story of the day. Chapter 9 wraps things up with information on editing and presenting the images to clients after the wedding.

This book is predominantly concerned with preparation and shooting strategies for the actual wedding day; it doesn't cover post-processing techniques or the marketing side of the business. The excellent book *VisionMongers: Making a Life and a Living in Photography,* by David duChemin (published by New Riders/Voices That Matter), is a wonderful resource to help photographers understand and develop the business side of things.

Chapter 2 includes a review of shooting basics, but the assumption is that you already have a basic understanding of fundamentals like proper exposure, how to use your digital SLR in various shooting modes, and so forth. For a more in-depth review of these topics, refer to the book *Exposure: From Snapshots to Great Shots,* by Jeff Revell (published by Peachpit), which is packed with useful information.

My hope is that the information and assignments in this book will enable you to truly capture the unique personality of each wedding you cover and continue to develop your own creative vision along the way. I want to show you how to not only survive the wedding day, but to *thrive,* creating images that will thrill both you and your clients.

Share your results with the book's Flickr group!

Join the group here: flickr.com/groups/weddingsfromsnapshotstogreatshots

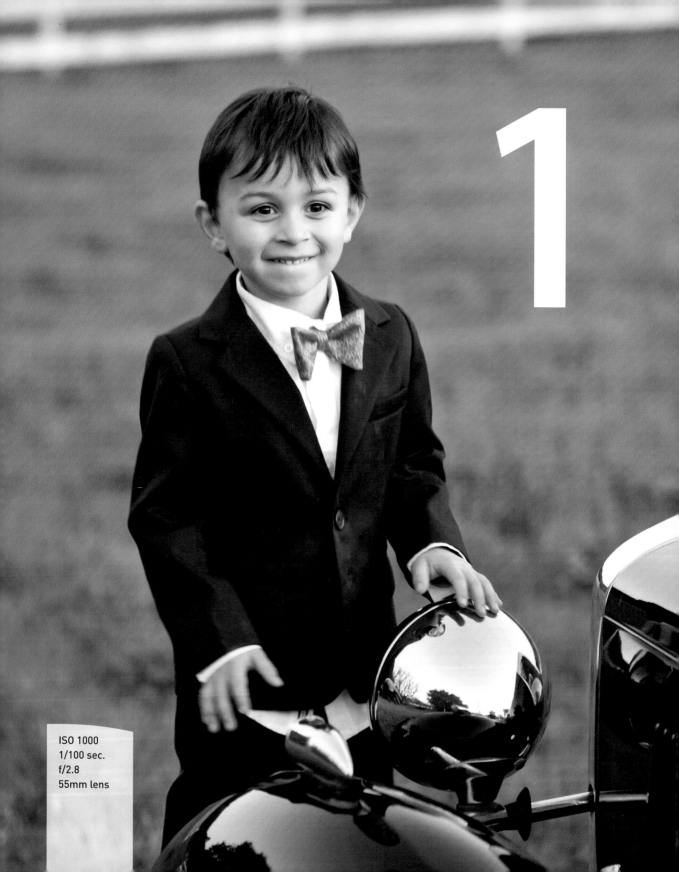

1

ISO 1000
1/100 sec.
f/2.8
55mm lens

Equipment

WHAT YOU NEED

To create consistently high-quality images, you need high-quality equipment. Entering the field of professional wedding photography involves an investment—but you don't need to own every lens and gadget under the sun. Keep it simple and know your equipment well so that it becomes an extension of you—a way to serve your vision. Ultimately, a photographer's knowledge, skill, and experience with her own equipment is nearly as important as the equipment itself.

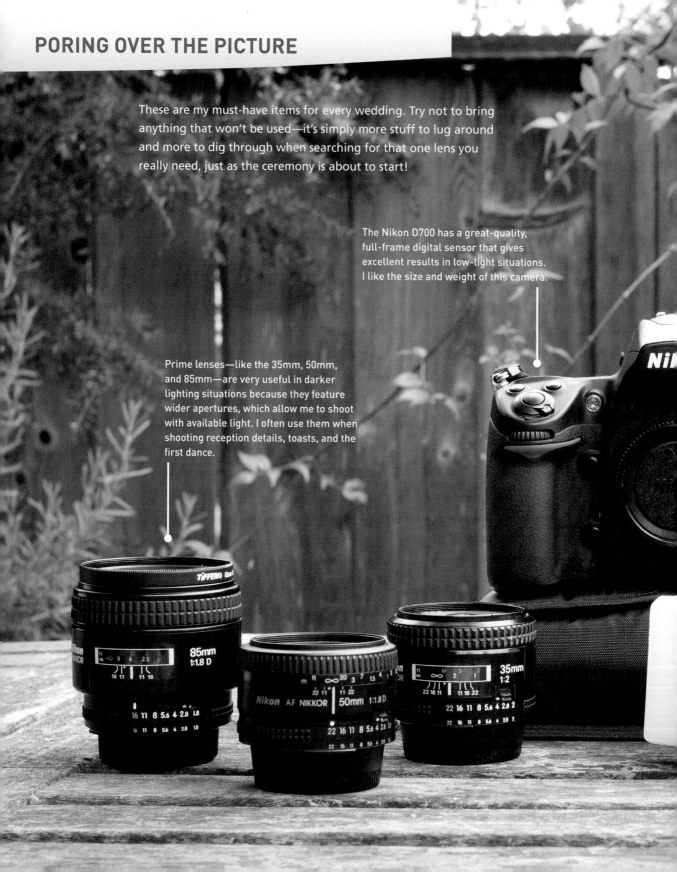

PORING OVER THE PICTURE

These are my must-have items for every wedding. Try not to bring anything that won't be used—it's simply more stuff to lug around and more to dig through when searching for that one lens you really need, just as the ceremony is about to start!

The Nikon D700 has a great-quality, full-frame digital sensor that gives excellent results in low-light situations. I like the size and weight of this camera.

Prime lenses—like the 35mm, 50mm, and 85mm—are very useful in darker lighting situations because they feature wider apertures, which allow me to shoot with available light. I often use them when shooting reception details, toasts, and the first dance.

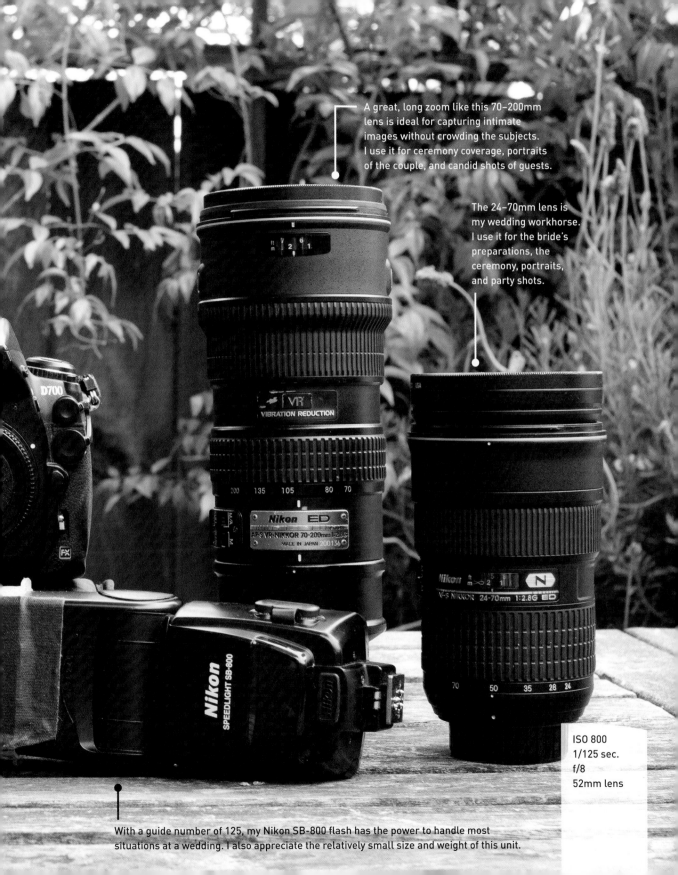

A great, long zoom like this 70–200mm lens is ideal for capturing intimate images without crowding the subjects. I use it for ceremony coverage, portraits of the couple, and candid shots of guests.

The 24–70mm lens is my wedding workhorse. I use it for the bride's preparations, the ceremony, portraits, and party shots.

With a guide number of 125, my Nikon SB-800 flash has the power to handle most situations at a wedding. I also appreciate the relatively small size and weight of this unit.

ISO 800
1/125 sec.
f/8
52mm lens

WHICH FEATURES ARE IMPORTANT

Everyone knows that photography equipment isn't cheap, but the good news is that you don't need to buy the most expensive, feature-laden equipment in order to make great images at weddings. Many of the features on the highest-end gear are irrelevant to wedding work, and you can stretch your equipment budget by prioritizing the features that matter most (and resisting those that don't). Invest in a few basic pieces of excellent-quality gear, and you'll have all you need to produce amazing results (**Figure 1.1**).

FIGURE 1.1
This beautiful image was shot with my least-expensive lens—it cost only $125 or so.

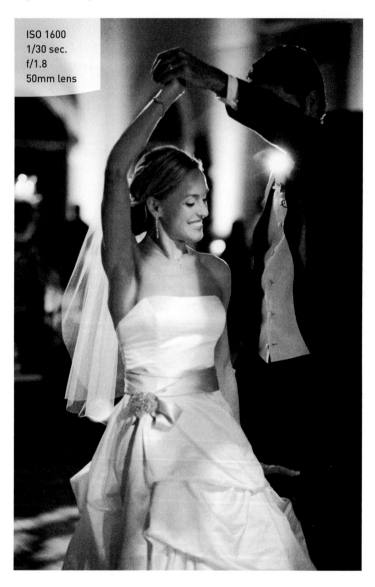

ISO 1600
1/30 sec.
f/1.8
50mm lens

CAMERA BODIES

The most important component of a DSLR body is the size and quality of the sensor. In terms of sensor quality, the most important feature for wedding work is the ability to shoot in low-light situations at very high ISOs. This gives you a lot more flexibility throughout the entire day—in dark hotel rooms when the bride is getting ready; inside churches, synagogues, and ballrooms; and even when shooting groups or party shots.

Avoid the temptation to fixate on the number of megapixels a camera has. File size is very important to a point, but just about any DSLR on the market today will produce files that are large enough for your needs as a wedding photographer—and the number of megapixels will only increase as technology evolves. The camera I currently use for most of my shooting produces 12.1-megapixel images, and I've never had an issue with the file size being too small when producing prints, albums, canvases, and other items for my clients.

Most major camera manufacturers carry three distinct lines of products:

- **Professional:** Camera bodies in the professional line generally cost anywhere from $5,000 to $10,000—and that's just for the camera body, not including a lens. Professional camera bodies have the highest-quality sensors and are jam-packed with features.

- **Prosumer:** In the prosumer line, the bodies generally cost $2,000 to $3,000. Although they may have fewer features than cameras in the professional line have, prosumer camera bodies often have the same great-quality sensors.

- **Consumer:** Consumer camera bodies typically cost less than $1,000. Sometimes (but not always) they have lower-quality sensors that don't perform as well in low-light situations. The sensors on consumer cameras often are cropped (see the sidebar on the following page).

Spending the extra money for the top pro models buys you additional features, but most of those features—things like huge file size, super-fast frames-per-second rates, and giant buffers to facilitate sustained rapid-fire shooting—really aren't that relevant to the needs of a wedding photographer. These features are more applicable to the needs of sports or fashion photographers.

FULL FRAME VS. CROPPED

Sensors are either full frame or cropped. If your camera has a cropped sensor, it will change the effective focal length of all your lenses, making them less wide. The actual amount that the sensor is cropped varies between manufacturers, but as an example, if the crop factor is 1.5X, a 35mm lens will behave more like a 50mm lens. This isn't necessarily a bad thing—it depends on which lenses you use, as well as your shooting style. Some photographers appreciate the extra "reach" it gives when shooting subjects from a distance. You'll definitely need the ability to capture wide-angle images, though, so if you have a cropped sensor, you'll need wider lenses to compensate (**Figure 1.2**).

FIGURE 1.2
This image was shot with a camera with a full-frame sensor. The line indicates what it would look like if the sensor had a crop value of 1.5X.

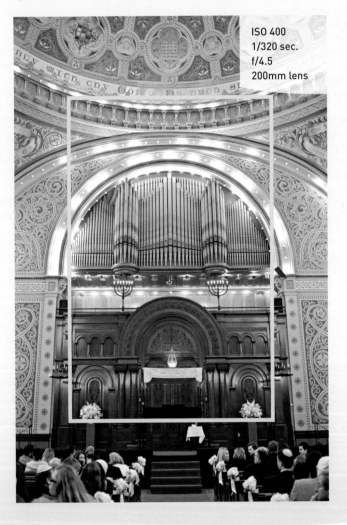

ISO 400
1/320 sec.
f/4.5
200mm lens

Pro models are often larger, and the casing may be more durable or weatherproof (**Figure 1.3**). But, again, these features aren't necessary for most wedding work—and they may even be a detriment. Larger, more rugged bodies are heavier, which can be difficult when you're shooting for nine or ten straight hours. Plus, you'll probably replace your camera bodies every few years due to rapidly changing technology, so durability isn't as important as it was in the past, when the same camera body could be used for decades.

ISO 200
1/200 sec.
f/4.5
45mm lens

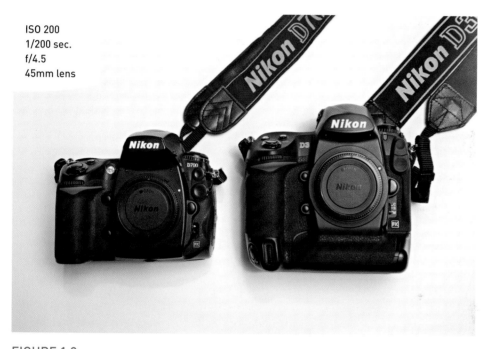

FIGURE 1.3
Camera bodies can vary quite a bit in terms of size and weight, so be sure to check out the models in person before buying. Featured here are the Nikon D700 (prosumer) on the left and the Nikon D3 (professional) on the right.

I recommend investing in the best-quality sensor available, but not necessarily the most expensive camera model. This often translates into a prosumer camera body, but some consumer models may have the best-quality sensors, too. Obviously, the landscape is changing all the time with the development and release of new models, so be sure to research the most current offerings and ask *lots* of questions to really understand the strengths and weaknesses of each model.

Although the sensor is the most important consideration when selecting a body, it's not the only one. You need to see and feel the camera in person. If you have the opportunity to borrow or rent the body you're considering and test it out, that's a definite plus.

I highly recommend finding a reputable, professional camera store in your area. There you'll find experienced, knowledgeable staff who use and understand the gear and can answer your questions, as well as make recommendations based on your specific requirements. Be aware that some large-scale, warehouse-style stores may be more interested in selling you whatever they happen to have in overstock rather than what will really meet your needs.

After you've narrowed your choices, hold each model in your hands. Does it feel balanced? Are the controls easily accessible and intuitively positioned? How about the weight? Can you envision being able to comfortably wield it (with lens attached) for nine straight hours at a wedding? I know some wedding photographers who struggle with carpal tunnel syndrome because of their gear, so weight is no small consideration.

LENSES

After you have your camera body, it's time to invest in some high-quality glass. The quality of the lenses you use will affect color, contrast, and sharpness in the image (**Figure 1.4**). No matter how talented you are, if your lenses are substandard, your images will suffer.

If you're interested in buying a particular lens, there are several ways to research it:

- Ask fellow wedding photographers about their experience with the lens.
- Read online reviews of the lens. Keep in mind that the reviewers may have different shooting priorities than yours.
- Borrow or rent the lens and try it out in similar situations to the ones you'll be shooting in. As with a camera body, trying out a lens is really the best way to get a feel for it and decide if it's right for you.

ISO 200
1/3200 sec.
f/2.8
50mm lens

FIGURE 1.4
My 50mm prime
lens gives me
excellent sharp-
ness and contrast,
especially critical
in this shot where
the subject and
the background
are similar.

Lens speed is a huge consideration. Throughout this book, I'll discuss all the ways that I use available light during virtually every part of the wedding day, for more natural and beautiful images. I frequently shoot at f/2.8 or wider. For my shooting style, slow lenses or zooms that open only to a range of, say, f/3.5–5.6 are virtually useless. Fast prime lenses and zooms that open to f/2.8 throughout the focal-length range are well worth the extra money (**Figure 1.5**).

Every wedding photographer should have at least one lens that opens to at least f/1.8. This speed is really helpful in extremely low-light situations. Plus, it offers more room for creative expression by manipulating depth of field with wider aperture settings (**Figure 1.6**).

ISO 1600
1/25 sec.
f/2.8
24mm lens

ISO 400
1/2000 sec.
f/2.0
50mm lens

FIGURE 1.5
In darker interior spaces, an aperture of at least f/2.8 is essential so that I can hand-hold the camera and, thus, move about freely and shoot quickly, unencumbered by a tripod.

FIGURE 1.6
Aside from opening up the possibilities in low-light situations, the wide apertures of fast prime lenses offer more possibilities for creative expression.

You'll pay a very steep premium for lenses that open even wider to f/1.4 or f/1.2. If you're absolutely in love with the look of a super-shallow depth of field, you may find it worthwhile to spend the additional money for these lenses. In my opinion, though, for general wedding use, it's generally not worth it—your money is better invested elsewhere, especially if you're still building your gear collection.

LIGHTING

Although many camera models (particularly consumer and some prosumer models) come with a pop-up flash, you should use that flash only in the event of an emergency—if, say, your mounted flash unit dies just as the bride is walking down the aisle of the dark church. The built-in flash can cause red-eye, and longer zoom lenses can actually cast a shadow on the subject because the flash is so close to the lens.

Every flash has a guide number to indicate how powerful it is, and the level you need will depend on how you intend to use it. If you'll use the flash to light large group shots, you'll need significantly more power than if you intend to use it for dancing and party shots only.

If you're considering a flash unit that's a different brand from your camera, pay attention to whether the flash and the camera will be able to fully communicate with one another, so that you can shoot in Automatic or TTL mode. Sometimes a special adapter is required; in other situations, full communication just isn't possible. Ask questions and test it out before you buy. Bring your camera to the store and set the whole thing up so you can see how the components work together.

Be sure that the flash head swivels so that you can bounce light from the ceiling, walls, and so on. Also, make sure that the flash accepts various types of diffusers. Some of the smaller models don't have these features.

BACKUPS

If you've accepted the responsibility to be the primary photographer at a wedding, then backup equipment is essential. Cameras and lenses can and do fail at the most inopportune times, and you must be prepared for that possibility. Have at least one backup camera body and flash, as well as enough lenses that you can still provide good coverage even if one goes down during a shoot.

BAGS

Many types of camera bags are available. I have a few different bags that I use for various types of shoots:

- A large rolling bag for weddings
- A shoulder bag that rides atop the roller if I need to bring additional lenses or lighting
- A smaller backpack that I use for portrait sessions, since I need less equipment and I want to keep it on my person at all times

If you decide on a rolling bag, make sure it can fit in airline overhead compartments so that you'll be ready when you book that sweet destination wedding. Although bags certainly aren't cheap, they are an investment and you shouldn't skimp on quality. I bought an amazing Tamrac rolling bag shortly after I started shooting weddings. The $350 price tag seemed steep at the time, but 13 years later the bag is still as good as new, and I've never regretted the investment.

BUILDING YOUR GEAR COLLECTION

All photographers have wish lists of cameras, lenses, and other items that they dream of owning one day, but most of us need to start more modestly and build our collections as we go. It's definitely possible to make wonderful images with very simple gear. In this section, I offer suggestions on how to begin your collection of equipment and how to think about what the most logical next purchase might be.

BEGINNING GEAR

If you aren't already shooting with a model that features the best sensor available, get hold of one as soon as you can! You'll see a huge difference in your images, and the investment will be worth it.

Many wedding photographers use zoom lenses, but the best-quality ones are very expensive. Until you can afford one, I recommend using a selection of great-quality prime lenses as an alternative to poorer-quality, slower zoom lenses (like the kind that are often included as kit lenses with camera bodies) and those that do not have a consistent aperture of f/2.8 throughout the range of focal lengths.

You'll pay a very steep premium for lenses that open even wider to f/1.4 or f/1.2. If you're absolutely in love with the look of a super-shallow depth of field, you may find it worthwhile to spend the additional money for these lenses. In my opinion, though, for general wedding use, it's generally not worth it—your money is better invested elsewhere, especially if you're still building your gear collection.

LIGHTING

Although many camera models (particularly consumer and some prosumer models) come with a pop-up flash, you should use that flash only in the event of an emergency—if, say, your mounted flash unit dies just as the bride is walking down the aisle of the dark church. The built-in flash can cause red-eye, and longer zoom lenses can actually cast a shadow on the subject because the flash is so close to the lens.

Every flash has a guide number to indicate how powerful it is, and the level you need will depend on how you intend to use it. If you'll use the flash to light large group shots, you'll need significantly more power than if you intend to use it for dancing and party shots only.

If you're considering a flash unit that's a different brand from your camera, pay attention to whether the flash and the camera will be able to fully communicate with one another, so that you can shoot in Automatic or TTL mode. Sometimes a special adapter is required; in other situations, full communication just isn't possible. Ask questions and test it out before you buy. Bring your camera to the store and set the whole thing up so you can see how the components work together.

Be sure that the flash head swivels so that you can bounce light from the ceiling, walls, and so on. Also, make sure that the flash accepts various types of diffusers. Some of the smaller models don't have these features.

BACKUPS

If you've accepted the responsibility to be the primary photographer at a wedding, then backup equipment is essential. Cameras and lenses can and do fail at the most inopportune times, and you must be prepared for that possibility. Have at least one backup camera body and flash, as well as enough lenses that you can still provide good coverage even if one goes down during a shoot.

BAGS

Many types of camera bags are available. I have a few different bags that I use for various types of shoots:

- A large rolling bag for weddings
- A shoulder bag that rides atop the roller if I need to bring additional lenses or lighting
- A smaller backpack that I use for portrait sessions, since I need less equipment and I want to keep it on my person at all times

If you decide on a rolling bag, make sure it can fit in airline overhead compartments so that you'll be ready when you book that sweet destination wedding. Although bags certainly aren't cheap, they are an investment and you shouldn't skimp on quality. I bought an amazing Tamrac rolling bag shortly after I started shooting weddings. The $350 price tag seemed steep at the time, but 13 years later the bag is still as good as new, and I've never regretted the investment.

BUILDING YOUR GEAR COLLECTION

All photographers have wish lists of cameras, lenses, and other items that they dream of owning one day, but most of us need to start more modestly and build our collections as we go. It's definitely possible to make wonderful images with very simple gear. In this section, I offer suggestions on how to begin your collection of equipment and how to think about what the most logical next purchase might be.

BEGINNING GEAR

If you aren't already shooting with a model that features the best sensor available, get hold of one as soon as you can! You'll see a huge difference in your images, and the investment will be worth it.

Many wedding photographers use zoom lenses, but the best-quality ones are very expensive. Until you can afford one, I recommend using a selection of great-quality prime lenses as an alternative to poorer-quality, slower zoom lenses (like the kind that are often included as kit lenses with camera bodies) and those that do not have a consistent aperture of f/2.8 throughout the range of focal lengths.

Here's a beginning gear list to get you started:

- One camera body (**Note:** Rent an additional body as a backup until you can buy one.)
- Two flashes (one as a backup)
- Normal lens, 50mm
- Wide lens, 35mm
- Telephoto lens, 85mm
- Tripod (lightweight carbon fiber)

Looking at Nikon as an example, you can purchase a 35mm f/2, a 50mm f/1.8, and an 85mm f/1.8 lens for under $1,000 total, which is close to half the price of one 24–70mm f/2.8 zoom, and the primes are all faster (**Figure 1.7**). With two camera bodies on hand, you can mount different lenses on each of them and easily carry both at the same time, so you have some choice in focal length at any given moment.

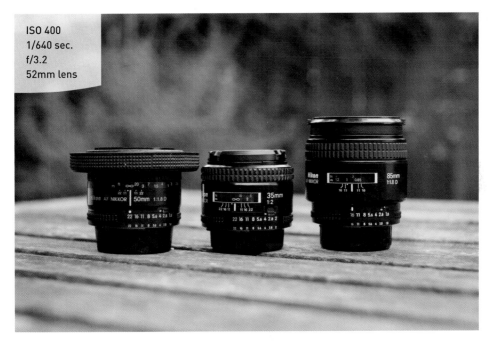

ISO 400
1/640 sec.
f/3.2
52mm lens

FIGURE 1.7
These three prime lenses will give you a great start with weddings.

If you have a camera with a cropped sensor, you might get 28mm, 35mm, and 85mm lenses instead, to compensate for the effect the sensor has on the perceived focal length of the lenses. Make sure that whatever lenses you buy can work with full-frame sensors as well; that way, if you upgrade your camera body, you won't have to buy all new lenses.

The lenses listed in this section obviously don't provide the flexibility in focal length of some of the zoom lenses, particularly on the telephoto end of the spectrum, but the affordability and great image quality are more important when you're just starting out. These lenses will continue to be useful for many aspects of wedding work even as your gear collection expands.

CAN'T BUY IT ALL? RENT!

Renting equipment is a great option if you can't yet spring for that amazing 70–200mm zoom or if you need something out of the ordinary for a particular wedding shoot. It's also a wonderful way to test-drive equipment before buying. Most rental houses count a weekend as a one-day rental, so you can pick up your toys on Friday and play with them all weekend long.

I'm lucky enough to live in San Francisco, home of an amazing local rental shop, Pro Camera. The folks there know pretty much everything about every piece of equipment they rent, and they hear feedback from photographers of all specialties about how items perform in many different situations. They can suggest appropriate equipment options depending on my needs—for instance, helping me decide which strobe lighting kit would work best for that 50-person group shot—and they know which lenses are fast and sharp, and which are sub-par. They're a tremendously valuable resource, and I can't recommend highly enough that you take advantage of your local rental shop, if you have one.

If you don't have a local source for rentals, you can rent at www.borrowlenses.com, and they'll ship the equipment to you.

PROFESSIONAL-LEVEL GEAR

By adding a few key pieces to the starter kit described in the preceding section, you'll have a very serviceable collection:

- Second camera body
- Medium zoom lens, 24–70mm f/2.8
- Telephoto zoom lens, 70–200mm f/2.8

The added lenses are pricey but beautiful, sharp, and fast, and they're the workhorses for many wedding photographers, myself included (**Figure 1.8**). With this equipment, you'll have many more options at your disposal and many more ways to express your creative vision.

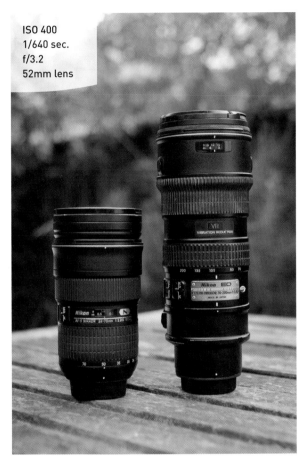

ISO 400
1/640 sec.
f/3.2
52mm lens

FIGURE 1.8
Very sharp, very fast zoom lenses are expensive but excellent. They're the workhorses for many wedding photographers.

BUYING USED

Buying great-quality used gear is an excellent way to stretch your equipment budget. Large camera stores like B&H (www.bhphotovideo.com) and Adorama (www.adorama.com) have extensive stock of used equipment that is tested before it's sold, so you know that the descriptions are accurate and the equipment is reliable. Most items even come with a warranty.

DREAM GEAR

The following additions simply add a little icing on the cake, opening up more creative opportunities on the wedding day (**Figure 1.9**):

- Third camera body (for backup)

- Macro lens for close-ups of details

- Super-wide prime or zoom lens, such as 20mm or 17–35mm

- Video light to allow for no-flash shooting in low-light situations

- Strobe lighting kit for larger group shots

FIGURE 1.9
A macro lens for close-ups and a super-wide lens will give you even more options.

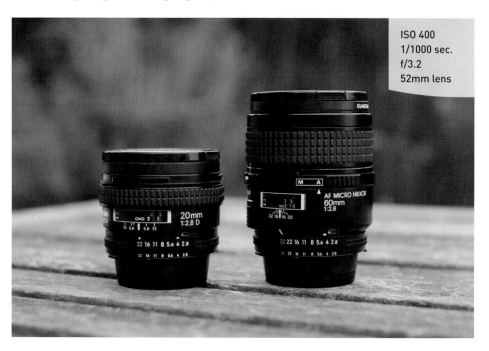

ISO 400
1/1000 sec.
f/3.2
52mm lens

2

ISO 400
1/250 sec.
f/5.6
60mm lens

Shooting Basics

UNDERSTANDING LIGHT, EXPOSURE, AND COMPOSITION

Photography, quite simply, is light.

The way that you see light and the way you choose to control it when making images are key to shaping the look of your work and developing your personal style. It all comes from you—the camera is merely the tool that helps you realize your vision. The more you understand the way your decisions about lenses, camera settings, and lighting impact the look and feel of the image, the more effective you'll be in using your camera in specific, intentional ways to achieve the desired look.

This chapter isn't a comprehensive review of all the fundamentals of photography, but it covers some of the basic principles and techniques I use at various points in a wedding to capture images that are authentic, emotional, and beautiful. For more in-depth information on exposure or composition, check out *Exposure: From Snapshots to Great Shots* by Jeff Revell or *Composition: From Snapshots to Great Shots* by Laurie Excell with John Batdorff, David Brommer, Rick Rickman, and Steve Simon (both published by Peachpit).

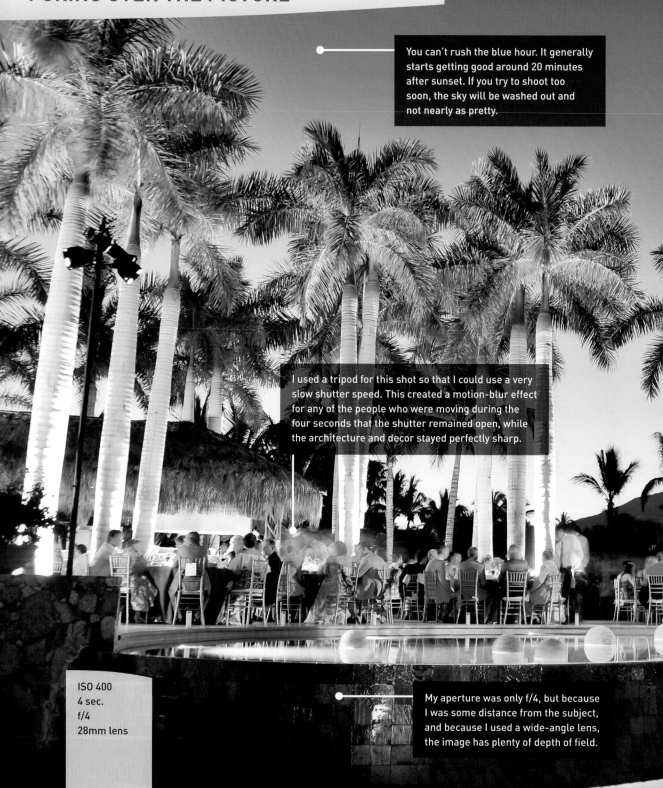

PORING OVER THE PICTURE

You can't rush the blue hour. It generally starts getting good around 20 minutes after sunset. If you try to shoot too soon, the sky will be washed out and not nearly as pretty.

I used a tripod for this shot so that I could use a very slow shutter speed. This created a motion-blur effect for any of the people who were moving during the four seconds that the shutter remained open, while the architecture and decor stayed perfectly sharp.

ISO 400
4 sec.
f/4
28mm lens

My aperture was only f/4, but because I was some distance from the subject, and because I used a wide-angle lens, the image has plenty of depth of field.

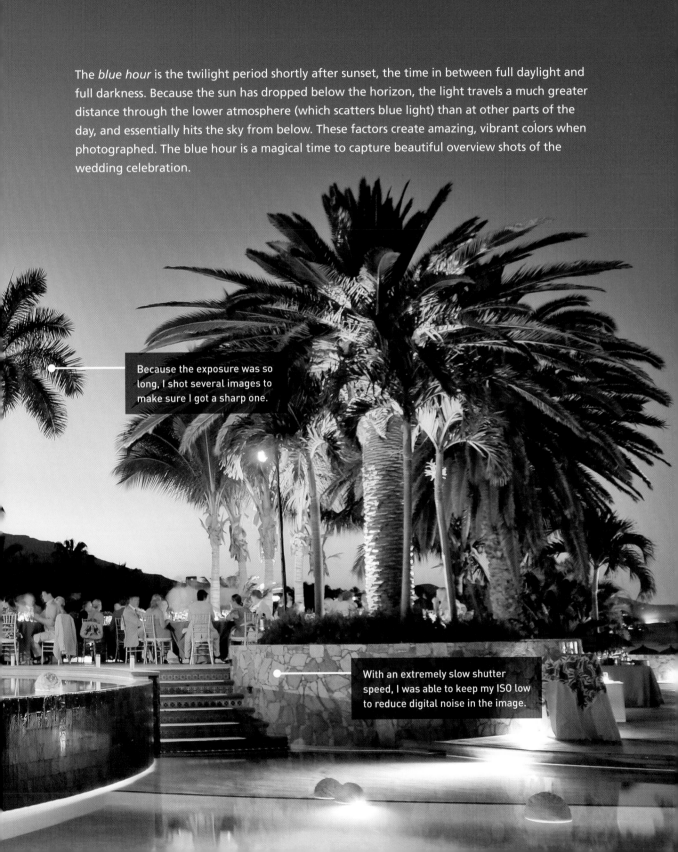

The *blue hour* is the twilight period shortly after sunset, the time in between full daylight and full darkness. Because the sun has dropped below the horizon, the light travels a much greater distance through the lower atmosphere (which scatters blue light) than at other parts of the day, and essentially hits the sky from below. These factors create amazing, vibrant colors when photographed. The blue hour is a magical time to capture beautiful overview shots of the wedding celebration.

Because the exposure was so long, I shot several images to make sure I got a sharp one.

With an extremely slow shutter speed, I was able to keep my ISO low to reduce digital noise in the image.

LIGHTING

I shoot with available light as much as I possibly can, primarily because it makes for more visually nuanced images. But there are other good reasons for using available light: It allows me to shoot from a distance using telephoto lenses, without concern about whether light from a flash will make it all the way to the subject. Plus, even when shooting close in, the absence of flash makes my shooting far less intrusive for the wedding participants, so they feel more comfortable and less aware of the camera. This allows me to capture more natural, organic images (**Figures 2.1** and **2.2**).

FIGURE 2.1
Shooting with natural light with a telephoto lens allows me to stay in the background and capture natural, unscripted moments like this one.

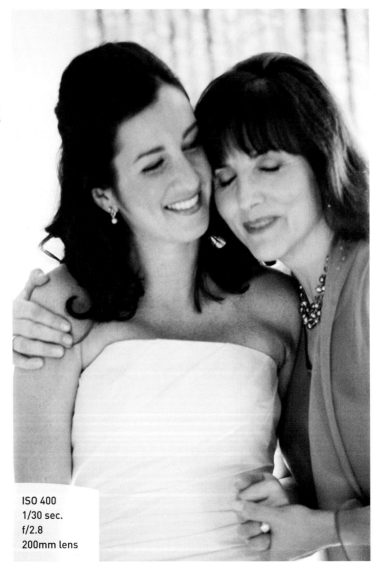

ISO 400
1/30 sec.
f/2.8
200mm lens

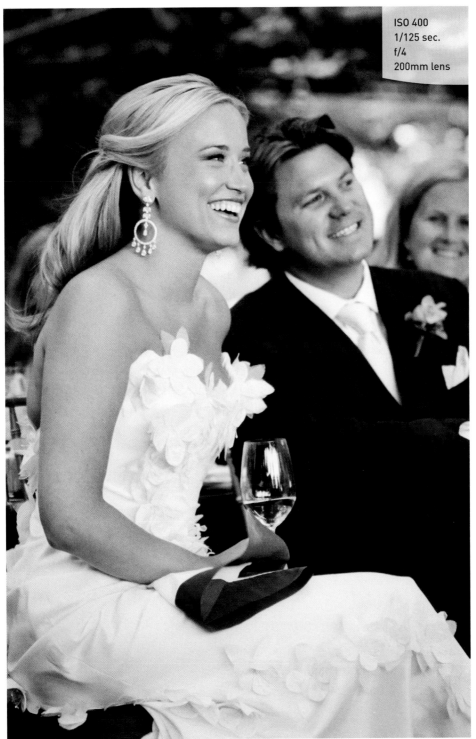

ISO 400
1/125 sec.
f/4
200mm lens

FIGURE 2.2
This was taken as the bride's father gave his toast, and because my shooting style is very discreet, she was able to forget about my presence and simply enjoy the moment— and I was able to capture extremely natural images like this one.

I'm always acutely aware of light—its source, its direction, its color, its intensity—and the ability to really see light in this way informs my decisions about how to shoot in any given situation. Although there are a few instances in which I use a flash as fill light—for example, at a ceremony that is either extremely backlit or has dappled sunlight—for the most part I don't use a flash at all during the day.

During some parts of the day, such as the portraits of the couple and family, I can mastermind the situation and direct the action to the places with the best light. At other times, such as the ceremony and many elements of the reception, I have to simply manage the situation as I find it and know how to add supplemental lighting when needed. The wedding day demands that you act as both designer, shaping what happens and where, and documentarian, capturing what's happening in an effective way without the ability to change it. I'll cover how to handle many specific lighting situations that typically arise as they relate to the stages of the wedding day in later chapters of this book.

EXPOSURE

It all begins with exposure: the amount of light that is allowed to enter the camera and hit the sensor. For great image quality, you need just the right amount of light. Too much light creates a washed-out image with blown highlights, and too little light results in a too-dark image with no shadow detail. Camera sensors are getting better all the time, and although you can, to some extent, save over- or underexposed images in post-processing, your images will look a lot better (and you'll spend a lot less time at the computer) if you get it right in-camera.

There are three basic ways to control the amount of light that hits the sensor: *shutter speed* (how long the shutter is open to allow light in), *aperture* (the size of the opening), and *ISO* (the sensitivity level of the sensor). Every exposure is a balancing act between these three elements. For any given lighting situation, innumerable combinations will give a correct exposure, but the way in which you choose to use them in combination has a huge impact on the way the image looks (**Figure 2.3**).

SHUTTER SPEED AND MOTION

The shutter is the mechanical device that allows light into the camera, and shutter speed is the amount of time that the shutter remains open to allow light in for a particular shot. Shutter speed is measured in fractions of a second, so 1/500 sec. is a much faster shutter speed (the shutter is open for a much shorter period of time) than 1/8 sec.

ISO 400
1/30 sec.
f/2.8
200mm lens

FIGURE 2.3
I chose to meter for
the shadows on the
bride's face, which
rendered soft,
glowing highlights,
radiant skin, and
a drop-off into
the darker areas
of the image that
help focus atten-
tion on the bride's
expression.

The main way that shutter speed affects the final look of the image is by determining whether there is any blur in the image due to movement—either of the subject or of the camera—during the exposure. A fast shutter speed (say, 1/500 sec. or faster, depending on how quickly the subject is moving) will freeze the action of the subject. At a wedding, I make sure that I have a fairly fast shutter speed when the couple is recessing from the ceremony and if they make a formal entrance at dinner—at both these times, they can move really quickly!

With slower shutter speeds, approximately 1/60 sec. or longer (depending on how quickly the subject is moving), you may capture some blur—either intentional or unintentional—due to the movement of the subject or of the camera while the shutter is open. Blur resulting from movement of the subject may be isolated to only part of an image (**Figure 2.4**). If blur is due to the movement of the camera (known as *camera shake*), then the entire image will be unsharp.

FIGURE 2.4
This is a dramatic example of shooting at night with a tripod and a very slow shutter speed. This technique creates the effect of motion blur for all the people in the shot, while the tabletop is perfectly sharp.

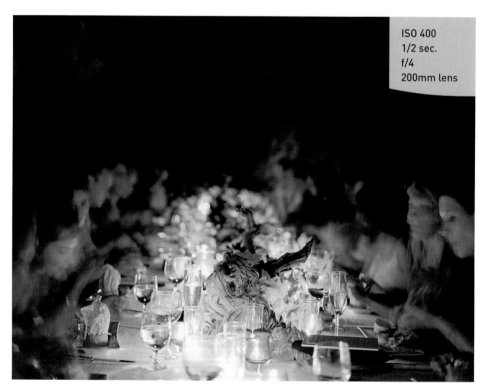

ISO 400
1/2 sec.
f/4
200mm lens

You can use motion blur intentionally to create various effects. It can be really effective in conveying a sense of movement in the image. Camera shake is generally to be avoided, but sometimes, it can create a softness that doesn't necessarily detract from an image—it can even enhance the emotional impact (**Figure 2.5**). But in order to avoid unintentional, image-ruining motion blur, you must first know the speed at which you can hand-hold the camera without shaking, and then always be aware of the shutter speed you're shooting to make sure you don't go beyond your limit. I know that I can hand-hold pretty well at 1/15 sec. or even 1/8 sec., but I certainly feel more confident that I'll avoid unintentional camera shake at 1/30 sec. or shorter.

To minimize camera shake at very slow shutter speeds, try leaning against a pillar or wall if possible, or rest the camera on a solid surface, such as a table. Take a breath, exhale, and hold it; then release the shutter. I often take several images in a row, all in the interest of nailing one perfectly sharp one. Unless my subjects are perfectly still, I need to keep in mind that their movement could also translate as motion blur in the image. I ask myself whether that's the effect I want, and if it isn't, I adjust my shutter speed accordingly.

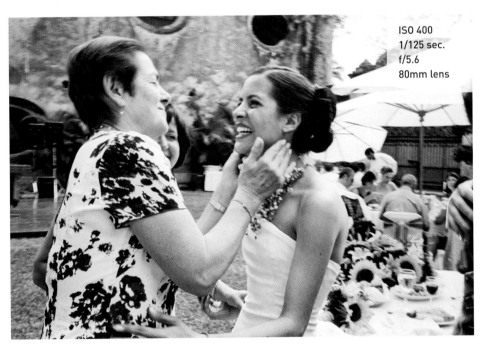

ISO 400
1/125 sec.
f/5.6
80mm lens

FIGURE 2.5
I shot this while I was hustling from behind the guest to the side to get the shot. I was moving really quickly, as were the subjects, so some motion blur was captured—but in this case, it actually enhanced the feeling of movement and excitement.

Panning is a fun technique that captures the excitement of motion in an image in a very deliberate way. You do it by using a relatively slow shutter speed (the speed will vary depending on how fast the subject is moving and the level of motion blur you want to create) and tracking the subject with the lens as you press the shutter. If you're tracking along with the movement, then the subject will be reasonably sharp, while the background will be captured in an exaggerated blur of motion. It takes a bit of experimentation and practice to get the feel for panning, but it's a great way to convey the feeling of movement in an image (**Figures 2.6** and **2.7**).

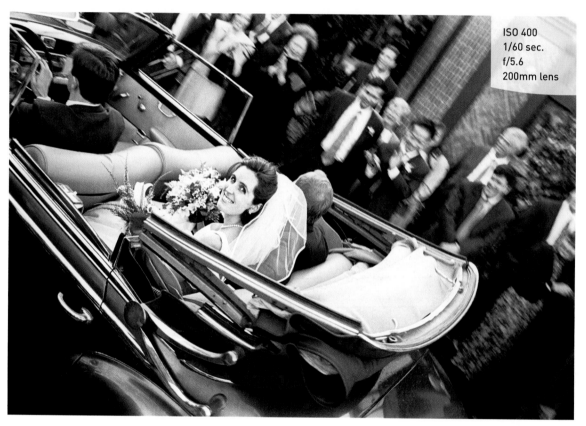

ISO 400
1/60 sec.
f/5.6
200mm lens

FIGURE 2.6
An open getaway car provides the perfect opportunity for a quintessential panning shot.

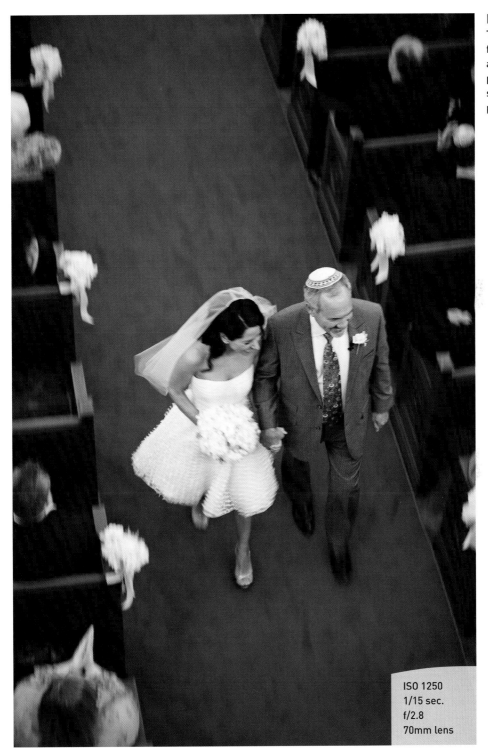

FIGURE 2.7
Tracking the couple
from the balcony
as they recess
puts a different
spin on the typical
panning shot.

ISO 1250
1/15 sec.
f/2.8
70mm lens

APERTURE AND DEPTH OF FIELD

Every lens has a diaphragm that opens to allow light into the camera. Aperture is the size of the opening for a given shot, measured in f-stops. The larger the f-stop, the smaller the opening; the smaller the f-stop, the larger the opening (**Figure 2.8**). So, f/22 is a very small aperture, and f/1.4 is a very large aperture.

f/2.8 f/4 f/5.6 f/8 f/11 f/16

The most important image feature to associate with aperture is *depth of field*—the distance between the nearest and farthest objects in a scene that appear acceptably sharp in an image. The smaller the aperture, the greater the depth of field; the larger the aperture, the shallower the depth of field. So, an image shot at f/22 will most likely be sharp throughout, even if there is a great distance between foreground and background; on the other hand, an image shot at f/1.4 will have very shallow depth of field—perhaps only a sliver of the image will be sharp.

Shallow depth of field can lend an image a softness that's really beautiful, especially for weddings. It creates a nice separation between the subject and the background and helps focus the viewer's attention precisely where you want it (**Figures 2.9** and **2.10**).

Shooting with a shallow depth of field at a wedding also can be really practical, because it helps reduce or completely eliminate distracting background elements over which you have no control (**Figure 2.11**).

I rarely shoot with an aperture smaller than f/5.6 for most of the day; most often, I'm shooting at f/2.8 or f/4. Use caution when shooting with super-wide apertures like f/1.4.

Other factors aside from aperture affect depth of field. A longer lens (like a 200mm zoom) will create a shallower depth of field than a wide lens (like a 35mm). Your distance from the subject makes a difference, as well—the closer you are, the shallower the depth of field. Figure 2.10 is a good example of this.

Once, I was shooting the bride during toasting with an 85mm lens, and because it was so dark at the nighttime reception, my aperture was wide open at f/1.8. When I was close in to the bride, I found that, with her face at a three-quarter angle to me, I couldn't get both of her eyes in focus—the depth of field was too shallow. That wasn't the look I wanted, so I switched to a 50mm lens and bumped up the aperture slightly to f/2.2; the depth of field increased enough to achieve a sharp focus on both eyes.

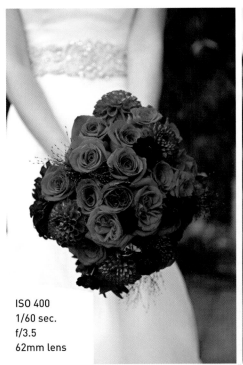

ISO 400
1/60 sec.
f/3.5
62mm lens

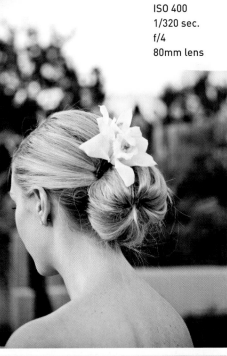

ISO 400
1/320 sec.
f/4
80mm lens

FIGURE 2.9
(left) The detail on this bride's gown was lovely, but I wanted to concentrate the viewer's attention on the bouquet. A wide aperture blurs the background just enough.

FIGURE 2.10
(right) With a focal length of 80mm, an aperture of f/4 was enough to soften the background to a soft, romantic blur.

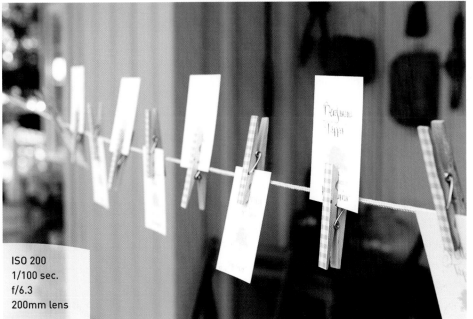

ISO 200
1/100 sec.
f/6.3
200mm lens

FIGURE 2.11
This background was very distracting, so I originally shot it with a very wide aperture. But because of the long lens (not the one I would normally use for this, but on my camera as I walked by) and my close distance to the subject, the depth of field was actually too shallow. I needed a smaller aperture to get the entire escort card in focus.

ISO

ISO is simply how sensitive the camera's sensor is to light. A higher ISO, such as 1600, is more sensitive and, therefore, needs less light to expose properly, making it incredibly useful in darker environments. A low ISO, such as 200, is less sensitive, requires much more light, and is best in brighter situations.

FILM VS. DIGITAL

I've been photographing images for over 20 years, so I obviously began with film and spent many happy years with it. As the technology and image quality with digital photography improved, I slowly began to incorporate it into my workflow. Now, I'm shooting nearly all my color work with digital, but I still shoot a lot of black and white with film because I just plain love it—I love the grain, the wonderful range of tones, and the timeless beauty of a true black-and-white silver print. Many of the black-and-white images in this book were shot on film.

Aside from my passion for black-and-white film, I view three features of digital photography as game-changing improvements over film when it comes to shooting weddings:

- You don't need to reload the camera every 24 or 36 frames. This is incredibly helpful at many times during a wedding, particularly the ceremony. With film, I often had to ration my remaining shots to ensure that I had enough exposures left for the kiss and recessional or gamble on whether I would have enough time to rewind and reload before the end of the ceremony. With digital, this concern is removed, and I can shoot away through the ceremony (or the first dance, or the toasts) with one less technical consideration to worry about.

- The sensors on digital cameras have become amazing for shooting at high ISOs—much higher than with film, and with a higher-quality result. As a natural-light shooter, I had ways to deal with very low-light situations, but they were limited and, frankly, I was less than excited about nighttime weddings. Now, I feel that a whole new world of low-light photography at weddings has opened up to me, and I'm excited and energized by the possibilities.

- You can change the ISO to anything you like at any time—the most wonderful feature of all! I can go from a dark church to the bright outdoors and back again, and, with a turn of the dial, adjust my ISO as necessary and continue shooting uninterrupted. With film, I would have to take the time to reload with another film type and often waste unshot exposures on a roll in the process.

I still love and cherish many aspects of film, but for me, the advantages of digital as they pertain to weddings are just too wonderful and exciting to ignore.

The trade-off for using a high ISO is image quality. The higher the ISO, the more digital noise and grain appear in the image. For this reason, you should always shoot at the lowest ISO possible.

In just the past few years, though, sensor quality has vastly improved, and many cameras can now capture very high-quality images at ISOs of 1600, 3200, or higher. The images have relatively little grain and great color. This is an amazing development for natural-light shooting in darker situations (**Figure 2.12**).

ISO 1250
1/20 sec.
f/3.2
60mm lens

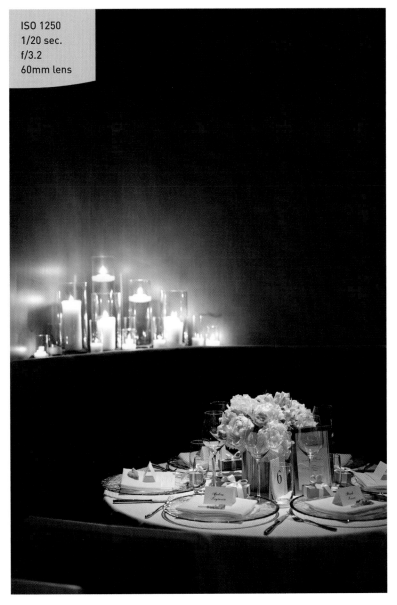

FIGURE 2.12
I had only a few moments to shoot the decor in the room of this nighttime wedding. Because of the great high-ISO capabilities of my camera's sensor, I was able to hand-hold and shoot really quickly. The color is beautiful, and digital noise is minimal.

CAMERA MODES

Most cameras give you four choices for how to meter for a scene: three automatic metering modes (Program, Shutter Priority, and Aperture Priority) and Manual mode. Refer to your camera manual for additional modes that may be available.

Using an automatic mode can be very helpful when you're moving quickly between different lighting situations because, for the most part, you can trust the camera to make the necessary exposure adjustments while you continue shooting. An automatic mode is also great when subjects are rapidly moving between areas of light and dark (say, in and out of the shade of trees) or when events are moving along so quickly that you don't have time to properly meter and set the camera yourself.

PROGRAM

In Program mode, the camera sets both the shutter and the aperture—all you have to do is point and shoot. I never use Program mode, because I want to be the one to make the exposure decisions.

If you're just starting out, you may be tempted to use Program mode, but I encourage you to leave Program mode behind, if for no other reason than most cameras won't allow you to shoot RAW when you're in Program mode, and RAW is always preferable (see the sidebar below).

If you're afraid of missing important shots because you don't trust your abilities in Manual mode just yet, try Shutter Priority or Aperture Priority instead. As you get more comfortable shooting in these auto modes, you can start switching to Manual and get even greater control over your images.

RAW VS. JPEG

You should always shoot RAW, not JPEG. When you shoot RAW, much more color information is retained, which results in greater *latitude* (the range of light to dark that is possible in an image, while retaining detail in both) and a lot more flexibility when making color adjustments in post-production.

In the past, the main arguments against shooting RAW had to do with the large amount of memory required to store the bigger files and the cumbersome, time-consuming nature of processing RAW files. Today, memory is very inexpensive, and amazing software programs like Aperture and Adobe Photoshop Lightroom make processing much easier.

SHUTTER PRIORITY

In Shutter Priority mode, you set the shutter speed that you want and the camera decides what aperture to use for the proper exposure. You may want to use Shutter Priority when you're photographing fast-moving subjects and you want a particular shutter speed to freeze the action.

APERTURE PRIORITY

In Aperture Priority mode, you set the aperture and the camera determines the appropriate shutter speed. Aperture Priority mode is helpful for maintaining a certain depth of field.

Although I shoot predominantly in Manual, I sometimes use Aperture Priority because, for me, depth of field is the most important consideration. When using Aperture Priority mode, I always keep an eye on my shutter speed to make sure it's not slow enough to cause unintentional motion blur.

MANUAL

In Manual mode, you determine the shutter speed and aperture settings yourself.

I shoot in Manual mode for much of the day. As an available-light shooter, I'm often working with lighting situations that could potentially trick the camera into giving an incorrect exposure, and I feel more confident when I've actually metered the light myself. For example, if the scene is very backlit, it could confuse the camera. The same is true if the scene is either very light overall, or very dark. This is because the camera reads the light that is bouncing off a subject. If the subject is very light in color, more light reflects back to the camera, and it interprets the scene as brighter than it really is. It then underexposes the image to compensate. When the subject is very dark, the opposite happens—less light is reflected back, the camera thinks that the scene is darker than it is, and it overexposes the image. (This is a big danger in dark churches and synagogues—be careful!)

METERING

I've had a handheld incident light meter since I started shooting, and I still use it often. Because an incident meter measures the light that is actually hitting the subject, not the light that is bouncing off of it (the way the camera's built-in light meter does), it gives a true reading regardless of how light or dark the overall scene is.

In-camera meters are very good, provided that you understand how they work and which metering mode is best for various situations. Most cameras have three basic metering modes: matrix, center-weighted, and spot.

With matrix metering, the camera looks at the values of the entire scene and bases the exposure on that. This works remarkably well much of the time, particularly when you're shooting a scene that is straightforward in terms of lighting and contains a mix of tones, but the exposure can be thrown off in certain situations, such as an extremely backlit scene, or one that is either very light or very dark.

With center-weighted metering, the camera looks at the whole scene but gives more emphasis to the center of the image when determining exposure. This mode is a little more reliable for tricky backlit, dark, or light scenes, as long as the most important element of your composition is in the center. Center-weighted tends to be my default metering setting if I choose to shoot in my preferred auto-exposure mode, Aperture Priority.

Spot metering can be both very useful and a bit tricky. With spot metering, the camera bases the exposure solely on that one spot in the frame, ignoring the rest of the scene. This is useful when you know that you want a certain element of the image to be properly exposed—say, the face of someone standing in a window—and you don't want the camera to try to balance the exposure for the whole scene. You also can use spot metering if you're faced with a scene that is either very light or very dark. Point the spot at an area of the subject that has a midtone value—neither the darkest dark nor the lightest light—and it will give you a more accurate reading (**Figure 2.13**). You can even hold out your own hand and spot-meter on that.

Instead of spot-metering and switching to Manual mode, some photographers prefer to use the exposure compensation control on the camera. This tells the camera to consistently adjust the exposure up or down by however many stops you indicate, based on how "off" the initial exposure is.

One more note about spot metering: It should be used very deliberately in specific situations, because it places so much emphasis on a very small area of the image. For example, if you're just casually shooting in spot metering mode and the spot lands on a black tuxedo, it will give a much different reading than if it lands on the bride's white gown—and it's likely that neither exposure will be the best one for the scene.

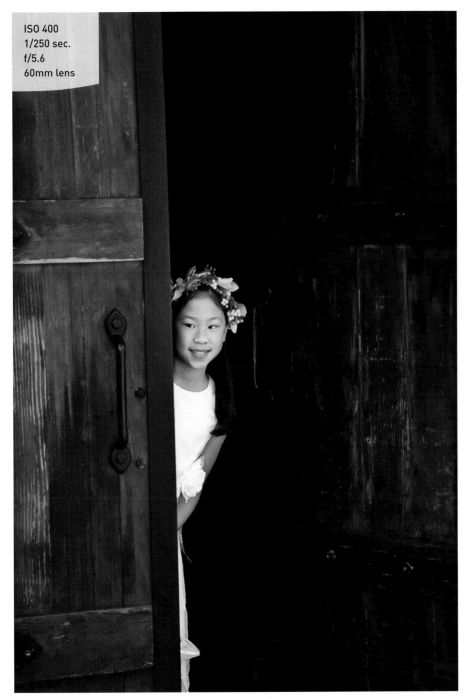

ISO 400
1/250 sec.
f/5.6
60mm lens

FIGURE 2.13
For a scene like this, the dark color of the door filling most of the camera frame could cause your camera to overexpose the image if it's in an auto-exposure mode such as Program, Aperture Priority, or Shutter Priority. Switch to spot metering, and center the spot on a light to midtone value, such as the girl's face, to get the correct exposure reading. Then switch your camera to Manual and dial it in.

USING HISTOGRAMS

Histograms are one of the best things about digital photography, and you'll really increase your control over your images if you understand them. The histogram is essentially a visual representation of the tonal range in an image. Darker tones are represented on the left and lighter tones are represented on the right. The peaks in the histogram show which tonal ranges are most prominent in an image.

There is no one perfect histogram; the way the histogram should look varies depending on the tones present in the scene and your choices about how to shoot it. In general, though, if you're shooting a very dark subject, your histogram will skew to the left, and if you're shooting a very light subject, it will skew to the right. For a subject with mostly midtones, the histogram for a proper exposure should be distributed throughout the middle portion; in this case, if the histogram is far to the left or the right, it's probably an indication that you have either underexposed or overexposed the image.

At a wedding, I mainly use the histogram to quickly check for smashed blacks—dark areas with no detail whatsoever—and blown-out highlights. These will show up as lines on the extreme left or right of the chart. (Sometimes, this line can be so thin that it almost looks like the border of the graph.) This would be expected for certain subjects, such as bright sunlight glinting off water, but for the most part the pure white or pure black pixels indicate that there is no detail information at all in part of the image, and they should be avoided. Doing these quick histogram checks can help you gauge exposure and make the necessary adjustments.

COMPOSITION

Composition is simply the way you choose to arrange the elements of a photograph in your frame. There are many, many "rules" for achieving good composition, and I'll briefly cover a few that I feel are most helpful for wedding photography—although I recommend approaching them more as guidelines than hard-and-fast rules.

Learn and practice these principles to help build a solid foundation in understanding composition. From there, you'll be able to more effectively experiment, play, and bend and break the rules.

THE RULE OF THIRDS

The rule of thirds is probably the most commonly cited principle of photographic composition. If you picture imaginary lines dividing your image into thirds both horizontally and vertically, you should place the most important elements of your composition along those lines, or at the points where the lines intersect (**Figures 2.14** and **2.15**). The rule of thirds can help you compose well-balanced and interesting images.

ISO 400
1/60 sec.
f/2.8
70mm lens

FIGURE 2.14
This image demonstrates the rule of thirds, with the focal point of this image in the lower-right. This rule can help you learn interesting ways to balance a composition.

ISO 400
1/250 sec.
f/4
70mm lens

FIGURE 2.15
Another example of the rule of thirds. This composition gives the image a very open feel, and it's much more compelling than if the couple were smack-dab in the middle.

LEADING LINES

Leading lines can help you create engaging compositions. Lines can be used to lead the viewer's eye through the image, as well as to direct attention to the area of the image that you want to highlight (**Figures 2.16** and **2.17**).

There are plenty of naturally occurring lines at every wedding—the ceremony aisle, banquet-style tables, strings of lanterns or lights, rows of ceremony chairs, a garden path or a hotel hallway. You can find lots of opportunities to use the principle of leading lines to great effect.

ISO 400
1/500 sec.
f/5.6
25mm lens

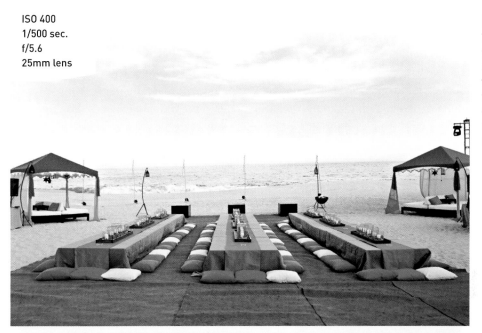

FIGURE 2.16
The lines formed by
the long banquet-
style tables lead the
viewer straight into
the image. This type
of setup offers so
many great ways to
use leading lines.

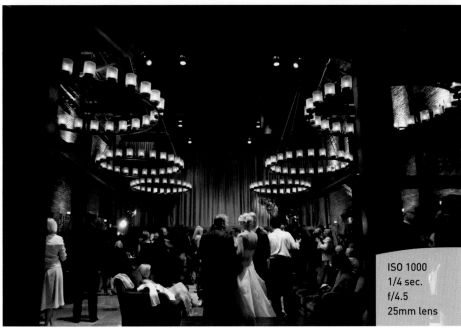

FIGURE 2.17
The chandeliers
form lines that
draw the viewer
right into the room.

ISO 1000
1/4 sec.
f/4.5
25mm lens

FRAMING

Framing is a technique in which you use other objects to frame the main subject in a photograph (**Figures 2.18** and **2.19**). Some elements that you might work with at weddings include trees, arches, architectural details, doorways, and chuppahs. With an open mind and a little imagination, you'll find that there are many, many ways to frame a subject. Don't take the idea too literally—the framing elements don't need to completely surround the subject in order to be effective.

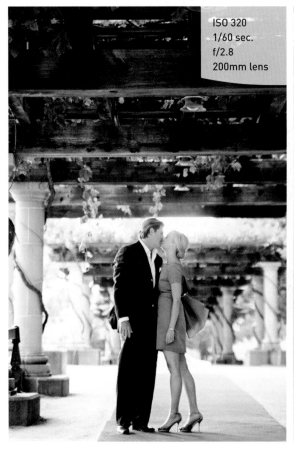

ISO 320
1/60 sec.
f/2.8
200mm lens

ISO 320
1/60 sec.
f/4
200mm lens

FIGURE 2.18
This beautiful arbor provided the perfect frame for this portrait of the couple at their rehearsal dinner.

FIGURE 2.19
Frames don't always have to be in the foreground. These trees in the background are wonderful framing elements.

SYMMETRY AND PATTERNS

Look for symmetry and patterns wherever strong graphic elements such as lines, shapes, or colors repeat themselves. These elements can be used to create arresting photographic compositions. Once you really start to notice, you'll see that we're surrounded by symmetry and patterns —and, thus, photo opportunities!

A well-designed wedding has many, many examples of symmetry—the decor of the ceremony (with, for example, identical urns of flower sprays on each side), the architecture at the altar of a church, the banquet-style table with the same floral arrangements stretching along both sides, and so on (**Figure 2.20**). Patterns may be formed by a sea of blooms in a floral arrangement (or the petals of an individual bloom), rows of perfectly placed escort cards, or a box of identical bouquets when viewed from above (**Figure 2.21**). A key to capturing a sense of pattern in a composition is to edit other elements out; telephoto lenses are useful for zooming in on the critical elements. Viewing the wedding with an eye to capturing its sense of symmetry and pattern will help you create truly compelling compositions.

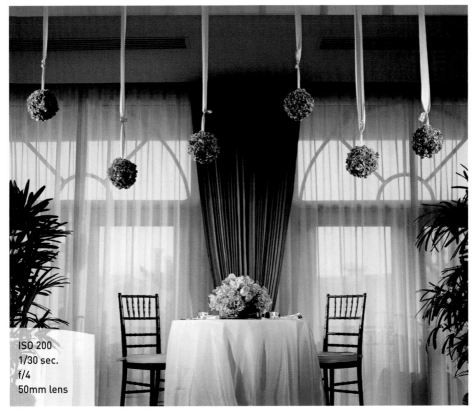

ISO 200
1/30 sec.
f/4
50mm lens

FIGURE 2.20
I framed this shot very carefully to emphasize the beautiful symmetry of the scene.

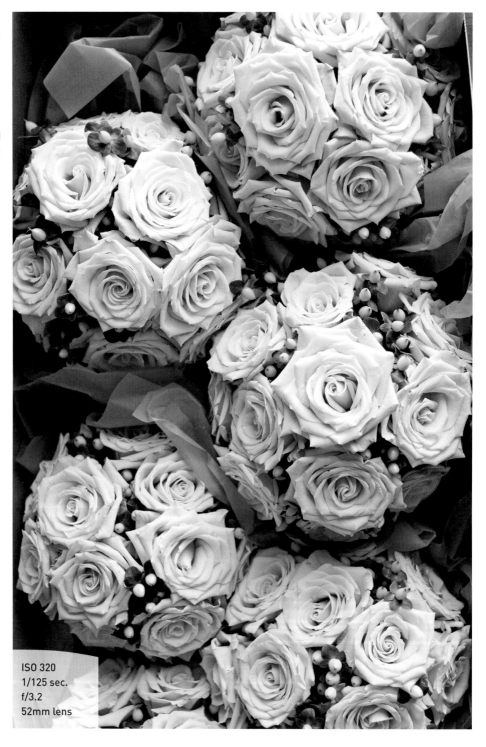

FIGURE 2.21
Sometimes, looking at a subject from another angle puts a whole different twist on things. When viewed from above, these identical bouquets created a pattern that made for a really nice composition.

ISO 320
1/125 sec.
f/3.2
52mm lens

Chapter 2 Assignments

Experiment with Aperture and Shutter Speed

Experiment with different combinations of shutter speed and aperture that achieve the same exposure. Remember that for every stop you go down with the shutter, you need to open up one stop with the aperture, and vice versa. For example, if the exposure is correct at 1/250 sec. at f/8, shoot the same subject at 1/60 sec. at f/11, and again at 1/2000 at f/2.8. They're all correct exposures, but the images will look very different. This experiment will give you a sense of the many, many combinations of settings that are possible for correct exposure for any given scene. You can also use this exercise to see the effects of aperture on depth of field as you move through the range. And if you're hand-holding, you'll see the effects of motion blur (and camera shake) come into play as you hit the very slow shutter speeds.

Throw ISO in the Mix

Once you've done the previous assignment and you have a good feel for the relationship between shutter speed and aperture, add ISO into the equation. Change the ISO and notice how it affects the shutter and aperture settings that are required for a correct exposure. Having a really strong, foundational understanding of the idea that exposure is a balancing act between these three settings, and knowing how each setting impacts the final image, will empower you to make purposeful choices.

Practice Panning

Have a friend model for you and practice shooting him as he moves through your field of vision from one side to the other. Have him move at varying speeds—walking quickly, running, riding a bike. Practice your tracking skills by following the subject with your lens as he moves. Experiment with setting your shutter from 1/8 to 1/15 to 1/60 to 1/125, making sure to adjust your other settings accordingly to achieve the proper exposure. Notice how much motion blur each shutter speed causes. Notice also how the speed of the subject affects how slow the shutter must be to capture the sense of movement. For a car driving by, 1/125 sec. or faster might do it, while you'll need a much slower speed like 1/30 sec. if the subject is walking.

Create Compositions

Take another look at the section on composition in this chapter. Then set out to either create or find examples of each compositional concept—the rule of thirds, leading lines, and so on. I suggest just walking out the door and around the neighborhood to see what you can find. At first, you might feel that looking for these types of compositions is a bit restrictive, but it can be really helpful in giving you a starting point, a way to begin to make sense visually of all that's around us.

Share your results with the book's Flickr group!

Join the group here: flickr.com/groups/weddingsfromsnapshotstogreatshots

3

ISO 320
1/125 sec.
f/5.6
70mm lens

Prepping for the Shoot

LAYING THE FOUNDATION FOR SUCCESS

Talent and skill will carry you far, but there is no substitute for preparation.
In order to capture the truly telling images at the wedding, you must keep
a clear head amidst the commotion of the day so that you can focus on the
wonderful moments going on all around. Having a solid understanding of
the sites where the wedding events will occur, the schedule, and the flow
of the event as well as any specific desires of the couple will set the stage
so that you can get into the creative zone when it counts.

PORING OVER THE PICTURE

While scouting this location beforehand, I found this wonderful balcony location for portraits. Shaded spots like this are especially good when the portraits of the couple need to be taken in the harsher afternoon light.

A wide aperture creates a shallow depth of field, softening the background and reducing the distraction of the buildings in the distance.

Compositionally, the balcony railing forms a leading line that draws the viewer's eye straight into the image.

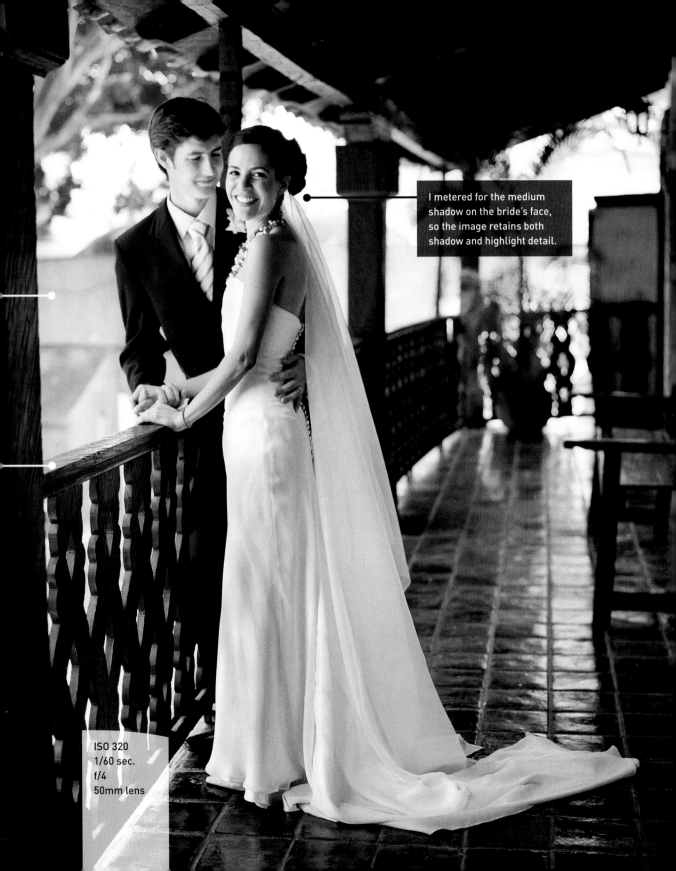

I metered for the medium shadow on the bride's face, so the image retains both shadow and highlight detail.

ISO 320
1/60 sec.
f/4
50mm lens

MAKING A PLAN

I spend a lot of time preparing for every wedding—gathering schedule information, scouting the location, conferring with the couple and planner, and so on. All this time and energy is well spent when it allows me to walk in on the wedding day with a clear sense of how the action will unfold and how I intend to capture it. The more legwork I do ahead of time, the clearer my vision for the day, and the better able I am to simply be in the moment at the actual wedding—in tune to the rhythms of the day, poised to capture the meaningful moments.

UNDERSTANDING THE GOALS OF THE COUPLE

Naturally, the fact that the couple selected me to be their photographer tells me that they understand and appreciate my style. They've hired me to come "do what I do" at their wedding. Still, I always take time to connect with them and learn whether there are any considerations or concerns that are specific to their event. Maybe they're exceptionally passionate about black-and-white photography, or perhaps they want special emphasis placed on certain family members. There may be particular elements of the wedding that are especially unique and important to them (**Figures 3.1** and **3.2**). And of course, if there are any tricky family dynamics at play, I need to know about them.

At the same time that I gather information from the couple, I also offer my opinion on various elements of their planning that will impact the photography, particularly the timing of events. Most clients don't realize what a huge impact timing can have on the way their images will look, so I want to be sure to give them the photographer's perspective. For example, many couples dream of a sunset wedding. A sunset wedding may be beautiful, but the rest of the wedding will be in pitch dark. From my standpoint as a photographer, it's much better to have the ceremony a couple of hours before sunset—the light will still be somewhat softened at that hour, and after the ceremony has ended there's a nice chunk of time to shoot portraits of the families and the couple, cocktail hour, and possibly even toasts or the first dance with natural light. All those elements will be much prettier as a result, especially for an outdoor wedding.

The question of whether the couple should see one another before the ceremony often comes up. From a photographer's perspective, it's always a great idea, because it allows me to take most or all of the posed groupings before the ceremony, as well as some portraits of the couple. I never pressure couples to see one another, but I'm very frank about the implications if they choose not to. If they have large families

and an extensive list of posed and family shots, they'll likely miss their cocktail hour as we plow through that list post-ceremony. If their ceremony is close to sunset, we may not have enough light afterward to make the most of the beautiful setting, and we'll be much more limited in what we can do with their couple portraits. If they clearly understand how the decision may impact other parts of the day and they still truly don't want to see one another, then I respect their wishes—it's their wedding, after all!

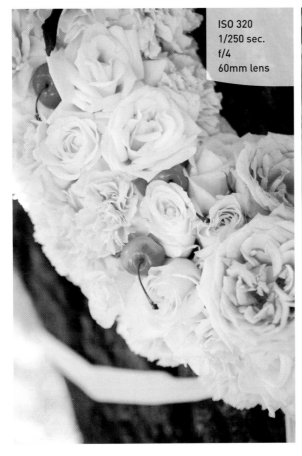

ISO 320
1/250 sec.
f/4
60mm lens

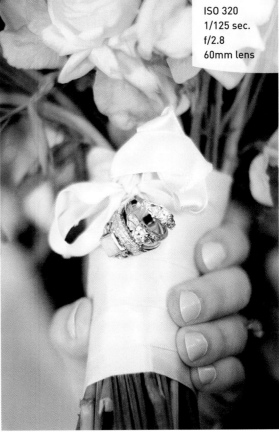

ISO 320
1/125 sec.
f/2.8
60mm lens

FIGURE 3.1
The cherries used in the decor of this wedding were a tribute to the summer trips to local cherry stands that the bride shared with her father as a child. Based on our pre-wedding conversations, I knew how meaningful this element was, so I emphasized it in the photos.

FIGURE 3.2
Attached to the bride's bouquet were wedding rings from her departed grandmothers and great-grandmothers. I might have missed these special touches if I hadn't had good communication with the client.

SETTING EXPECTATIONS

Part of laying the foundation for smooth coverage of the day is making sure that the couple has realistic expectations. I can't expect them to know all the factors that will affect the photography at their wedding. Part of my job, as a professional, is to educate them about what they can reasonably expect and to guide them toward decisions that will result not only in the best experience of the day but also in the best images possible.

Most commonly, clients simply don't realize how long things will take. They may be planning to fit a lot more into a short amount of time than is actually possible. For example, I was hired by a couple getting married in San Francisco; they had their heart set on driving their entire wedding party to a beautiful location on the other side of the city to shoot group portraits as well as couple portraits, and then returning to cocktail hour. They allotted 30 minutes in the schedule to do this, which wasn't even close to the amount of time we would actually need! During our pre-wedding conversations, I had to tell them that this wasn't going to be possible.

I never enjoy having to disappoint my clients, but it's better to have that conversation in advance than it is to go along with a plan that's clearly unworkable and that would mess up the schedule for the rest of the day.

CREATING A SHOT LIST

For most of the wedding day, I don't work from a shot list. But for the posed family and group portraits, I always do. Despite my heavy bias toward spontaneous, candid moments, I realize that these formal images represent an important historical document of the families present at the wedding. I want to be sure to capture everything necessary and do it as quickly and efficiently as possible. Working with the couple to develop a specific list of groupings helps me do that.

I have a very basic sample family/group shot list that I send to my couples to use as a starting point:

- Bride with maid of honor and then with bridesmaids
- Groom with best man and then with groomsmen
- Bride and groom with entire wedding party
- Bride and groom with bride's parents
- Bride and groom with groom's parents

- Bride and groom with bride's immediate family

- Bride and groom with groom's immediate family

- Bride and groom with any other special family members
 (for example, grandparents)

Every family is different, so I ask the couple to customize this list to suit their needs. I encourage them to keep the list as streamlined as possible, avoiding endless combinations of nearly the same set of people, and to consider what groupings they, or their family members, will actually want to include in an album or a frame after the wedding (**Figure 3.3**). If the image isn't going to be used for anything, it's simply not worth using precious time on the wedding day to capture it.

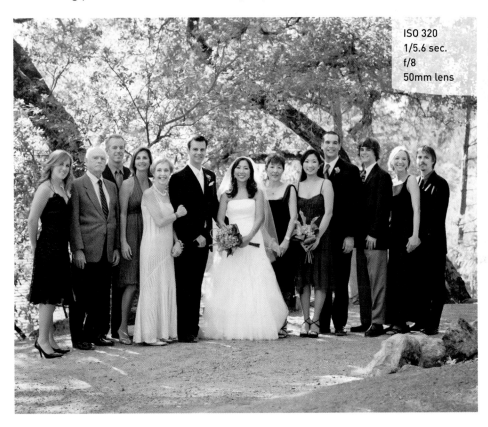

ISO 320
1/5.6 sec.
f/8
50mm lens

FIGURE 3.3
I encourage couples to put family members in big, happy shots of everyone all together, as opposed to time-consuming combinations of essentially the same people.

I also ask them to include the names of the specific individuals who are in each shot, so I can answer any questions that may arise among the family over who's included. Once I have the final list, I rearrange the shooting sequence for the best flow of individuals in and out of each shot (for instance, I want to avoid making the bride

repeatedly enter and exit shots, because it may be difficult for her to maneuver in her gown), and I make sure that any shots involving children or people with mobility issues are done first (**Figure 3.4**).

Preparing all this information is not the most glamorous part of the job, but when the time comes, you'll be glad you have all this information on hand. Developing a shot list allows me to capture these images quickly and efficiently, while ensuring that I don't miss anything important for the couple or their families.

FIGURE 3.4
Don't make
kids wait a long
time for posed
shots. I always
shoot kid-centric
groupings like this
first to minimize
meltdowns!

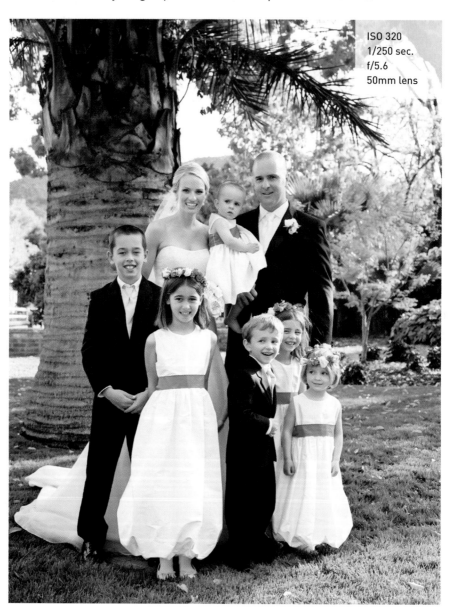

ISO 320
1/250 sec.
f/5.6
50mm lens

LOOKING OVER THE SCHEDULE

A few weeks prior to the wedding, I request a detailed copy of the schedule from either the wedding planner or the couple so that I can review it and ensure that it makes sense for what I need to accomplish in terms of the photography for the day. This is especially important for the first half of the day—from before the ceremony through the end of the cocktail hour—because so many critical events take place during this time and they often take place at multiple locations. Once the guests are settled in for dinner, I know that I'll only be able to capture whatever is happening, and the pressure eases a bit.

I try to make sure that things like dinner courses and toasts are scheduled in such a way that I have the opportunity to take the couple outside for a mini-portrait session around sunset, when the light is most beautiful—assuming that they're willing, of course (**Figure 3.5**). And while events like the first dance and cake cutting often take place later in the evening, if it's an outdoor, summer wedding it's sometimes possible to schedule them while there is still daylight, which gives me many more options in terms of the kinds of images I can get (**Figure 3.6**).

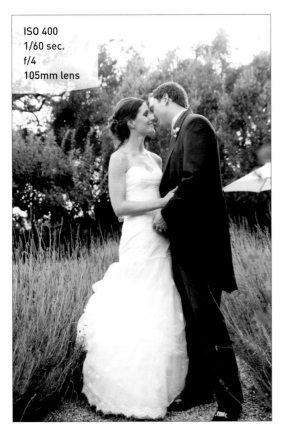

ISO 400
1/60 sec.
f/4
105mm lens

FIGURE 3.5
The most beautiful light of the day happens just before and just after sunset. Take the couple for a brief portrait session around this time, making sure to schedule it in conjunction with the toasts and other reception events so as not to disrupt the flow of the party.

FIGURE 3.6
If there is any flex-
ibility to do so, try
to work with the
wedding planner
or the couple to
schedule the first
dance and other
reception events
while it's still light.

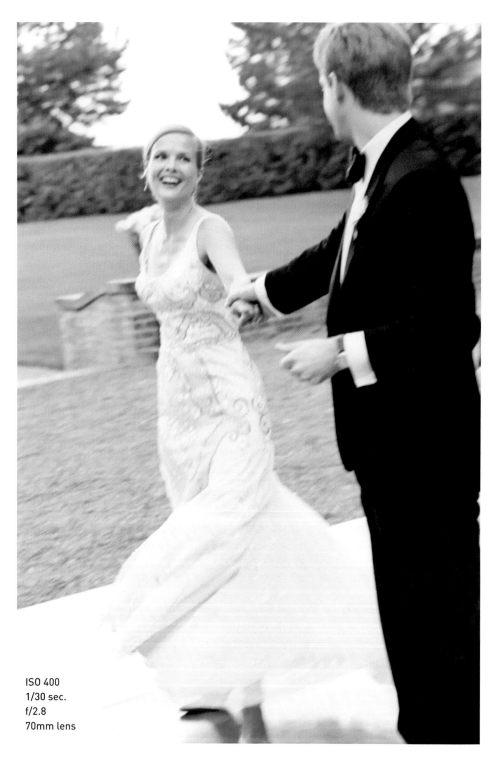

ISO 400
1/30 sec.
f/2.8
70mm lens

Once I receive the schedule, I look for the following:

- **Do I have enough time during the "getting ready" stage of the day?** I like to be in the room with the bride for a *minimum* of 45 minutes—and greatly prefer an hour or more—to have time for all the detail work and candid photos of the wedding participants as they prepare.

- **Does the schedule have me arriving at the ceremony site at least 20 to 30 minutes before the ceremony is scheduled to begin?** I need time to get set up for the ceremony and shoot the decor.

- **Is there a little cushion in the post-ceremony timing?** It's good to have some wiggle room in case the ceremony runs a bit late or the families are hard to gather.

- **Is there enough time allotted for the list of family shots I received from the couple?** Allow two to three minutes per shot, plus a little cushion.

- **Is cocktail hour actually scheduled for a minimum of at least one hour?** A bit longer is always nice, especially if we're doing the family shots during this time.

- **Does the timing of toasts and other reception events allow me the opportunity to slip outside with the couple around sunset for some portraits in the beautiful, end-of-day light?**

If the answer to any of these questions is "no," I have a conversation with the couple or wedding planner to make the necessary adjustments.

SCOUTING THE LOCATIONS

If the wedding is taking place at a location where I've never shot, I take the time to visit the ceremony and reception sites ahead of time, if possible. I always go around the same time of day that I'll be shooting, so I can see exactly what's happening with the light. It's incredibly helpful to lay eyes on the sites, take some light readings, and visualize where I'll want to be during the ceremony, as well as other key parts of the day.

I also determine whether I need to supplement my gear with any rental equipment in order to cover the event as effectively as possible. For example, if I know that I'll be restricted to the very back of a large church, I'll rent a 300mm lens to help get a little closer to the ceremony action (**Figure 3.7**).

FIGURE 3.7
My scouting trip to the site showed me just how far away from the ceremony I would be, due to restrictions at the church. I decided to rent a 300mm lens, and it really helped round out my coverage of the ceremony.

ISO 1600
1/80 sec.
f/2.8
300mm lens

One of the most important tasks when scouting the location is to find a good spot for the family/group portraits. If I can determine ahead of time exactly where I want them to be, then the planner and the couple can pass it on to everyone involved, which helps that part of the day run more smoothly. Ideally, I like to find a pretty spot outside, with nice, even, open-shade lighting, where I can shoot the family portraits with available light and get great results. It's also helpful if the chosen spot is set a bit apart from the location of cocktail hour to minimize the chance that key people will wander off.

I also look for spots to take the couple for their portrait session. I always try to do these photos outside, so I look for things like pretty paths, beautiful trees, and interesting architectural elements like elaborate doorways, pillars, or arches (**Figure 3.8**). Indoors, I look for window light and pretty decor.

ISO 400
1/40 sec.
f/2.8
105mm lens

FIGURE 3.8
When scouting locations for the couple portraits, I can take as much time as I need to look for interesting perspectives and unique elements that I can use in my compositions.

Finally, I wander the grounds and see if there is a way to get a unique view of the ceremony or the reception site itself (**Figure 3.9**). If there is a balcony or a window that I want to use, I make sure I know how to access it (**Figure 3.10**). Sometimes I shoot a few details of the site—the signage, architecture, and so on—so I don't have to take time to shoot them on the wedding day.

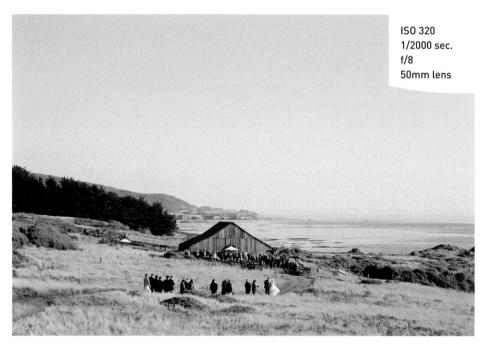

FIGURE 3.9
While wandering around this property the day before the wedding, I saw this spectacular vantage point. At the wedding, I sent my assistant to take this shot while I was down below, closer to the wedding party.

ISO 320
1/2000 sec.
f/8
50mm lens

A SITE VISIT CHECKLIST

- Are your directions to the site accurate?

- What is the lighting like for the ceremony? How will you shoot it from various angles and perspectives, given the layout of the site and any restrictions that may be placed upon your movement?

- Is there a balcony or another alternative location that gives you a good angle on the ceremony or reception? If so, how can you access it?

- Is there any special equipment you should rent that will help you cover the event more effectively?

- Where do you want to take family or group portraits?

- Where do you want to take the couple for their portrait session?

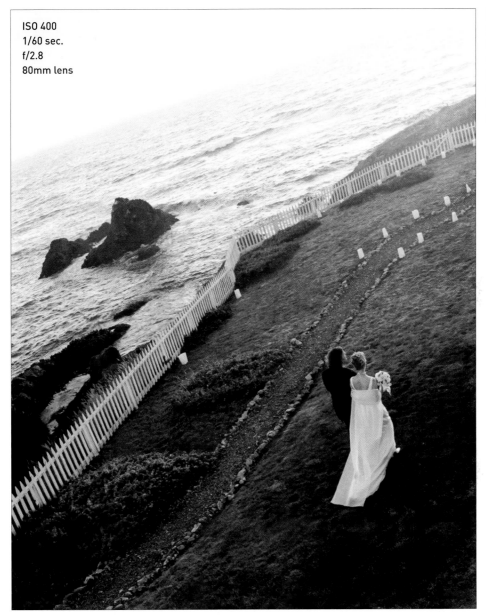

ISO 400
1/60 sec.
f/2.8
80mm lens

WHEN YOU CAN'T VISIT THE SITE IN ADVANCE

Sometimes the wedding site is just too far away to visit ahead of time. In that case, I look for images on the property's website to get a general sense of the place, and then I arrive about an hour early on the wedding day so that I can familiarize myself with the setting.

If I've traveled in for a destination wedding, I often can swing by the site during the rehearsal the day before. The rehearsal is often around the same time of day as the ceremony, and I have the added advantage of seeing the actual setup, as well as where everyone will enter, stand, exit, and so on.

Another benefit with destination weddings is that I'm often staying at the same place where the wedding will be held, so the night before the wedding, I can really pay attention to how the light changes throughout the evening and further refine my ideas for shooting the event.

GO WITH THE FLOW

You can spend a lot of time (and I do) carefully planning how to handle each stage of the wedding day, but when the time comes, you have to be flexible, because the wedding day is very fluid. Invariably, things will change, and you have to be ready and able to change with them. The ceremony may begin late, impacting the timing of all subsequent events. A tent may be brought in at the last minute, completely changing the light. A critical family member may be a no-show for the family portraits, making it necessary to do those photos later in the day than scheduled.

When something unexpected happens, it may seem as though your carefully laid plan goes out the window and that all the time and effort you spent on it was wasted. But I find that the opposite is true—this is the moment when all my planning really pays off. Having such a clear vision as I go into the wedding day really helps me keep my thoughts organized when the pressure is on and things are rapidly changing. It helps me stay cool and quickly come up with alternative solutions when necessary. The better you know your gear, the locations, the schedule, and the desires of your clients, the better equipped you'll be to handle whatever curveballs come your way.

TAKING CARE OF YOURSELF

Shooting a wedding is very grueling work, both physically and mentally. Take care of yourself during the couple of days leading up to the wedding—get enough sleep and eat well. Don't leave your preparations until the last minute. Leave plenty of cushion in your travel time so that you don't arrive frazzled and on the edge of being late. Try doing a little creative visualization, imagining the day unfolding smoothly and successfully. These steps lay a foundation that allows you to arrive on the wedding day feeling your best and most creative.

Just to be safe, I keep a few essential comfort items stocked in my bag at all times:

- Advil and/or Tylenol
- Band-Aids
- Cough drops (very important)
- Tissues
- Lip gloss
- Sunscreen
- Energy bars
- Water

A GEAR CHECKLIST

- Camera bodies
- Camera batteries (charged)
- Camera battery charger
- Lenses
- Light meter
- Compact flash cards (formatted)
- Film and film bag (if applicable)
- Flash with battery (charged)
- Video light with battery (charged)
- Tripod
- Camera body manuals (in bag)
- Anti-static cloth
- Mini flashlight
- Leatherman multi-tool
- Grip tape
- Sharpie marker
- Business cards
- Shot list
- Schedule
- Directions

Chapter 3 Assignments

Practice Strategizing for a Wedding Day

Visit a common wedding site such as a local church or park and make a plan for how you would shoot a wedding there. Where would you place yourself at various points of the ceremony? What equipment would you use? Where would you take the group shots? The more you practice thinking in this way, the easier it will be to come up with plans for many different types of sites.

Scout Here, There, and Everywhere

Whenever you find yourself in a pretty place, imagine how you would handle a couple's portrait session there. Where is the best light? What are some interesting angles? How would you use the elements in the setting to make interesting compositions? Begin to train your eye to view locations in this way. After years of scouting locations, I find that I can't turn off that part of my brain—I'm constantly envisioning couples in the distance whenever I go to a park or beach!

Share your results with the book's Flickr group!

Join the group here: flickr.com/groups/weddingsfromsnapshotstogreatshots

4

ISO 400
1/30 sec.
f/4
80mm lens

Getting Ready

WEDDING STAGE ONE

Anticipation. Excitement. Nerves. Beautiful hair, gowns, shoes, and jewelry. Is it any wonder that "getting ready" is one of my favorite parts of the day? But, in addition to all the lovely moments with the bride and her bridesmaids, there is much to do in the time before the ceremony: detail shots of personal flowers such as bouquets and boutonnieres, family and guests arriving, bride and groom seeing one another for the first time, and more. As with every aspect of the wedding day, you need to have a plan—and then be prepared to change it as needed!

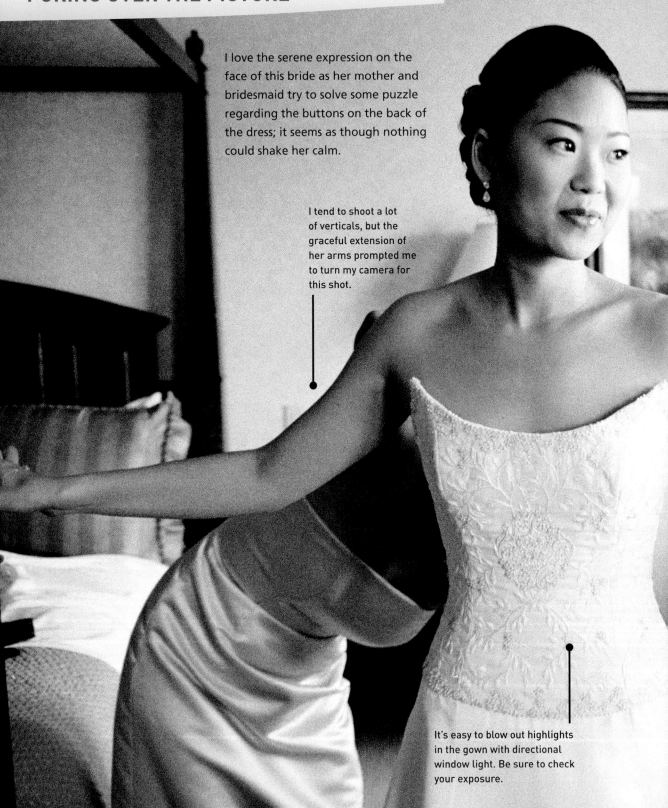

PORING OVER THE PICTURE

I love the serene expression on the face of this bride as her mother and bridesmaid try to solve some puzzle regarding the buttons on the back of the dress; it seems as though nothing could shake her calm.

I tend to shoot a lot of verticals, but the graceful extension of her arms prompted me to turn my camera for this shot.

It's easy to blow out highlights in the gown with directional window light. Be sure to check your exposure.

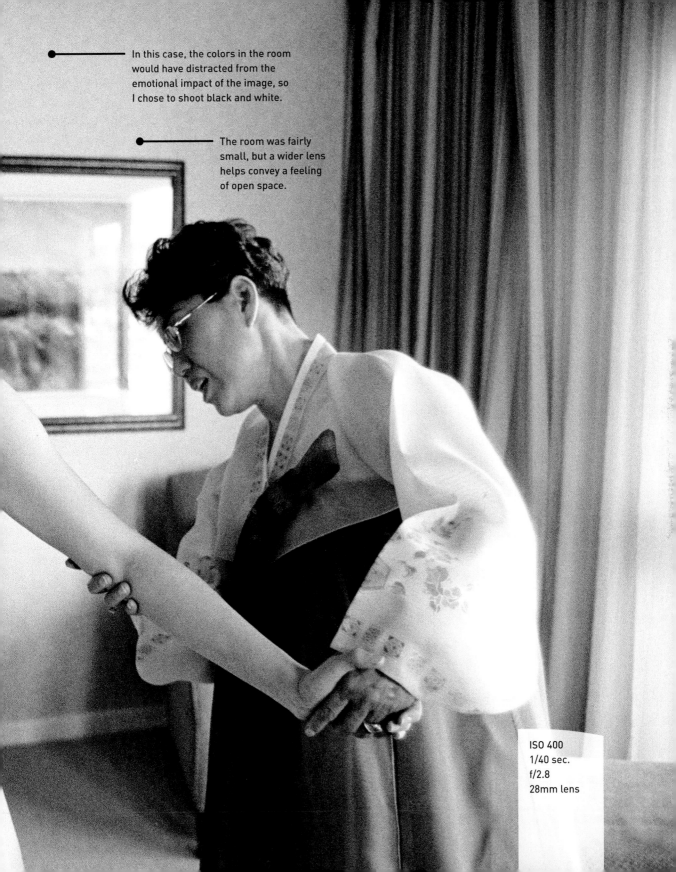

In this case, the colors in the room would have distracted from the emotional impact of the image, so I chose to shoot black and white.

The room was fairly small, but a wider lens helps convey a feeling of open space.

ISO 400
1/40 sec.
f/2.8
28mm lens

GETTING STARTED

The bride's room is usually where I begin the wedding day coverage, and after all the preparation and planning for the day's shoot, it always feels great to finally get started. I ease into the situation, often concentrating on various detail shots first, staying alert for special moments between the people who are there, and thinking ahead to how I'll handle the moment of the bride getting dressed.

PUT THEM AT EASE

The first thing I do upon entering the room is greet everyone and introduce myself with a smile. *Remember:* People aren't accustomed to being photographed in a candid way and they may be intimidated. Part of your job is to help everyone feel comfortable with your presence. The good news is, this will result in more natural, authentic images.

SHOOT THE DETAILS

The second thing I do is locate the dress, and—putting on my "stylist" hat—scout for a good spot to hang it for a photo. A beautiful armoire, a canopy bed, a curtain rod, the back of a door, outside on a patio overhang…there are many possibilities. I always, *always* check with the bride to make sure that she's comfortable with my removing the dress packaging and relocating the dress, and I'm obsessively careful when handling it! Before moving the dress, I grab a towel from the bathroom and wipe down any surface that will touch the dress, and I make sure that whatever I'm using to hang the dress is sturdy enough to support the weight of the gown— wedding dresses can be really heavy!

I shoot both the front and back of the gown, and sometimes I need to use a fairly wide lens to include the whole gown in the shot (**Figure 4.1**).

Next, I move in for close-ups of any wonderful lace, ribbon, or beading details; simple folds of sumptuous fabric as it hangs; the row of tiny buttons up the back (**Figure 4.2**). When shooting these details, watch your exposure—if you're using an automatic exposure mode such as Aperture Priority, the light color of the gown can trick the camera's meter into underexposing the image. This isn't a disaster, but you'll save some time in post-processing—and the image quality will be better—if you take a moment to make sure it's exposed properly in-camera.

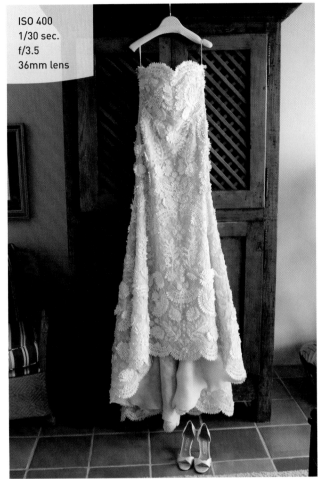

ISO 400
1/30 sec.
f/3.5
36mm lens

FIGURE 4.1

The side-lit armoire was a perfect spot to hang this dress. I used a wide focal length on my 24–70mm lens in order to get the entire dress in the shot.

ISO 400
1/60 sec.
f/3.2
52mm lens

FIGURE 4.2

For detail work, I sometimes use my 35mm lens on an APS-sensor (not full-frame) camera. The sensor makes the 35mm lens look like a 52mm lens, and it focuses in very close. It also has a wider aperture (f/2) than my macro lens (f/2.8), so it's especially good in darker situations.

Once I'm finished shooting the dress, I very carefully return it to the place where I found it (while breathing a small, private sigh of relief!). Then I look for all the other accoutrements, such as shoes, jewelry, handkerchief, and so on, and I find nice spots to photograph each of these items. The possibilities are endless! Shoes look great placed on a window ledge, hung on a pretty doorknob, or placed daintily on an ottoman or a freshly made bed. Jewelry can be artfully arranged on a wooden table or on a pretty bedspread or throw pillow. If the rings are available to shoot, they can be placed on the jeweler's box they came in, on a spread-out scarf or pashmina shawl, or simply in an outstretched hand. If you have a macro lens, now is the time to use it—especially to get wonderful close-ups of the rings (**Figure 4.3**).

FIGURE 4.3
I used my 60mm macro lens for this close-up of the rings. Notice how narrow the area of focus is. The slightest bit of movement while shooting would throw off the focus, so I took a few shots to make sure that I got one that was perfect.

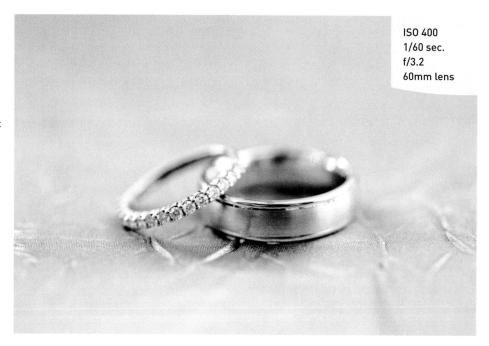

ISO 400
1/60 sec.
f/3.2
60mm lens

For these types of details, I shoot with a fairly wide-open aperture, somewhere in the f/2 to f/4 range. This creates a shallow depth of field that gives the images a wonderful softness and helps the subject stand out from the slightly blurred background. Be careful, though, and keep an eye on your depth of field (use the depth-of-field preview button on your camera to check it). It can sometimes be too shallow, with only the tiniest sliver of the image in focus—and not always the part you intended.

Depth of field becomes more shallow the closer you get to the subject, so this effect is more pronounced when using the macro lens for very tight close-ups; sometimes I need to use a smaller aperture (such as f/5.6 or f/8) in these situations to ensure that my depth of field isn't *too* shallow! The slightest movement when you're shooting can also move the focal point to an unintended spot, so be mindful and hold still when releasing the shutter.

FOCUS ON FLORALS

Personal flowers such as bouquets and boutonnieres are often delivered to the bride's room during this time, and you'll want to capture some solid shots of them while they're at their freshest. I move the flowers close to a window or take them outside if possible; a shady or backlit spot is perfect for capturing beautiful, natural color. I shoot a wide variety of images: all the bouquets lying together, each one individually, and very tight close-ups of the prettiest blooms. Once the ladies have picked up their bouquets, I shoot them again as they're being held. I also reshoot the boutonnieres on the guys' lapels. I adore shooting the flowers, and I can never get enough (**Figures 4.4** and **4.5**).

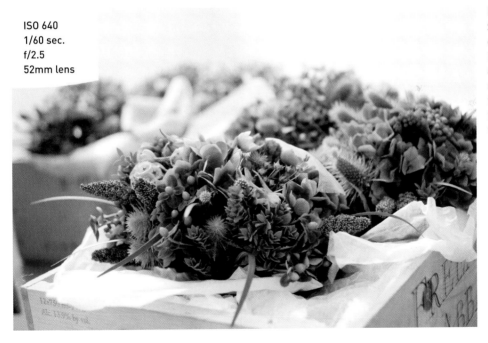

ISO 640
1/60 sec.
f/2.5
52mm lens

FIGURE 4.4
Shoot the bouquets en masse for impact. I used a wide-open aperture to create separation between the bouquet in the foreground and those beyond.

Keep the other wedding vendors in mind as you shoot the florals and decor. Your responsibility is first and foremost to your client, of course, but you should also strive to capture images that showcase the work of your colleagues at the wedding. Afterward, the planner, florist, designer, rental house, caterer, and so on will be thrilled to receive the images. Not only will they share those images with future, potential clients, but they'll be more likely to refer you, knowing that you'll take the time and care to create images that show their work in the best possible light.

FIGURE 4.5
I shot these wonderfully creative boutonnieres individually on the lapels as well, but I loved the look of them taken all together.

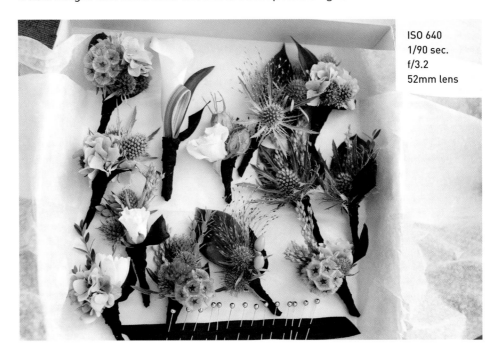

ISO 640
1/90 sec.
f/3.2
52mm lens

SEEK OUT THE SWEET MOMENTS

Of course, at the same time that I'm diligently capturing all the details, I'm also paying attention to the bride and the others in the room. I frequently jump back and forth from still-life work to candid shots of the bride getting ready, the bride having her hair and makeup done, bridesmaids and family members hanging out or busy with their own preparations, and so on. Be sure to shoot everyone who is present in the room, and, of course, give a little extra emphasis to mothers and other family members (**Figures 4.6** and **4.7**). I prefer to hang back from the action as much as possible—particularly at this part of the day when we're in such close quarters with one another, everyone is still getting accustomed to my presence, and nerves may be running a bit high—so I use my zoom lenses and shoot as unobtrusively as possible.

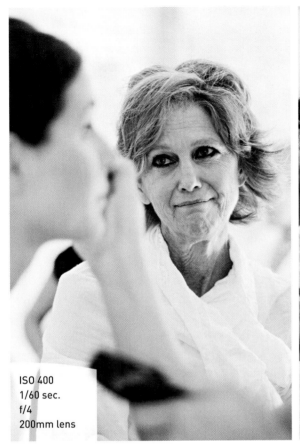

ISO 400
1/60 sec.
f/4
200mm lens

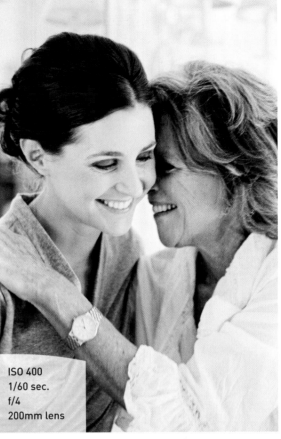

ISO 400
1/60 sec.
f/4
200mm lens

FIGURE 4.6
There is so much to do before the ceremony, but always stay alert for sweet moments like this one, shared between a bride and her mother. I abandoned the shoes to hustle over for this shot; my 70–200mm lens got me close enough without intruding on the scene.

FIGURE 4.7
I swung around in front of my subjects to capture this. It's a touch blurry because I was moving very quickly and my shutter speed of 1/60 sec. didn't quite freeze the action, but it works because it captures the emotion of the moment.

GETTING DRESSED

Up to this point, I have been very unobtrusive, but I do insert myself into the situation a bit more when it comes time to put on the dress. I want to capture the moment in a timeless, beautiful way, and it helps to think about where the bride should stand and how exactly I intend to capture it. I plan it out in advance so that when the time comes to shoot, my focus is on capturing the genuine emotion that is expressed by the bride and by those around her as they see her in the gown for the first time.

THE LEAD-IN

Before the bride is ready to step into her dress, I determine where I would like her to be—indirect window light is best—and I quietly do any necessary tidying up. (Although I like the environment to look natural and authentic, I don't want something like an ugly water bottle mucking up the background of my shots.) When the time comes for the bride to dress, I ask her to stand near the window, and—unless it's really dark in the room—I turn off any overhead lights to avoid the unattractive color clashes that can come from mixed natural and tungsten lighting. I measure the exposure ahead of time and preset my cameras; I want to be completely prepared because, often, the actual moment of getting dressed happens very quickly!

WINDOW LIGHT

I love the look of window light as backlighting while the bride is getting dressed, and I almost always shoot some version of this. There are, of course, many ways to do it. I can silhouette the subject (**Figure 4.8**), I can expose for the subject and allow the background to blow out (**Figure 4.9**), or I can shoot something in between. You'll have your own personal vision of how to best capture the moment, but the important thing is to be in control of your tools and know how to use them to realize that vision. Happy accidents are wonderful things, but we can't rely on them at a wedding! Know what you want to do, and how to do it.

For images of the bride getting dressed, I usually choose to expose for the subject and allow the background to blow out, and I almost always shoot it in black and white because I love the dreamy and timeless look that results. With that in mind, I have a trick for setting myself up to achieve the effect I want. From the angle where the bride will be backlit, I use my handheld light meter to measure exposure for the shadows. (If you don't have a handheld light meter, you can measure it in-camera by pointing at someone who is standing in front of the window—just use spot metering, or move in close enough so that the subject fills the whole frame.) You don't want the light streaming in from the window to interfere with the reading. Set your camera to Manual, and dial in that exposure. When shooting from that angle, I use the Manual setting, so that the backlighting doesn't trick the camera into drastically underexposing the image. When I swing around to shoot from another angle, where the light is falling directly on the bride (rather than from behind her), I quickly switch to Aperture Priority and let the camera make the necessary adjustment to exposure (**Figure 4.10**). When I move back to my original position, I switch back to Manual and keep shooting. In this way, I can move very quickly and capture many different angles, while being assured of the proper exposure throughout.

ISO 400
1/640 sec.
f/4
105mm lens

ISO 400
1/60 sec.
f/4
105mm lens

FIGURE 4.8
(left) I set my camera to matrix metering to meter for the whole scene and used Aperture Priority mode, knowing that the light from the window would cause the camera to underexpose the image and create a silhouette.

FIGURE 4.9
(right) I manually set my camera to achieve my favorite backlit look: exposing for the subject while allowing the background to overexpose.

ISO 400
1/60 sec.
f/4
70mm lens

FIGURE 4.10
When I changed position, the lighting drastically changed from entirely backlit to this lovely side light from the window. I quickly switched from Manual to Aperture Priority so that I could shoot continuously and still be assured of the proper exposure.

The room is often fairly dark, so keep an eye on your shutter speed, making sure that it's fast enough that you can hand-hold without motion blur (remember that you can increase your ISO to help achieve a faster shutter speed). I can hand-hold fairly well at a shutter speed of 1/8 sec., but the movement of the subject also will cause motion blur at such a slow speed. Sometimes, this results in a beautiful, dreamy image, and sometimes it results in a mushy mess. For me, 1/30 sec. or a little bit faster is ideal for this part of the day.

Once the dress is on, I use my 24–70mm lens on one camera and my 70–200mm lens on another camera to capture everything from wide shots of the whole scene to tight close-ups of the back of the dress being buttoned or the ribbon sash being tied. As with every part of the wedding day, capturing this variety of perspectives is key to creating a descriptive set of images that, taken together, truly tell the story.

BRIDAL PORTRAITS

Most of the time, I don't pull the bride aside for a dedicated portrait session. My clients tend to be fairly camera-shy, and one of the reasons they've hired me is because I help them feel natural and at ease in front of the camera—mainly by letting them be themselves and allowing them to forget that they're being photographed. I find plenty of great opportunities throughout the getting-ready process to shoot a bride in ways that capture beautiful, spontaneous, expressive portraits without asking her to pose for me (**Figure 4.11**). Figure 4.10 is another good example of this.

A great time to look for portrait opportunities is right after the bride has gotten dressed—she's still standing in the window light, she's excited about finally wearing the gown "for real," and she's surrounded by her best friends and family, who are all equally excited. The interplay between them creates some wonderful, vivid moments, and the bride is so caught up that she doesn't even notice that I'm shooting.

I'm nearly always able to find naturally occurring portrait opportunities for the bride, but if I feel that it's not happening, I'll simply ask her to come to the window or step outside if it's a pretty setting, and shoot a few quick images in a casual way. Portraits are most flattering when shot with a longer lens, such as an 85mm, and I use a wide aperture (usually f/2.8 or f/4) for shallow depth of field, to keep a soft look. I make it really fast, because my clients generally want to simply enjoy their day with minimal interruption from me.

ISO 1600
1/30 sec.
f/2.8
80mm lens

FIGURE 4.11
As this bride walked away from me into the next room, I could see that the light and the frame of the doorway would make a wonderful shot. I couldn't anticipate the lovely gesture of her head and arm as she walked through, but I was ready and released the shutter at the crucial moment.

COLOR AND BLACK AND WHITE

I shoot the florals and all the details in color, but I tend to prefer black and white for much of the people work during this time of the day. In part, this is just a very practical decision. Shooting black and white eliminates any color-balance issues resulting from mixed lighting, removes any problems with clashing colors in the room decor, and reduces distraction from any just-plain-ugly elements in the room. All this allows me (and, ultimately, the viewer) to concentrate more deeply on the emotional content of the image.

But beyond these practical concerns, I think that black and white simply lends itself to the subject matter beautifully. Lovely figure-study-type images of, say, the curve of her back as the dress is zipped, or a glimpse of her leg as she steps into her shoes…to my eye, creating these images in black and white infuses them with a romantic, ethereal beauty that is truly timeless (**Figure 4.12**).

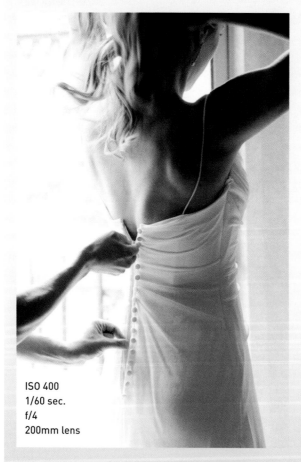

FIGURE 4.12
This shot has a fine-art figure-study sensibility that is rendered beautifully in black and white.

ISO 400
1/60 sec.
f/4
200mm lens

THE GUYS

It's true that this part of the day is mostly about the ladies, but let's not forget the guys! If the groom and his groomsmen are getting ready at the same site as the bride, I slip away from the bride during a lull in the action and grab a few shots of the men. (You can also send your assistant to do it, if you have one.)

It's quite a contrast—I may spend an hour or more in the bride's room, but I generally need no more than five or ten minutes with the guys. I'm looking for a few key shots of the groom straightening his tie (or, as in one case, actually learning how to tie it from a sheet of printed instructions!), fastening his cufflinks, having a beer with his buddies (**Figure 4.13**). I might ask him to pose for a very quick portrait. Then I head back to the ladies—I don't want to miss her putting on the dress!

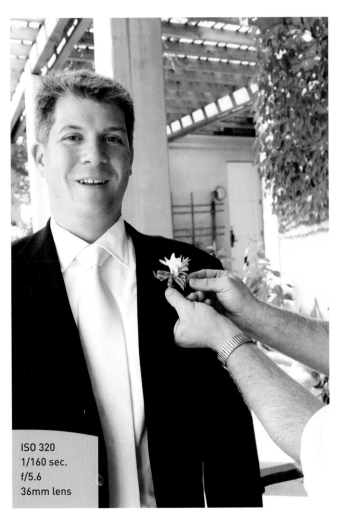

ISO 320
1/160 sec.
f/5.6
36mm lens

FIGURE 4.13
I always spend much less time with the groom before the ceremony, but I like to catch the pinning of the boutonnieres.

If the guys are getting ready at a different site and I'm not able to go there, I make a special effort to capture some good candid shots of them at the ceremony site, before the ceremony begins.

BRIDE AND GROOM SEEING ONE ANOTHER

If the bride and groom have chosen to see one another before the ceremony, I take the lead in selecting where and how it will happen, and I use a bit of planned choreography to capture everything that I want. I position the groom in a pretty spot, preferably with nice, even light, and grab a few shots of him alone—it's a great moment, full of energy and anticipation. I then position the bride some distance behind him and instruct her to approach him slowly. I move back in front of the groom and shoot him again while the bride moves toward him in the background; I also zoom in on the bride over his shoulder (**Figure 4.14**). When she's about 10 feet away, I ask her to freeze for a moment while I quickly move around behind her; this way, I'm in position to capture his expression when he turns around to see her. At this point, I give him the go-ahead, he turns, and I snap away (**Figures 4.15** and **4.16**). Once I've photographed his initial reaction, I swing around to the side of the couple so that I can continue shooting them as they enjoy the moment.

This is definitely the part of the day where I'm giving the most very specific direction to the couple that—let's face it—doesn't feel completely natural. This is so different from my usual, as-unobtrusive-as-possible approach to the wedding day that I often acknowledge it. I let the couple know that I realize it may feel a little strange, but it's worth it to make this moment of seeing one another a very special one and to capture it for them in photographs.

ISO 400
1/250 sec.
f/5.6
70mm lens

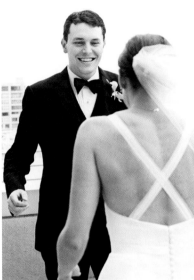

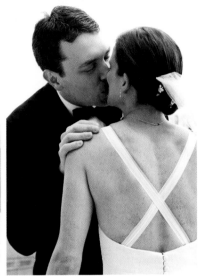

FIGURE 4.14
Step 1: Shoot the bride and groom as she approaches him from behind.

FIGURE 4.15
Step 2: Ask the bride to pause, and then move behind her so you can capture his expression when he turns to see her.

FIGURE 4.16
Step 3: Continue shooting this great moment, moving about as necessary.

ARRIVING AT THE CEREMONY SITE

Once you've finished shooting all the preparations and any pre-ceremony portraits, it's time to head to the ceremony site and get ready for the main event. Aside from the ceremony decor, this is a great time to capture images of guests arriving, ushers handing out programs, kids playing, and family being seated (**Figures 4.17** and **4.18**). If it's daylight, take the opportunity to shoot candid coverage of the guests—especially if it will be dark by the time cocktail hour comes around. I also try to capture images of the bride and wedding party arriving at the site and lining up for the processional. There are often wonderful moments between the bride and her parents before they take her down the aisle. The excitement and anticipation at this time is exhilarating!

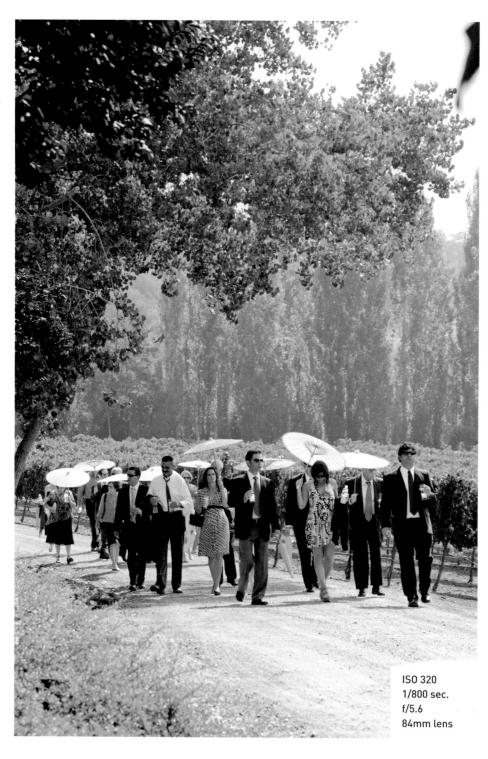

FIGURE 4.17
I like to arrive at the ceremony site early enough to capture shots of the guests arriving.

ISO 320
1/800 sec.
f/5.6
84mm lens

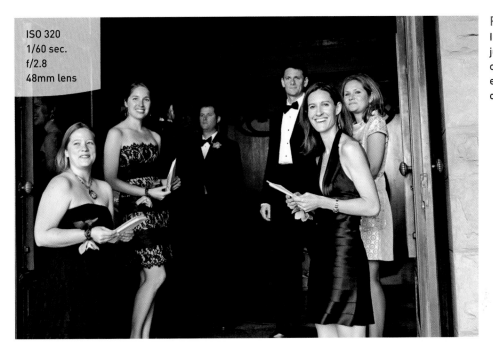

ISO 320
1/60 sec.
f/2.8
48mm lens

MOMENTS TO WATCH FOR

As you're photographing before the ceremony, watch for the following moments:

- **Small gestures from the bride once she's dressed:** Look for the bride clasping her hands, smoothing the fabric of her gown, twisting to check the back of her dress, and so on.

- **Details of the bride's ensemble, as she's wearing them:** You might focus on her earrings; the dress's bow, buttons, or other details; or the bride's hairstyle and other adornments.

- **The bride putting on her veil:** There is something about this moment. For many brides, the veil is what really makes it real for them. Capture that emotion.

- **Anyone entering the room or seeing the bride in her dress for the first time:** People coming into the room for the first time will probably get a heartfelt greeting from the bride, and the first glimpse of her in her dress will surely elicit some great emotion (**Figure 4.19**).

- **Guys getting boutonnieres pinned:** The guys never have as much going on in the "getting ready" department as the ladies, so the boutonnieres represent a nice opportunity to capture that feeling of wedding preparation for them.

- **Kids:** Shoot them early while they're fresh, clean, and happy! Children often leave the event early, so catch them while you can.

FIGURE 4.19
I love the energy and excitement in this shot of the bridesmaids seeing the bride in her gown for the first time.

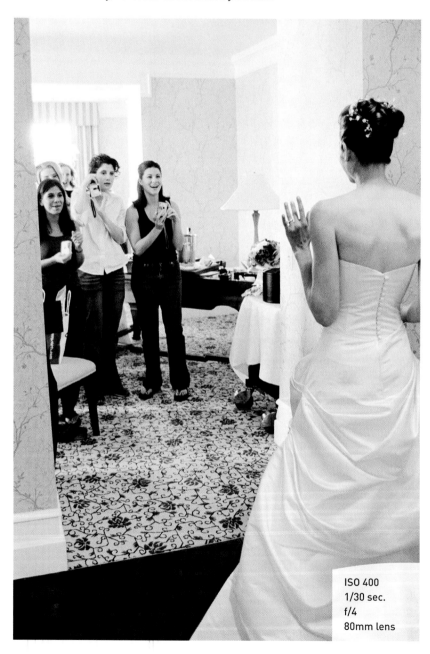

ISO 400
1/30 sec.
f/4
80mm lens

Chapter 4 Assignments

Getting a Feel for Backlighting

Set up a backlit lighting situation and practice manually metering and using the in-camera meter in various ways. Notice how differently the camera interprets the scene, depending on whether you use matrix metering, center-weighted, or spot metering. Get a sense of how the image changes as you stop up and down. If you can develop an innate sense of how these changes impact the image, you'll have a much easier time adapting quickly to achieve the look you want.

Shooting all around a Window

Find a friend to model for you, and set up a fake "getting dressed" moment next to a window. Using the technique described in the "Window light" section of this chapter, manually meter for the shadows when the subject is backlit. Practice shooting as you move around the subject. Notice how the light changes as your angle to the window changes. Get used to quickly switching your camera from Manual for the backlit shot to Aperture Priority as you move.

Choreographing the "Seeing One Another" Moment

Get two friends to help you with this one, and direct them as if they were a couple seeing one another for the first time. You don't have to do it exactly the way I do—get a feel for what angles work for you and what lenses you like to shoot at various moments. Trying it out with actual people will help you understand the flow of the movement, and you'll feel clearer about how to direct your clients at the wedding.

Share your results with the book's Flickr group!

Join the group here: flickr.com/groups/weddingsfromsnapshotstogreatshots

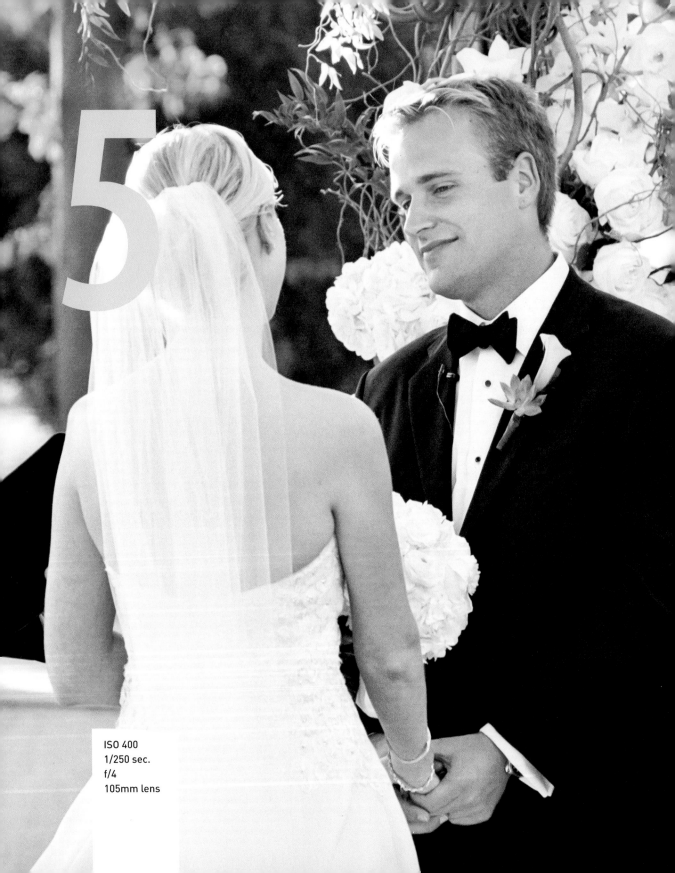

5

ISO 400
1/250 sec.
f/4
105mm lens

The Ceremony

WEDDING STAGE TWO

This is it. The heart and soul of the wedding. The moment when two people commit themselves to one another, in front of family, friends, and the world.

Never underestimate the power of this moment—it is profound. As photographers, our challenge is to capture the flavor of the event in big, bold strokes (the kiss, the triumphant recessional) as well as in subtle, nuanced details (a stolen glance, a shared smile). More than any other segment of the day, the ceremony is the time when we have only one chance to capture the images that will meaningfully preserve the experience forever. And if that weren't enough, we have to do it in a way that doesn't actually intrude upon the moment for the couple or the guests. We must be inconspicuous, yet highly effective. Are you ready?

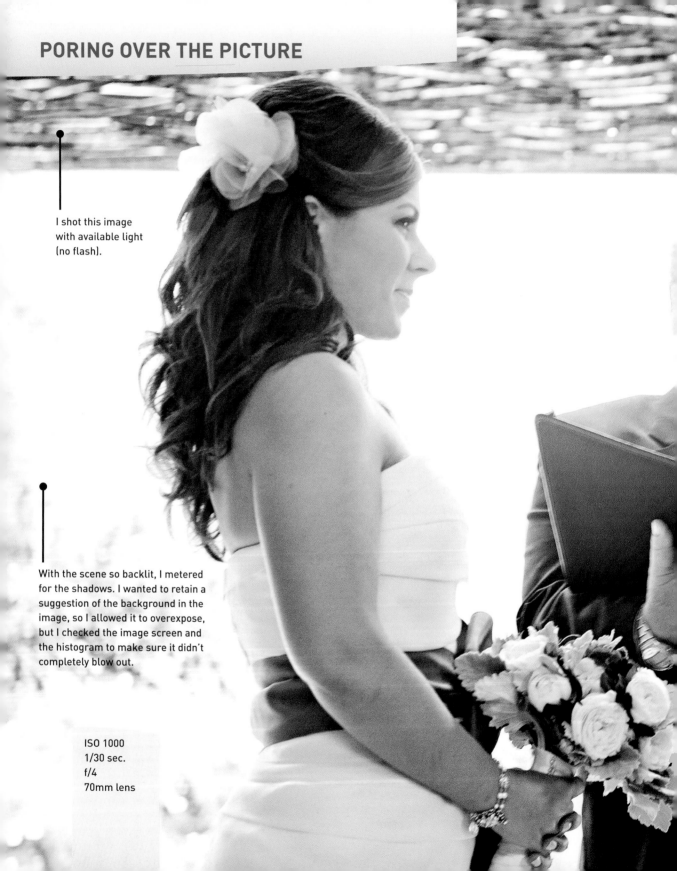

PORING OVER THE PICTURE

I shot this image with available light (no flash).

With the scene so backlit, I metered for the shadows. I wanted to retain a suggestion of the background in the image, so I allowed it to overexpose, but I checked the image screen and the histogram to make sure it didn't completely blow out.

ISO 1000
1/30 sec.
f/4
70mm lens

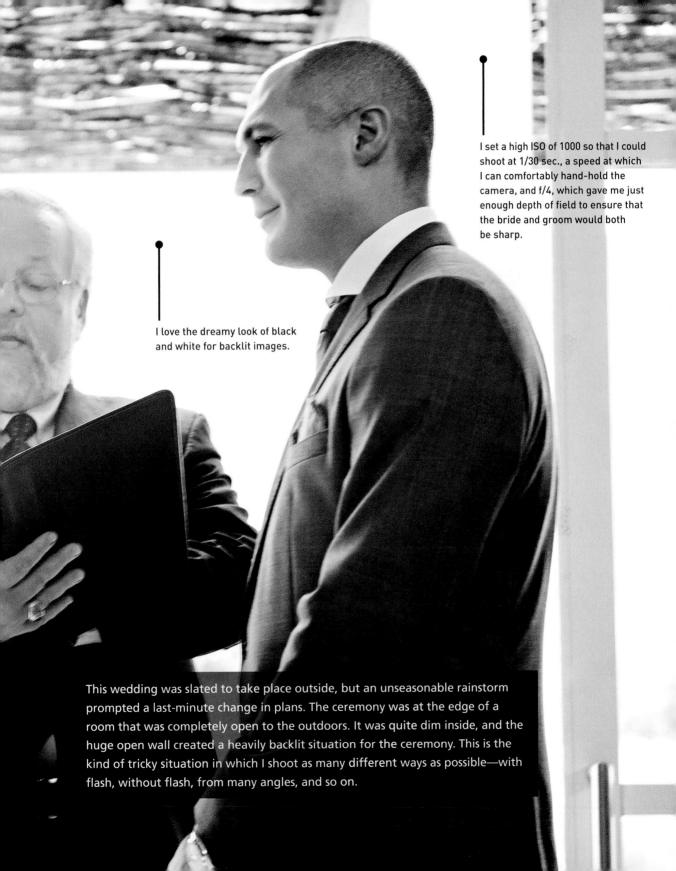

I set a high ISO of 1000 so that I could shoot at 1/30 sec., a speed at which I can comfortably hand-hold the camera, and f/4, which gave me just enough depth of field to ensure that the bride and groom would both be sharp.

I love the dreamy look of black and white for backlit images.

This wedding was slated to take place outside, but an unseasonable rainstorm prompted a last-minute change in plans. The ceremony was at the edge of a room that was completely open to the outdoors. It was quite dim inside, and the huge open wall created a heavily backlit situation for the ceremony. This is the kind of tricky situation in which I shoot as many different ways as possible—with flash, without flash, from many angles, and so on.

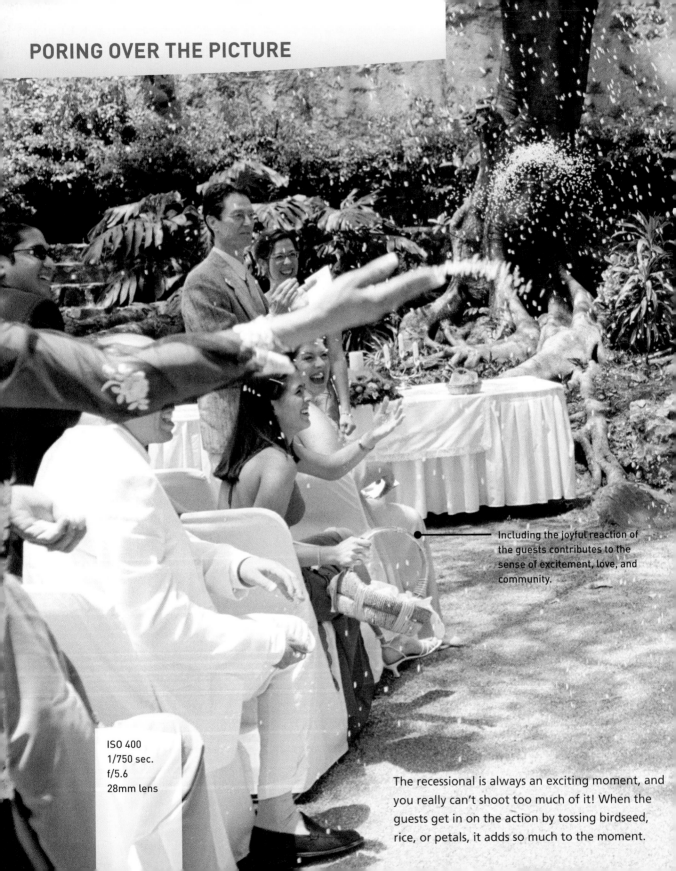

PORING OVER THE PICTURE

Including the joyful reaction of the guests contributes to the sense of excitement, love, and community.

ISO 400
1/750 sec.
f/5.6
28mm lens

The recessional is always an exciting moment, and you really can't shoot too much of it! When the guests get in on the action by tossing birdseed, rice, or petals, it adds so much to the moment.

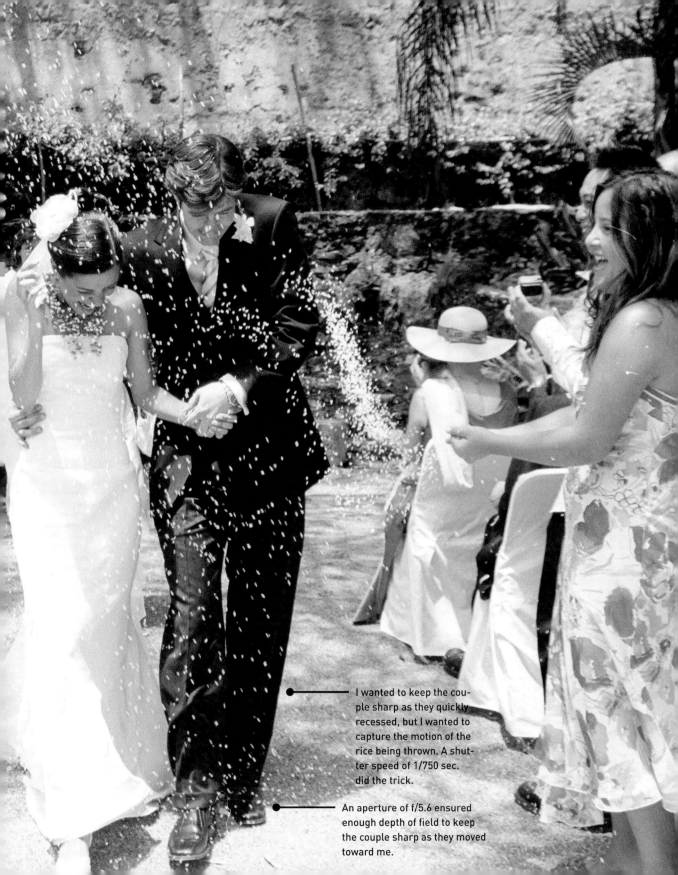

I wanted to keep the couple sharp as they quickly recessed, but I wanted to capture the motion of the rice being thrown. A shutter speed of 1/750 sec. did the trick.

An aperture of f/5.6 ensured enough depth of field to keep the couple sharp as they moved toward me.

CEREMONY ETIQUETTE

As a wedding photographer, your job is to get the best possible shots, without disrupting the ceremony. Ideally, people won't even notice you're there.

In this section, I give you tips for how to conduct yourself so that the bride and groom and their guests remember the ceremony, not the photographer.

BE DISCREET

Your goal is to be as unobtrusive as possible while photographing the ceremony. Remember that you're just one part of an entire team of people who are all working toward the same objective: to provide the couple and their guests with the loveliest wedding experience possible.

We've all attended weddings where the photographer stood right next to the couple or stuck a big lens directly over the shoulder of the officiant in the middle of the ceremony. Don't be that guy. There are plenty of wonderful shots to be had that don't require such tactics and a few simple things you can do to stay discreet.

I try to time my movements to coincide with the transitional moments in the ceremony—when guests are sitting down, standing up, or singing, or when a speaker is standing up or sitting down. When I'm positioned in the middle of the aisle, I crouch down much of the time, stand for a quick burst of shooting, and then crouch again. When I'm standing to the side of the altar, I keep enough distance so that I don't attract the attention of the officiant, couple, or guests. Depending on the ceremony setup, I may be able to slip around the back of the altar for a different perspective on the scene—often the decor or the wedding party blocks me from sight—but if standing behind the altar would create a distraction for the guests, I don't do it.

In darker settings, even if flash isn't prohibited, I use it in a deliberate and targeted way to minimize distraction. For example, each time I move into a new shooting position, I fire off a few shots with the flash, and then set it aside and shoot without flash so that I'm not bombarding the ceremony with a constant stream of flash bursts.

STAY CALM

Never let them see you sweat. A visibly frazzled wedding photographer is, in itself, a source of distraction for the guests and concern for the couple. The moments before a ceremony begins—and many other moments throughout the wedding day—can be stressful for the photographer, but no matter how anxious you may feel, it's important to project a calm, in-control demeanor.

If things are feeling a little out of control, take a moment. Breathe deeply, survey the task in front of you, and devise a plan. Once you know how you intend to tackle the situation, you can start simply doing it, step by step, and the panic will subside.

BE PROFESSIONAL

Collaborating and building good relationships with all the other vendors involved with the wedding, including the officiant, should be a top priority for you. If possible, I always take a moment to introduce myself to the officiant before the ceremony. A friendly smile, a cooperative demeanor, a quick outline of what I plan to do, and reassurance that I won't be unnecessarily intrusive during the ceremony go a long way toward building good will and ensuring that everyone knows what to expect.

If the ceremony site has published rules for photography, assure the officiant that you understand and will adhere to them. Every once in a while, I get lucky and learn that the officiant has a looser attitude toward the rules than expected, and I end up with a bit more leeway. Most of the time, though, the rules are the rules, and I simply must follow them. The couple generally knows about the rules ahead of time, but I make sure to set their expectations realistically if I'll be severely limited in what I can shoot. Obviously, I'm not always happy about the strict restrictions at some sites, but I always respect them.

There was one occasion, though, when I had to break the rules just a bit. According to the church guidelines, the photographer had to stay at the back during the service and shoot without flash. I had no problem with that, but the officiant took things a bit further when he forbade any photography whatsoever from the time the bride entered until the ceremony kiss and recessional. The couple didn't know about this restriction until moments before the wedding, and they were crushed that there would be no photos of the ceremony. I was allowed to stand in the back, but not shoot, and two women affiliated with the church were sitting across the aisle from me, watching my every move. In this one instance, I borrowed a page from my street-shooting playbook: I held the camera casually against my ribs, adjusted the zoom to various lengths, and, without looking through the viewfinder or at the image screen, snapped several frames during moments when various noises from the ceremony (such as guests standing up or sitting down) would cover the sound. Nobody was the wiser, and my clients were thrilled that I was able to capture something from their ceremony after all.

A GAME PLAN FOR CEREMONY SUCCESS

As with every aspect of photographing a wedding, preparation and planning are essential to successfully capturing the crucial elements of the ceremony. If you visited the site ahead of time, then you already have a strategy about where you plan to be, and when, in order to capture the key moments. It's a good idea to go in with a plan, because you may end up walking into the site mere moments before the ceremony is to begin, despite your best efforts to arrive sooner. (For example, the bride may have fallen behind while getting ready, requiring you to stay beyond the scheduled time to finish shooting her preparations.)

First, figure out what cameras and lenses you need for the actual ceremony and prepare the gear. If you have an assistant, factor that into your decisions—where will you be, where will your assistant be, and what gear will each of you need? Make sure you give your assistant clear instructions, and think of your movements as a dance between the two of you. Your movements should be targeted, purposeful, and efficient—don't wander randomly during the ceremony, duplicating shots and creating unnecessary distraction for the guests.

Assuming that you still have a few moments before the ceremony is to begin, shoot the florals, ceremony decor, site features, and so on (**Figures 5.1, 5.2,** and **5.3**). In the meantime, my assistant can shoot guests arriving and being seated.

There are certain key moments during a wedding day when I find it helpful to rely on a bit of a routine, and the ceremony is one of them. It's not that I want to take the same, cookie-cutter shots at every wedding—I just have a lot to achieve in a very small amount of time, with no room for error. Having a template helps me know that I nailed the coverage, allowing me to be more creative.

Every ceremony is different, of course, but if no restrictions are placed on my movement and the ceremony is set up in a typical way with a center aisle, then I usually have my assistant shoot the processional from the front of the aisle (crouching down to remain inconspicuous, of course). In the meantime, I shoot the wedding party as they're lined up, the bride with her father as they await their turn to walk, and so on. Once they enter, I shoot the bride from behind as she walks down the aisle, capturing all the beautiful details of her dress, train, and veil (**Figure 5.4**). I love to use my long lens to get a shot of the groom's face as the bride is coming down the aisle (**Figure 5.5**).

ISO 320
1/250 sec.
f/4
50mm lens

FIGURE 5.1
Always try to get
a clean shot of the
ceremony site with
no guests. The
planner and florist
will love you for it.

FIGURE 5.2
I used a wide aperture to transform the background into a soft, beautiful blur and put the ceremony object center stage.

ISO 400
1/500 sec.
f/2.8
50mm lens

FIGURE 5.3
Because the sensor in my camera performs so well at high ISOs, I can shoot this type of detail quickly, without a tripod.

ISO 800
1/25 sec.
f/2.8
35mm lens

ISO 400
1/2000 sec.
f/5.6
70mm lens

FIGURE 5.4
This is a quintes-
sential shot—the
beautiful details
of the back of the
gown as the bride
enters. Seeing
her groom waiting
in the distance
adds to the depth
and drama of the
moment.

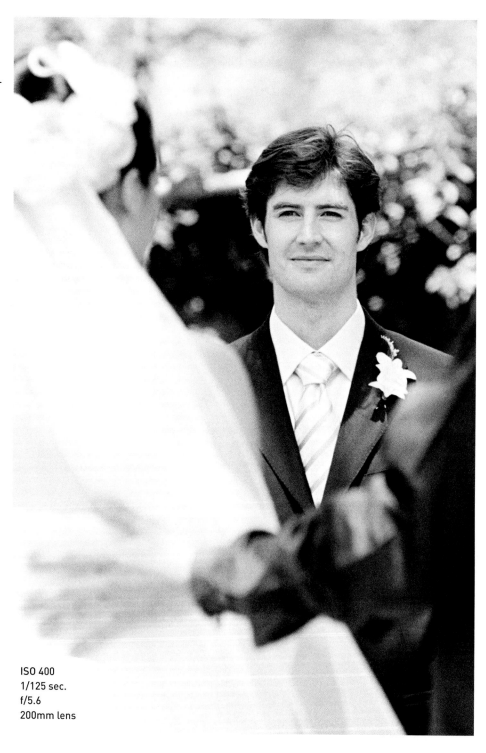

FIGURE 5.5
I use my longest
telephoto lens to
capture a shot of
the groom's expres-
sion as his bride
approaches.

ISO 400
1/125 sec.
f/5.6
200mm lens

Once the ceremony is underway, I get a few shots of the whole scene (**Figure 5.6**), and I may send my assistant to another location—such as a balcony or a spot some distance away—to shoot the whole scene from a different perspective (**Figure 5.7**). Then I quickly and quietly move along the back edge of the seated guests to the side of where the couple is standing. From there I get some over-the-shoulder shots of the bride as she faces her groom (**Figure 5.8**), and then I turn to the guests and get reaction shots from parents and other family members (**Figure 5.9**). Next I walk around the back to the other side and do the same thing with the groom (**Figure 5.10**). While I'm doing this, my assistant usually stays crouched discreetly at the back of the center aisle with a long lens, in case anything notable happens while I'm in transit or off to the side.

ISO 400
1/500 sec.
f/5.6
24mm lens

FIGURE 5.6
The beautiful tree that forms the ceremony backdrop was a key element in the design of this whole wedding, so I used a wide-angle lens to capture it in its entirety.

FIGURE 5.7
My assistant ran up to the balcony during this ceremony, while I stayed on the ground. We used discreet hand signals to coordinate with one another so that I wouldn't end up in his shots.

ISO 400
1/320 sec.
f/4
24mm lens

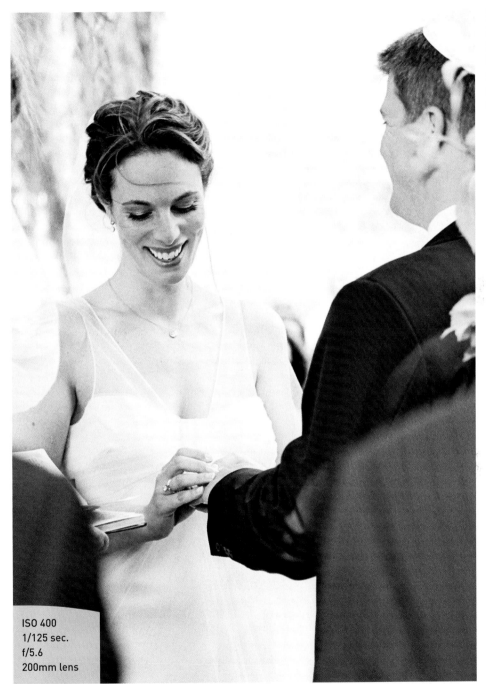

FIGURE 5.8
I waited for this
great expression
from the bride
and shot it from a
distance with my
telephoto lens.

ISO 400
1/125 sec.
f/5.6
200mm lens

FIGURE 5.9
While the guests were engrossed with a speaker, I was able to unobtrusively slip around in front of them and capture this shot.

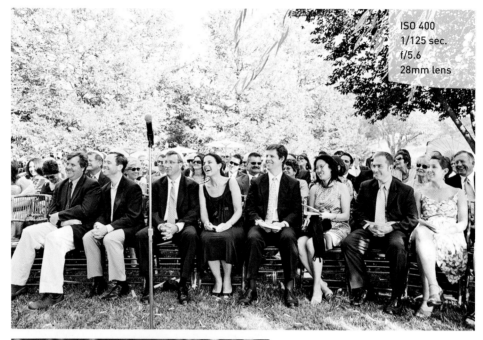

ISO 400
1/125 sec.
f/5.6
28mm lens

FIGURE 5.10
I found a spot from which I could discreetly photograph the groom's reaction to the vows.

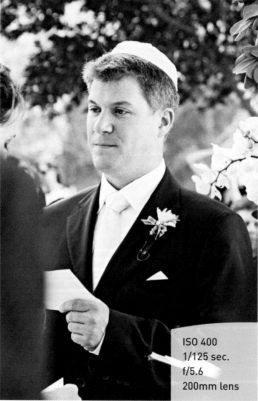

ISO 400
1/125 sec.
f/5.6
200mm lens

As I move, I stay very present, very alert to the many smaller moments and details that are all around me (**Figures 5.11, 5.12**, and **5.13**). I didn't set up these moments—they already existed, and I was able to capture them because I noticed them. You can train your eye to notice these types of details (see the assignments at the end of this chapter), and they add a beautiful dimension of depth to the ceremony coverage.

Many of the ceremonies I shoot are quite brief, so at this point, I take stock and determine how much time is left before the kiss; if I can, I spend a few more minutes looking for any small details or other descriptive moments that really convey the flavor and feel of the event. When the end of the ceremony is near, I position myself in the center aisle for the kiss and recessional.

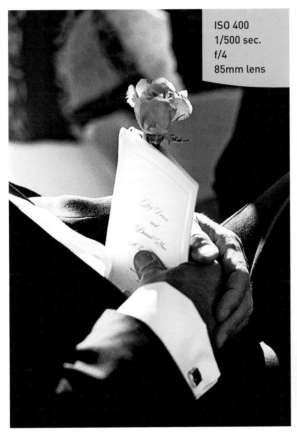

ISO 400
1/500 sec.
f/4
85mm lens

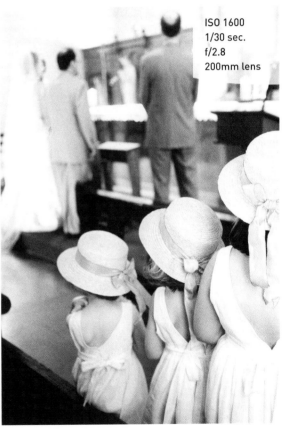

ISO 1600
1/30 sec.
f/2.8
200mm lens

FIGURE 5.11
I noticed this detail as I was walking along the center aisle to get into position for the ceremony kiss. It was a quick snap along the way.

FIGURE 5.12
While off to the side of the ceremony, I saw the three flower girls all lined up in a row. I couldn't have planned anything more perfect.

FIGURE 5.13
I loved the line of the bride's dress from this angle, so I had already shot a few frames when she turned to smile at her maid of honor...and gave me the money shot. The image captures her joy perfectly.

ISO 400
1/60 sec.
f/2.8
105mm lens

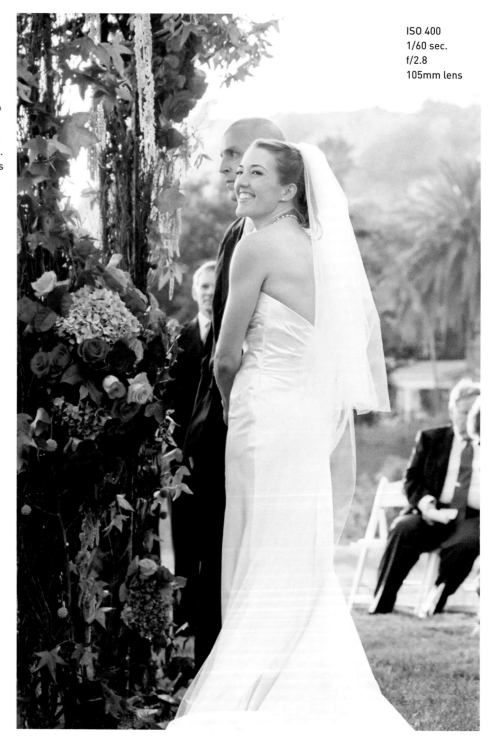

The recessional is a great time to capture the thrill and excitement of the freshly minted married couple. Remember that they'll be moving toward you, and you'll most likely be moving backward as you shoot them, so make sure your shutter speed is fast enough to freeze the action (**Figure 5.14**). How fast it needs to be depends on the speed at which the couple—and you—are moving, but I usually try to set it for at least 1/160 sec.

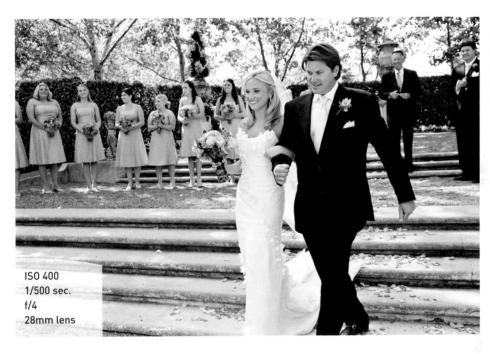

ISO 400
1/500 sec.
f/4
28mm lens

FIGURE 5.14
Select a faster shutter speed for the recessional to avoid unintentional motion blur.

Once the couple has recessed, I stick with them because those few brief moments immediately following the ceremony provide a wonderful opportunity to capture completely spontaneous, candid images with real emotional impact (**Figure 5.15**). The image-making frenzy continues as the wedding party and families show up with tears and hugs. It's one of the best parts of the day (**Figure 5.16**).

Naturally, I adapt this approach based on each individual ceremony setup, but it's a great starting point because it allows me to very quickly capture a wide range of shots for the ceremony. If necessary, I can run through the entire pattern in five minutes and know that I have the essentials covered: long overview, medium, and close-ups of the ceremony straight on; intimate, emotional images of both the bride and the groom from the sides; reaction shots from family members, wedding party, and guests; and close-ups of details such as placing of the rings, the hands during the vows, bouquets, and so on. It's this range of perspectives coming together that really conveys the emotions of the day in an enduring way.

ISO 400
1/125 sec.
f/5.6
70mm lens

FIGURE 5.15
The moments immediately following the ceremony are ripe with spontaneous, genuine emotion.

ISO 400
1/60 sec.
f/4
200mm lens

FIGURE 5.16
Stay with the couple and capture the joy as their friends and family join them right after the ceremony. If there is space, I prefer to shoot these moments with a long lens for a more intimate feeling.

TACKLING TOUGH LIGHTING SITUATIONS

An effective wedding photographer must have the ability to deal with virtually any lighting situation imaginable, and this is especially true during the ceremony. We have absolutely no control over the ceremony environment, and we're responsible for coming up with authentic, beautiful, meaningful images no matter what. We may be faced with anything from an extremely dark church to a meadow in full sun at high noon, and we have to make it work.

Again, I emphasize the importance of preparation and scouting the location at the same time of day that you'll be shooting, so that you can think about strategies ahead of time and be prepared with any additional gear that will help you get the job done. It's also a good idea to shoot a challenging setting in more than one way, both for variety of images and for assurance of ultimate success. In this section, I go over my approach to a few of the most common ceremony lighting challenges.

DARK INTERIORS

This is probably the most typical scenario: the dark church with rules preventing you from using flash, and in some cases limiting your movement as well. It's surprising how much you can cover in this type of situation, if you have the right gear: a camera body with a good low-light sensor, excellent lenses that are f/2.8 or faster, and a solid tripod. If you don't own everything you need, rent it.

If you're required to remain at the back of the congregation, consider bringing a 300mm lens that will allow you to get closer to the couple. If the decor is very dark (lots of dark wood, dark carpet, and so on), pay attention to your metering. I always determine the exposure and dial it in on Manual to avoid overexposing my images (**Figure 5.17**).

If you aren't allowed to move, set up your camera on the tripod and simply change lenses from wide to normal to telephoto to get as much variety as possible. If you're allowed to move about, but you're not allowed to use flash, try to get vibration reduction (VR) lenses—they'll allow you to shoot at slower shutter speeds while still avoiding camera shake. I can hand-hold pretty well at 1/15 sec., and even 1/8 sec. if I need to, but I'm much more comfortable at 1/20 sec. or 1/30 sec., so I try to get a combination of high ISO and wide-open aperture to get the shutter speed there, if possible. I don't use a monopod, but some photographers find them helpful to avoid camera shake.

Be sure to have another camera body all set up with a flash so that when you're allowed to use it again (usually during the recessional), you'll be ready to go.

FIGURE 5.17
Because of the dark decor at this synagogue, I made sure to determine the proper exposure and then set my camera to Manual. If I had used an auto-exposure mode, the darkness of the scene would've tricked the camera into overexposing the image.

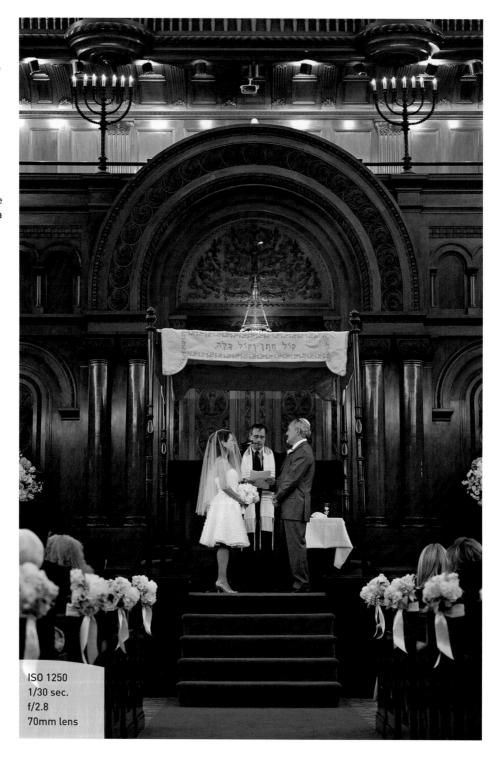

ISO 1250
1/30 sec.
f/2.8
70mm lens

FULL SUN AND DAPPLED LIGHT

As much as I adore natural light, there are times when it isn't actually my friend—every sunny day between the hours of around 10 a.m. and 3 p.m., to be precise. If I'm faced with a ceremony that's in full sun or dappled shade during these harsh-light hours, I shoot it both with fill flash (to take the edge off those dark shadows) and without flash (so that I can have more control over depth of field than flash allows). I like to keep the setup simple; I determine the proper exposure for the sunny part of the subject, set my shooting mode to Manual, set my flash to TTL, and dial down the flash anywhere from two-thirds to a full stop. I don't want to over-power the natural light, or even completely eliminate the shadows, because that results in a very artificial, cartoonish look. I simply want to fill in those shadows a bit, so they aren't so blocky and harsh (**Figure 5.18**).

ISO 400
1/250 sec.
f/11
35mm lens

FIGURE 5.18
The light of the aisle at this ceremony was extremely dappled, so I used flash to eliminate the shadows. I don't shoot this way often because I prefer a more natural look, but in cases of extremely bad light, it's sometimes necessary.

When shooting flash, the shutter speed for most cameras can't be faster than 1/250 sec. (check your camera's manual to learn the flash sync speed for your particular model). I can compensate a bit for this by setting my ISO as low as possible, but on a sunny day I still often need to have a very small aperture, such as f/11 or f/16, to avoid overexposing the image. I like to be able to shoot with a shallower depth of field than what results from f/16, so, I also shoot without the flash and lower the contrast a bit when editing the images.

BACKLIGHTING

I actually love shooting backlit subjects—I use this technique a lot when I'm doing portraits of the couple—but backlighting can be challenging for a wedding ceremony. I basically handle it the same as full sun, shooting multiple ways, both with flash and without. The flash setup is basically the same—TTL flash, dialed down two-thirds to a full stop less than the metered exposure—and I tend to use this technique more for the medium-length shots of the ceremony that show the whole scene (**Figure 5.19**). When shooting without flash, I simply meter for the shadow area of the subject and let the background blow out. This can create a really wonderful, dreamy quality, especially in black and white, and I often use this for close-ups.

Another option for backlit situations, if you can do it without being too distracting, is to move slightly behind the bride or groom during the ceremony, so that you can turn back and shoot them with the light falling on their faces (**Figure 5.20**).

FIGURE 5.19
Notice how much more detail is captured in the background when shooting with fill flash, as compared to the first Poring Over the Picture image at the beginning of the chapter. Although it looks a tad artificial, this is closer to how your eye actually perceives the scene.

ISO 1000
1/125 sec.
f/4.5
60mm lens

ISO 1000
1/45 sec.
f/2.8
87mm lens

FIGURE 5.20
Stepping slightly
behind the bride
allowed me to
capture a few shots
with the beautiful
outdoor light
falling on the
groom's face.

MOMENTS TO WATCH FOR

As you're photographing the ceremony, watch for the following moments:

- **Anytime the couple laughs or looks out over guests during the ceremony:** This transforms an image from something that could seem rather generic to something deeply intimate and personal to the couple.

- **Small details that fill in the moments that the couple can't witness:** The bridesmaids' bouquets all in a line, emotion on the maid of honor's face, the delicate curve of the bride's back or the fall of her veil as she faces the groom, and so on.

- **Kids being kids:** Often, the flower girls, ring bearers, and other children find amusing ways to keep themselves entertained during the ceremony. Keep an eye on them and be ready to capture these moments when they happen (**Figure 5.21**).

FIGURE 5.21
Flower girls +
lollipops =
adorableness
galore, and a
sweet detail that
helps round out
the story of the
ceremony.

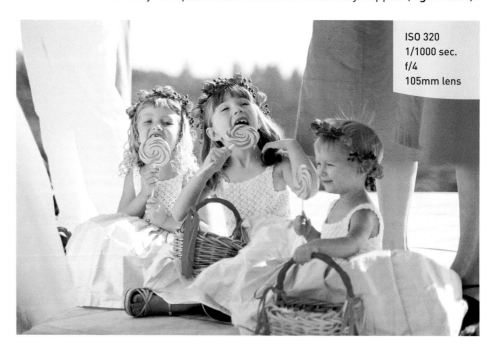

ISO 320
1/1000 sec.
f/4
105mm lens

Chapter 5 Assignments

Train Your Eye

Walk around your neighborhood. Nothing much happening? Look again. Really pay attention and find unique, descriptive moments in everyday situations. Notice when the light is particularly beautiful in a particular spot, and use it. Think about your composition as you shoot; notice the background and adjust your angle of shooting to eliminate unwanted elements, if necessary. Keep refining your approach to a particular subject until you know you've made the best image you possibly can. All this will help you train your eye to capture the wonderful, unexpected moments that abound at a wedding.

Tough Lighting: Dark Interiors

Practice shooting in very dimly lit interiors, without flash. Test how well you can hand-hold your camera with various lenses, at various shutter speeds (such as 1/60, 1/30, 1/15, or 1/8). Try holding your breath when pressing the shutter, and see if it helps avoid camera shake. This will give you a sense of how slow you can set your shutter when you need to shoot available light in dark interiors.

Tough Lighting: Full Sun and Dappled Light

Practice shooting a subject in full sun, using your flash to soften the shadows as described in this chapter. Move the subject to the dappled shade of a tree and try it again. Experiment with shooting the flash at full power, at –1/3 stop, –2/3 stop, and –1 stop. Get a feel for what level of flash looks best to your eye.

Tough Lighting: Backlighting

Set up a backlit situation and shoot it both with flash (as described in the "Backlighting" section earlier in this chapter) and without flash while metering for the shadows. Again, play with the power level on the flash and see how those changes affect the images.

Share your results with the book's Flickr group!

Join the group here: flickr.com/groups/weddingsfromsnapshotstogreatshots

6

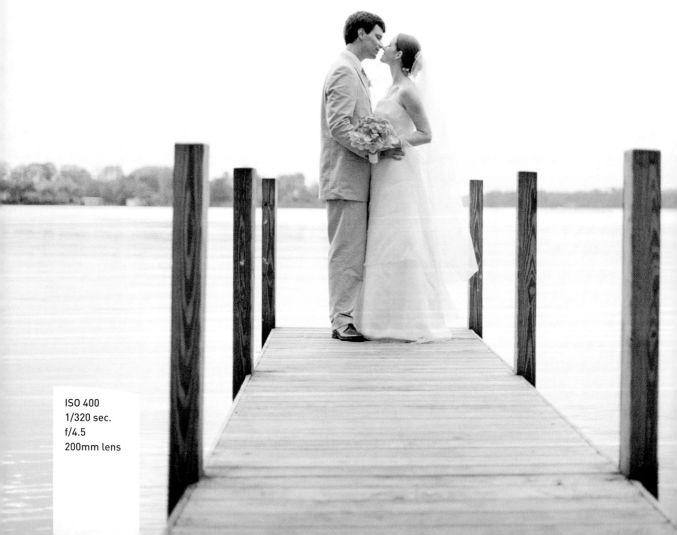

ISO 400
1/320 sec.
f/4.5
200mm lens

Post-Ceremony Portraits

WEDDING STAGE THREE

The ceremony's over, and you killed it. Congratulations! But you'll have to hold the celebration, because it's immediately on to the next thing—most often, family and group portraits, as well as portraits of the brand-new husband and wife. Time is of the essence, so pull out the shot list you prepared prior to the wedding and get ready to roll!

PORING OVER THE PICTURE

Open shade is always the most desirable lighting for family portraits, and the trees created a nice backdrop for this set of images. I always do the shots that include children first, to minimize their wait time. I didn't even notice the baby's antics until afterward!

There was a white building directly behind me, and the light bouncing off the wall and onto the subject provided a nice fill light for this shot.

The aperture of f/5.6 ensured that all the subjects would be in focus, while still softening the background a bit.

Catching the baby's tug on her poor brother's ear was pure luck.

ISO 400
1/250 sec.
f/5.6
50mm lens

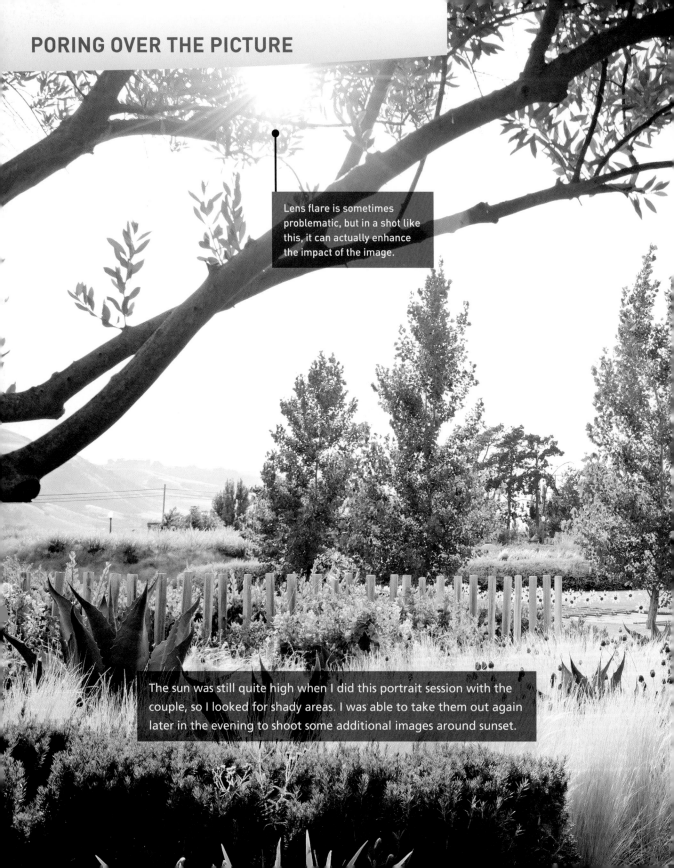

PORING OVER THE PICTURE

Lens flare is sometimes problematic, but in a shot like this, it can actually enhance the impact of the image.

The sun was still quite high when I did this portrait session with the couple, so I looked for shady areas. I was able to take them out again later in the evening to shoot some additional images around sunset.

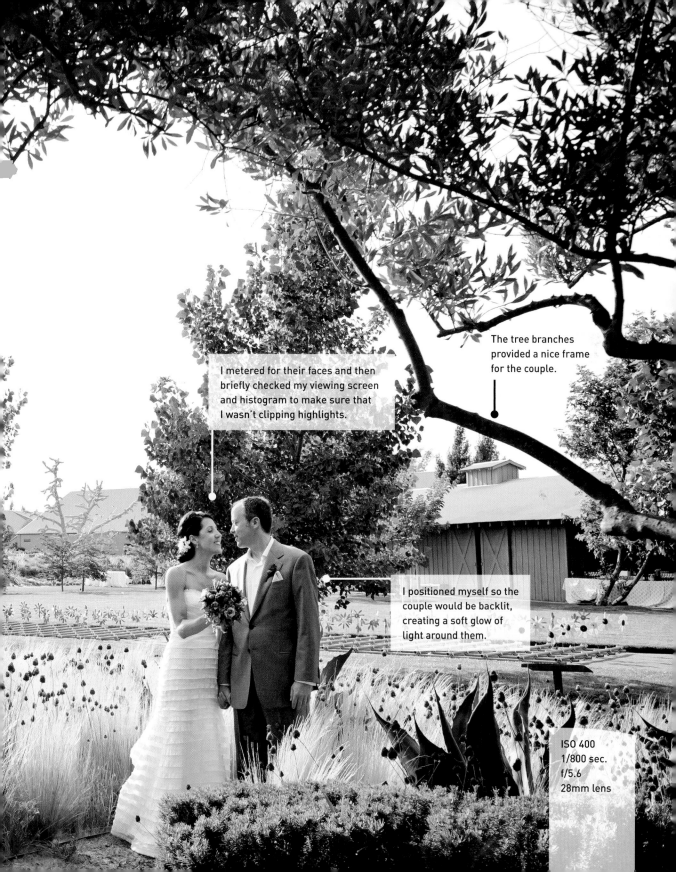

I metered for their faces and then briefly checked my viewing screen and histogram to make sure that I wasn't clipping highlights.

The tree branches provided a nice frame for the couple.

I positioned myself so the couple would be backlit, creating a soft glow of light around them.

ISO 400
1/800 sec.
f/5.6
28mm lens

GROUP FORMALS

When I'm shooting weddings, my joy is in capturing candid moments, but I also recognize the importance of family and group portraits. They create a historical document of the wedding and of the families that are present. I spend a lot of time planning a strategy for these formal portraits before each wedding so that, on the big day, I can make them beautiful, cover everything that is needed, *and* finish them up quickly. Nobody wants to spend hours on these! (See Chapter 3 for more on the planning phase.)

Although I spend most of the day staying in the background and shooting as unobtrusively as possible, when photographing the posed group shots, leadership is required. Don't be afraid to command the attention of the group and corral people as necessary. Some groups are more docile than others, of course, but this is one part of the day where you really must take charge in order to keep things moving.

OUTDOOR LIGHTING

I prefer to do the group shots with available light, if possible, because I can start shooting so much more quickly if I don't have to set up supplemental lighting and I don't have to wait in between shots for the light to recharge. I do them outside if weather permits, and aside from the lighting advantages, I just prefer the more casual feeling of outdoor groupings. I always try to find a location with even, open shade (think of a cloudy day, or the smooth, undappled shade created by a building or a large canopy of trees). With this type of light, I can shoot the posed groups very quickly, and they look beautiful (**Figure 6.1**).

I can usually find something at the site that will work in this way, but obviously I need to have techniques to deal with situations where a nice, open shady spot simply doesn't exist, or it's pouring rain, or the wedding is taking place entirely at night.

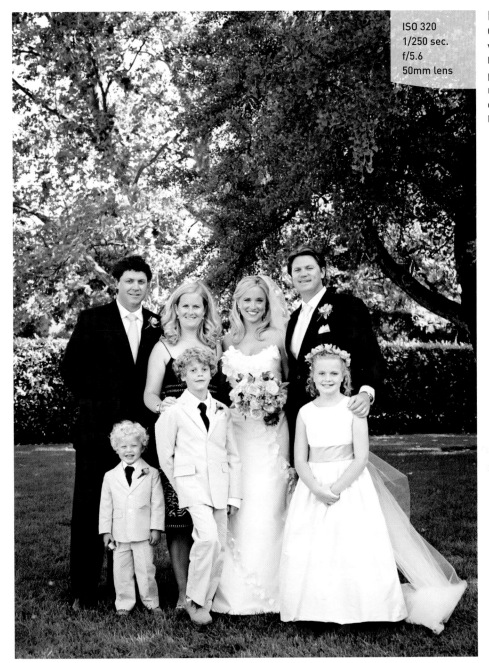

ISO 320
1/250 sec.
f/5.6
50mm lens

FIGURE 6.1
Open shade pro-
vides smooth, even
light for the group
portraits and allows
me to work very
quickly through my
list of shots.

If there is a pretty spot under the shade of a tree, but the light is dappled, I situate the group so that the sun is behind them, through the tree branches. This way, the dappled light falls on their backs and the light on their faces is nice and smooth (**Figure 6.2**).

If there is no shade at all, and it's a little later in the day (meaning, the light is already somewhat low and softened), I can often simply put the sun at their backs and meter for the shadows. If it's the middle of the day, though, the sun will be so high that you can't really avoid distracting shadows, and the background will blow out too much. In this case, I use fill flash to soften those shadows and even out the light with the background (**Figure 6.3**). I dial the flash down about two-thirds of a stop so that it doesn't overpower the ambient light in the image.

FIGURE 6.2
When the shade is dappled, put the sun behind the group.

ISO 400
1/125 sec.
f/5.6
50mm lens

ISO 200
1/250 sec.
f/8
50mm lens

FIGURE 6.3
Fill flash can soften the shadows when the group portraits need to be taken in the bright sunlight.

LENS FLARE

A note of caution about shooting into the sun: watch out for lens flare! This occurs when the sunlight enters the lens directly. Playing with flare can be fun at other times of the day, but not for formal portraits. If I see that I'm getting flare, I flag the lens with my hand (meaning, I place my hand in such a way that the lens glass is in shade) or have my assistant flag it for me. If you're working alone, you can ask a friendly, obliging guest to help out.

USING NATURAL REFLECTORS

Often, you can use natural outdoor elements to your advantage when looking for the best (and most effortless) lighting for group shots. I always look for buildings that can be used as huge, existing reflectors. Simply position the group so that they're facing the building—it'll bounce the light back at them and create a nice fill (see the first "Poring Over the Picture" for this chapter). You also can use "available fill" by placing the group on a lighter surface, such as gravel. It's really amazing how much light can bounce up from this type of surface (**Figure 6.4**).

ISO 400
1/1000 sec.
f/5.6
50mm lens

FIGURE 6.4
The sunlight bouncing up from the gravel created a nice fill light for this portrait.

INDOOR LIGHTING

For indoor group situations, I still try to find a way to work with available light if possible. For smaller groups, I can sometimes use window light. With bigger groups, I've sometimes been able to place them close to a bank of windows or an entrance, or under a skylight (**Figure 6.5**). In a couple of cases when it was raining very lightly, I stood outside to shoot the subjects as they stood in an entranceway with an over-hang (**Figure 6.6**).

If none of these is an option, I sometimes simply use my on-camera flash to provide lighting. I find this works best if there is a fair amount of light in the scene, but just not quite enough to achieve the settings that I need (see the nearby sidebar for my recommendations on aperture and shutter speed for group shots).

ISO 800
1/30 sec.
f/4
50mm lens

FIGURE 6.5
The unique architecture made this a great choice for the group shots. With such a slow shutter speed, I mounted the camera on a tripod to avoid camera shake.

FIGURE 6.6
The subjects were protected from a very light rain by an overhang above the doorway, and the cloudy skies produced a soft, even light.

ISO 400
1/250 sec.
f/4
50mm lens

I never point a flash directly at the group, because it creates unattractive shadows, especially if there is more than one row of people. If the ceiling is low enough, I can bounce the light from the flash off the ceiling. To do this, simply point the flash at a 45-degree angle toward the ceiling when shooting. (I use my flash on the Through the Lens, or TTL, setting so that it always emits the correct amount of light for a proper exposure.) Some light will travel forward and directly illuminate the group, but most of it will hit the ceiling and bounce back down in a much more diffused form, and because it comes from above—like the sun—it looks more natural (**Figure 6.7**). Be aware that if the ceiling is colored, it can create an unwanted color cast on the subjects. And shoot slowly, making sure that the flash is fully recharged before each exposure.

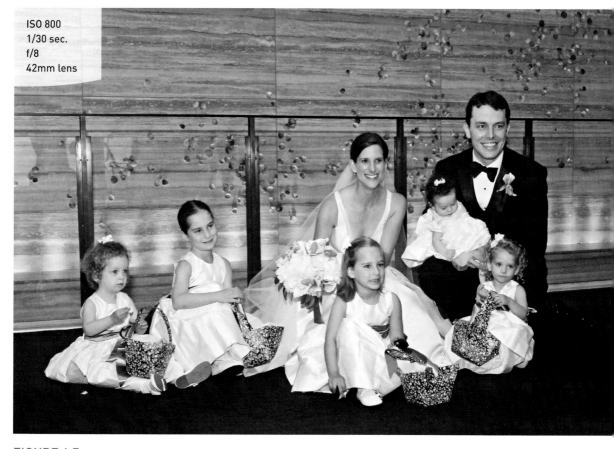

ISO 800
1/30 sec.
f/8
42mm lens

FIGURE 6.7
I just needed a bit more light for these shots. The ceiling was low enough that I could simply bounce my flash off it, creating even light.

If I know from my scouting trip that I'll be doing these group shots indoors and the ceiling is too high to bounce my flash, I bring strobe lights. These lights are big to lug around and take more time to set up, but they give a very nice quality of light and I never have to worry about the light being powerful enough to illuminate a whole group. I keep the setup as simple as can be, using one light, shot into an umbrella behind me (to soften and diffuse the light) and bouncing back on the group. I place the light directly behind me, and far above the camera (**Figure 6.8**).

To learn more about using strobe lighting, refer to *Speedlighter's Handbook* by Syl Arena (Peachpit Press) for good, basic information, and *Hot Shoe Diaries* by Joe McNally (New Riders/Voices that Matter) for more anecdotal instruction on strobe lighting.

ISO 400
1/15 sec.
f/5.6
48mm lens

FIGURE 6.8
This was shot with the strobe and umbrella setup. Note that the long shutter speed allowed me to pull in some of the background, which otherwise might have looked completely dark.

APERTURE AND SHUTTER SPEED FOR GROUP SHOTS

Most of the day, I'm shooting with a fairly wide aperture and enjoying the shallow depth of field it creates. For the posed groupings, however, I choose to expose a bit more conservatively, creating a wider depth of field—particularly if there is more than one row of people—because I need to be absolutely certain that everyone in the shot is sharp. Of course, as I discussed in Chapter 2, lens choice and distance from subject also affect depth of field. I'm always using either a normal or a wide lens for group shots, and I'm always some distance from the subject, so most of the time, f/5.6 will give me sufficient depth of field. Still, just to be safe, I prefer to use f/8 if there are more than one or two rows of people. I always want to achieve the perfect balance between keeping everyone sharp and softening the background enough to create a bit of separation, but if in doubt, I err on the side of caution. I guarantee you that your clients won't mind if the trees behind them are slightly less soft and dreamy. On the other hand, if only half the people in the shot are sharp, you'll have a very big problem!

When it comes to shutter speed, you want to use a fast enough shutter speed that you eliminate camera shake. When hand-holding, I keep my shutter at a minimum of 1/60 sec. and prefer it to be a bit faster than that, just to be safe. If I need slower shutter speeds, I use a tripod, which has an added benefit: it causes me to slow down a bit while shooting, and frame the images more carefully. If time is really tight, though, it can slow things down too much, so I use it on an as-needed basis. Because the subjects are perfectly stationary, I have been known to shoot as slow as 1/8 sec. with a tripod. When shooting this way, I always instruct the group to hold very still, and I take a few extra exposures of each setup to make sure that a couple of them are perfectly sharp. Another benefit of using a very slow shutter speed in dark, indoor situations, even when using flash, is that it allows more of the ambient light to hit the sensor, capturing some of the background detail. With a fast shutter speed, it would look much darker or even be completely black. Figure 6.8 is a good example of this.

POSING AND LENS CHOICE

My goal with formal portraits is simply to create well-balanced, descriptive images that document the wedding party and family groupings in an elegant and attractive way. To do this, I have a two-step approach to posing the group:

1. I make sure that the most important people are next to the couple (for the wedding party shot, it's the maid of honor and best man; for family shots, it's usually the parents), and then I give some very general direction, such as "Everyone gather on either side of the couple!" and let them arrange themselves. This is because I don't know the relationships between every person there, and, when left to their own devices, people will naturally (and quickly) place themselves next to the people they should—their own spouses, family members, and so on.

2. Once they've positioned themselves, I evaluate the group and make any adjustments necessary. I ask myself: Can I see all the faces? Is the distribution of people fairly even around the couple, in terms of numbers of people and how tall they are? Is anyone wearing sunglasses or holding a purse or drink? Do any of the men's jackets look bunchy due to the way they're standing? Are they standing in a straight line or a semicircle? For some reason, people naturally tend to group themselves in a semicircle, and this has the effect of making the people in the center—usually the bride and groom—look much smaller than the people on the sides. Once they're in a nice, straight line, if I need to tighten the group a bit, everyone can turn slightly toward the center and take a small step in.

Now I'm ready to roll through the list I prepared prior to the wedding. *Remember:* The crowd is looking to you for leadership and to get this part of the day finished as quickly as possible. Don't be afraid to exert your authority (with a smile, of course).

Keep an eye on how everyone is doing as you work your way through the list—especially the bride and groom, since they're in nearly every shot. If they're getting stiff, have them take a moment for a few deep breaths, shoulder rolls, and some silly stretchy faces to loosen things up.

Here are some additional tips to keep in mind as you work on the portraits:

- **Bouquets:** Ladies tend to hold their bouquets very high, blocking the details of their dresses. Instruct them to rest their wrist bones on their hip bones, and this will put the bouquets in just the right place and look more relaxed.

- **Jackets:** Sometimes the guys don't want to fasten every jacket button, and they're not sure if they should button only the top one or only the bottom one. They should button the top.

- **Kids:** When young children are in the shot, adults tend to interact with them, trying to get them to look at me. I ask the adults to just keep looking at me—not at the kids—so that when the little ones do glance my way, everything else is in place and I can catch the moment.

- **Very large groups:** Either find some steps for them to stand on, or get much higher than the group—for instance, shoot from a balcony or second-story window (**Figure 6.9**). The bigger the group, the more important this becomes!

ISO 400
1/125 sec.
f/5.6
66mm lens

FIGURE 6.9
For this large wedding party, I used the low wall to give height to the back row. I stood on a similar wall to get the camera higher, as well.

- **Cropping:** When framing the shots, keep in mind that clients often want to buy these images as 5x7 or 8x10 reprints. To have flexibility to crop the image to these sizes, you have to leave enough space around the group (**Figure 6.10**).

FIGURE 6.10
Be sure to leave
enough space
around the group
so that the image
can gracefully
be cropped to a
5x7 (red) or 8x10
(green).

ISO 400
1/500 sec.
f/5.6
50mm lens

MOMENTS TO WATCH FOR

When you're photographing formal group portraits, you may think there's no room for spontaneous moments to occur, but that's not the case at all. Look for the following:

- **Individuals within the group:** I often capture quite nice portraits by homing in on specific people as they're standing in the larger group (**Figure 6.11**).

- **Friends and family members who are watching and waiting for their turn to join the group:** There are often interesting moments to be found as people find ways to amuse themselves while waiting (**Figure 6.12**).

- **The more casual moments that occur between the formal shots:** You can find these particularly if the session takes place right after the ceremony, when the excitement level is high (**Figure 6.13**).

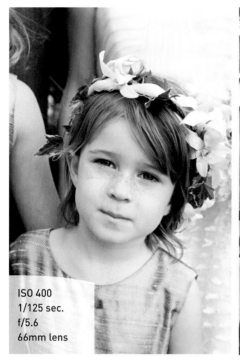

ISO 400
1/125 sec.
f/5.6
66mm lens

FIGURE 6.11
Zoom in on individual people while they
are within the larger group for some nice
portrait opportunities.

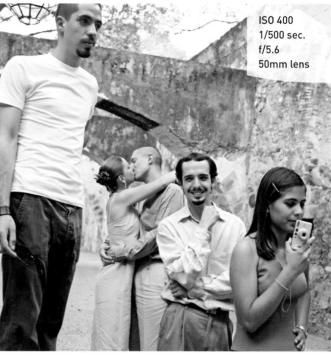

ISO 400
1/500 sec.
f/5.6
50mm lens

FIGURE 6.12
While assembling one of the family groupings,
I spun around, saw this, and quickly shot one
frame before turning back to the formal shot.

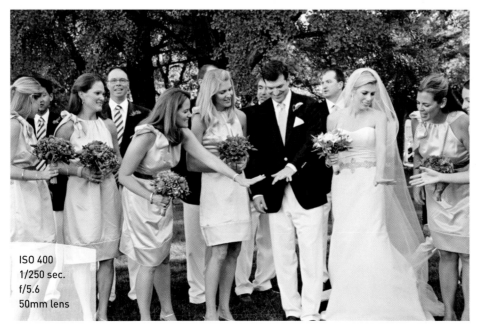

ISO 400
1/250 sec.
f/5.6
50mm lens

FIGURE 6.13
While we were
setting up the shot
of the entire bridal
party, I noticed the
bride and groom
both showing off
their rings.

BRIDE AND GROOM PORTRAITS

One of my favorite parts of the day is the portrait session with the bride and groom. For the couple, this should be a pleasant interlude, a time when they can slip away from the crowd to simply be with one another and enjoy the wedding afterglow. For me, it's an opportunity to create truly timeless images that capture all the love and joy that they experience on that day.

This is the time when I have more control over elements like setting, lighting, positioning, and so forth, but I don't want the images to look phony or overly produced. Portraits that look very natural, intimate, and uncontrived are the most enduring and meaningful, even years later, and my entire portrait technique is built around the idea of capturing images that reflect this.

LOCATIONS

The first step in my strategy for capturing engaging, authentic portraits is to place the couple in a beautiful setting. During the scouting trip to the site, I look for various elements that I can use to create compelling compositions: lovely outdoor paths, picturesque trees, weathered fences, cool brick walls, dramatic arches, and so forth (**Figure 6.14**).

Ideally, the setting has some beautiful natural detail, without being too cluttered or distracting. Avoid compositions that have elements such as tree branches appearing to come out of your subject's head. If you're shooting in a public space such as the park or beach, you'll need to be creative in blocking out the unwanted elements, such as people in the background. They can't totally be avoided, but by paying close attention to your framing, you can often reduce their visibility by blocking them with objects in the foreground or with the couple.

If the portraits have to be taken indoors, I look for window light, elegant pieces of furniture, and architectural details—there is always something that I can use (**Figure 6.15**). And because I've thought it all out in advance, I'm able to make the most of the brief time that I have with the couple—often only about 20 minutes.

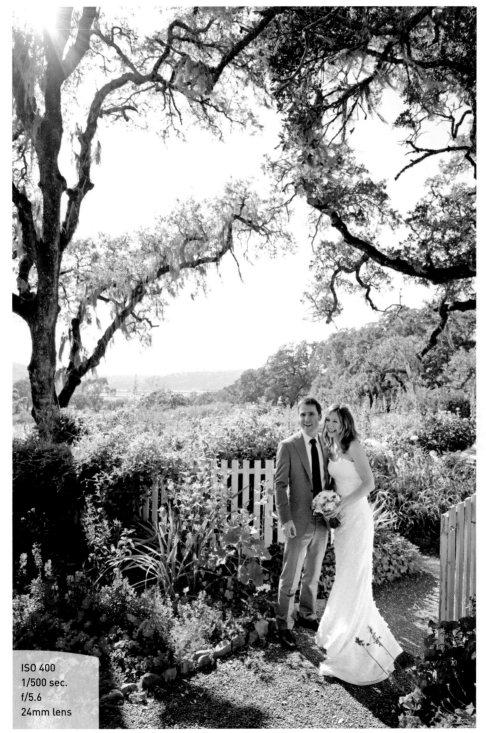

FIGURE 6.14
Using the tree
branches to
frame the couple
created a compel-
ling composition
and enhanced the
existing beauty of
the setting.

ISO 400
1/500 sec.
f/5.6
24mm lens

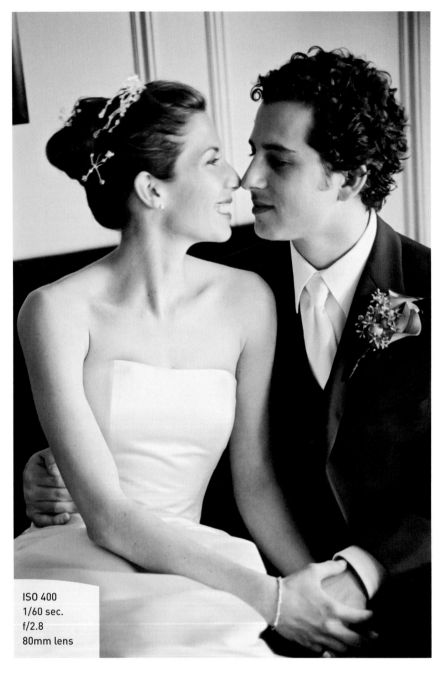

FIGURE 6.15

For this indoor hotel wedding, the couple didn't want to go outside at all. I seated them on a sofa near the window and zoomed in to minimize the less-than-interesting background and put the focus on them.

ISO 400
1/60 sec.
f/2.8
80mm lens

LIGHTING

Beautiful light for the portraits is perhaps even more important than a beautiful set-
ting. Of course, I have my preferred time of day and type of light for shooting, but
often I'm not shooting under those ideal conditions. As with the group portraits,
I need to be flexible and have techniques to shoot beautiful portraits in many different
types of situations. Because I time my location-scouting visits to be at approximately
the same time of day that I'll be shooting, I have a pretty good idea of where the
prettiest pockets of light are.

Depending on the schedule, it sometimes makes sense to break the couple's portrait
session into two mini-sessions—one early in the day, and the other right around sun-
set. The earlier session is often in the afternoon when the sunlight is still bright, and
I approach it the same way that I described for the group portraits. I look for trees
and other shady areas where I can find smooth, even light for their faces, and I posi-
tion the couple so that they are backlit (**Figure 6.16**).

While I seek smooth shade for closer shots of the couple, I embrace the sunlight for
wider images that take in the environment (**Figure 6.17**).

ISO 400
1/640 sec.
f/4
50mm lens

ISO 400
1/2000 sec.
f/5.6
28mm lens

FIGURE 6.16
(left) When the
couple is backlit,
the harsh shadows
on their faces
are avoided.

FIGURE 6.17
(right) Shots like
this one are about
capturing the
couple in an inter-
esting setting, so
I didn't mind the
bright sunlight or
the shadows on
the couple.

The most beautiful light for portraits is immediately following sunset. Once the sun dips below the horizon, you have 10 to 15 minutes of soft, glowing, golden, non-directional light (**Figure 6.18**). The light is warm, flattering, and simply wonderful, and you should try to take the couple outside for portraits if at all possible. When planning the timing with the wedding schedule, keep in mind that if the site is in a valley, the sun will dip out of sight sooner than the posted sunset time.

FIGURE 6.18
Everything looks beautiful in the soft, warm light that occurs just after the sun dips below the horizon.

ISO 400
1/60 sec.
f/2.8
70mm lens

There are often interesting shots to be had once night falls. I look for areas that are illuminated by either overhead lighting, such as streetlights, or the uplighting that is sometimes used on the exterior of buildings. I sometimes have my assistant direct a video light at the couple; if you don't have a video light, you can ask the videographer (if there is one) to help by shining his light on them. (See Chapter 8 for more on video light.)

The trick is to place the couple in a spot where they're illuminated and where there is something illuminated behind them that you can capture with a long exposure. Meter for the couple, and don't be alarmed if the shutter speed is measured in seconds, not fractions of seconds! The camera needs to be on a tripod, and you should instruct the couple to hold as still as possible for the duration of the exposure. Have them inhale and then exhale and hold their breath; then press the shutter. I have them close their eyes, because blinking would be captured as motion blur. After shooting, check the viewing screen and histogram to make sure that you aren't clipping highlights in the background. I always bracket the exposure—meaning, I take a few extra shots, changing the exposure by one-half to one whole stop each time, just to make sure that one of the shots has a good exposure (**Figure 6.19**).

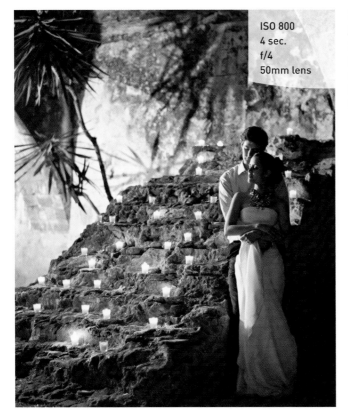

ISO 800
4 sec.
f/4
50mm lens

FIGURE 6.19

As I was leaving the reception, I saw this beautiful sea of candles. I simply had to ask the couple to give me five more minutes to take this long-exposure shot.

LENS CHOICE

Within the very brief amount of time available to shoot the bride-and-groom portrait sessions, I need to really quickly capture a wide variety of shots. I routinely use two cameras, one with a wide- to normal-range zoom and the other with a telephoto zoom. My lenses of choice are the 24–70mm f/2.8 and the 70–200mm f/2.8. With these two lenses, I have a wide range of focal lengths covered and can rapidly shoot a particular scene in many different ways.

I use the wider lens to capture a sweeping view of the scene, incorporating the environment, beautiful views, and so on (**Figure 6.20**). I also can take medium shots that show the couple full length and include the setting but are not dominated by it (**Figure 6.21**). I tend to use color for both these types of shots.

ISO 400
1/2000 sec.
f/5.6
28mm lens

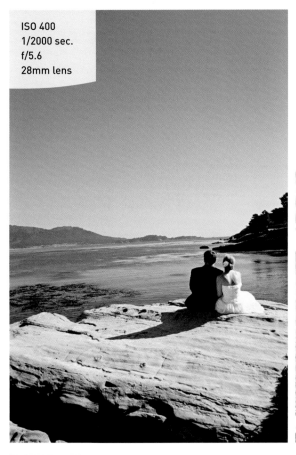

ISO 400
1/2000 sec.
f/4
60mm lens

FIGURE 6.20
With my wider lenses, I can capture scenic shots that take in the landscape.

FIGURE 6.21
Focal lengths in the normal range (close to 50mm) are similar to the way our eyes see.

With the telephoto zoom, I can shoot very close and intimate shots while remaining some distance away (**Figure 6.22**). By giving the couple a bit of space, I allow them to experience the portrait session as a sweet moment between the two of them, away from the commotion of the wedding, which in itself is a real gift. And, of course, it helps bring out their most relaxed and natural selves, which is what I want to capture in photographs. I often choose black and white for these intimate images that are more concerned with expressing the emotion between the couple.

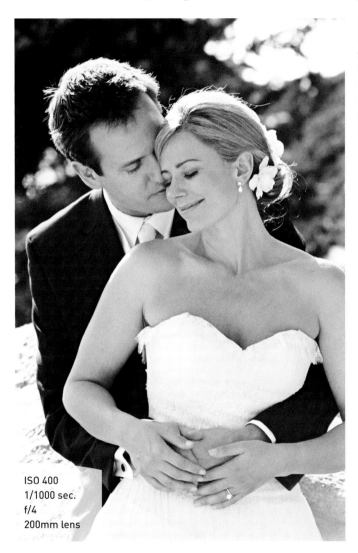

FIGURE 6.22
I often choose black and white for images like this, because it emphasizes the emo-tional content of the moment. Telephoto lenses allow me to get closer to the subject.

ISO 400
1/1000 sec.
f/4
200mm lens

By using my lenses in this way, I can shoot several completely different types of portraits in the space of a few minutes. And I can shoot a great variety even if I'm limited to only one or two suitable settings in which to place the couple.

If you really can't find a setting that is free of distracting or unattractive elements, just shoot with a very wide aperture to blur the background into a pretty, soft, indiscernible collage of color. This is another reason to invest in high-quality, fast lenses that open to at least f/2.8.

POSING

Once I've placed the couple in the loveliest spot with the best light I can find, I step back and allow them to be very natural within that setting. Most people simply aren't comfortable in front of the camera, so the more I can help them forget that they're being photographed, the more relaxed and genuine they'll be. Strictly speaking, I don't really pose my couples at all. I do set the stage for them to successfully "pose" themselves, simply by enjoying some time with the person they love.

I might direct them to sit in a certain place, to walk back and forth along a particular path, or to pause under a pretty tree. I may ask them to stop and glance back at me as they walk, or turn to one another and share a kiss. By giving general directions such as these, I give the couple space to make the movements their own, so they never feel unnatural. The overall effect is to gently encourage them to instigate their own sweet interactions with one another—and then I shoot like crazy. As things unfold, I'm constantly moving, looking for the best angle by changing my own position, not theirs.

I don't run them through a set of predetermined poses or micromanage the placement of their heads, hands, and so on. That type of direction would only make them more self-conscious, and the photos would look stiff and contrived.

CAMERA SETTINGS

I usually shoot portraits of the couple on Manual so that I don't have to worry about the exposure being thrown off by predominantly light or dark colors in a scene, or pockets of backlighting. (Refer to Chapter 2 for more on this topic.) If the couple quickly moves to an area with very different light (say, they move from the shade of a tree into full sun) and it looks really great, I quickly switch to Aperture Priority to fire off the first few shots—just to get something usable while the moment is fresh. Eventually, I take the time to remeter and reset the camera on Manual.

My preferred aperture and shutter settings depend on what the couple is doing. If they're walking, I try to use a shutter speed of at least 1/125 sec. to avoid blur and an aperture of around f/5.6 so that I have a bit of leeway with depth of field as they move. If they're stationary, I may open up the aperture to f/2.8 to get a shallower depth of field, softer background, and more separation between the couple and their surroundings. I'll also feel more comfortable shooting a slower shutter speed, such as 1/30 sec. In fact, although I generally want the portraits to be sharp, a bit of motion blur for some of the more intimate shots can actually be quite beautiful (**Figure 6.23**).

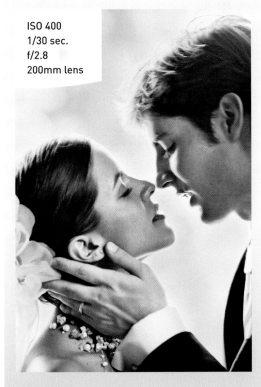

ISO 400
1/30 sec.
f/2.8
200mm lens

FIGURE 6.23
The slight motion blur in this image heightens the sweet sense of anticipation just before the kiss.

GETTING THE MOST FROM YOUR COUPLES

Most of my clients experience some level of discomfort in front of the camera, ranging from mild self-consciousness to extreme agony. Part of my job is to find a way to put them at ease and help them enjoy this time for what it is: a chance to savor a few (nearly) private moments with their true love in the midst of the wedding whirlwind.

Here are a few tricks that I use to help them relax and feel more comfortable, resulting, of course, in more expressive and natural images:

- Talk about it ahead of time. Especially if the couple is very apprehensive, talking about what you're planning before the big day helps them to know what to expect. I let them know that I won't do a lot of heavy posing with them or expect them to bust out super-model moves—they can just be themselves.

- Give them something to do. I have my couples walk throughout much of the portrait session, back and forth along pretty pathways, along fences, and so on (**Figure 6.24**). The walking shots themselves can be lovely, but in addition, the simple act of keeping them moving transforms the more stationary moments of the session into mere pauses along the way. It makes the stops feel more casual, and they don't have as much time to get stiff in any one spot.

- Give them something to hold. The bride usually brings her bouquet, which works well because it helps her to have something to do with her hands. If she needs to hold up her gown to walk, she'll often hand the bouquet to the groom, which makes for a sweet shot as well.

- Ask questions that elicit an emotional reaction. For example, "When did you know that he or she was the one?", "How did you propose?", and "How does it feel to be married?" Be ready to shoot immediately to capture the emotion of their reaction!

- Make them laugh. Silly jokes help. I don't mind coming off like a bit of a goofball if it means better images.

- Ask them to kiss. Kisses are wonderful, of course. But the moments right before and right after the kiss are often more compelling than the kiss itself. Once you notice this, you'll want to ask them to kiss over and over again!

ISO 400
1/125 sec.
f/2.8
28mm lens

MOMENTS TO WATCH FOR

When you're photographing the bride and groom, watch for the following moments:

- **Small gestures as they walk:** Zoom in on the groom helping his bride manage the dress, his hand on her waist, the two of them holding hands, and so on (**Figure 6.25**).

- **The in-between moments:** Catch the limbo between shots. Sometimes I look down and pretend to fiddle with my camera for a moment just to give them the chance to stop reacting to me in any way. Then I quickly shoot the genuine moments that follow (**Figure 6.26**).

- **Bridal details in action:** Images of the dress, bouquet, shoes, hair flowers, veil, and so on while she's wearing them have a very different feel than the still-life shots done earlier (**Figure 6.27**).

- **The couple walking back into the reception area, after our session:** I let them know they're finished, and then I keep shooting as they reenter the party (**Figure 6.28**).

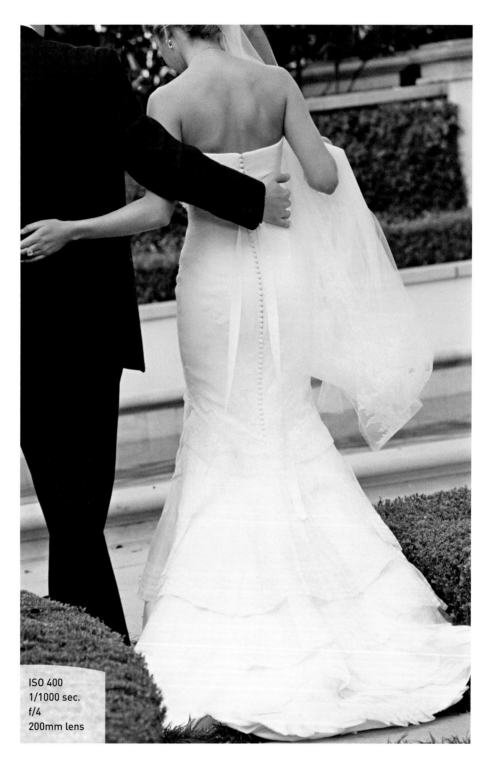

FIGURE 6.25
Capturing these
small interactions
add sweetness to
the body of work.

ISO 400
1/1000 sec.
f/4
200mm lens

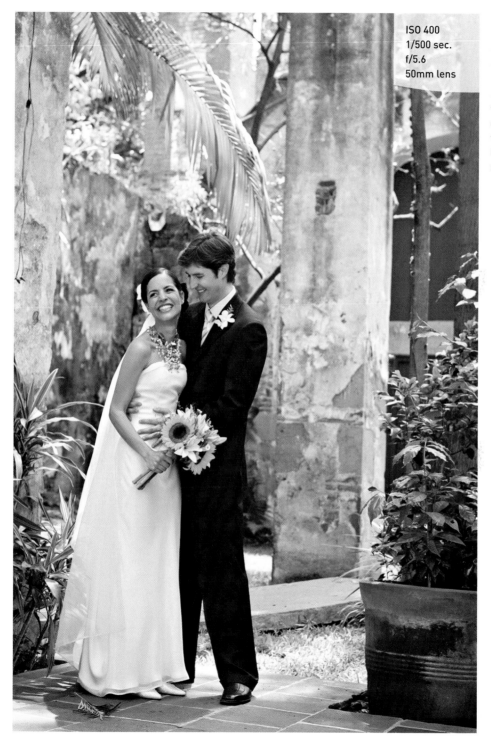

ISO 400
1/500 sec.
f/5.6
50mm lens

FIGURE 6.26
I fake-adjusted my camera until the couple wasn't paying the slightest bit of attention to me and then quickly captured this shot of them laughing with the maid of honor.

ISO 400
1/1000 sec.
f/4
200mm lens

FIGURE 6.27
Details of the bride's ensemble in action, as she's wearing them, have a totally different energy than the still-life shots done earlier in the day.

ISO 400
1/125 sec.
f/4
70mm lens

FIGURE 6.28
After releasing the couple from our portrait session, I always keep shooting as they rejoin the party.

Chapter 6 Assignments

Comparing Light

Shoot a series of portraits at the same location at different times of the day. Head out around noon, about two hours before sunset, and again just before sunset, and continue shooting after the sun dips below the horizon. Compare the images and see how the quality of the various types of light affects the look and feel of the images.

Experimenting with Natural Reflectors

Find some natural reflectors, such as light-colored buildings. Take practice portrait shots in midafternoon both with and without the fill light from the reflecting surface, and notice the difference it can make.

Keeping your subject backlit and without changing the angle to the sun, try placing your subject on light-colored gravel, grass, and a dark surface such as blacktop. Notice how the light reflects off the ground to provide fill light on the subject, and how the color of the ground impacts the amount and color of light that is reflected.

Shooting for Variety

Practice shooting portraits with a couple of friends. In particular, use lenses ranging from wide to telephoto, work as quickly as you can, and see how many distinct "looks" you can achieve in a single setting. This will help you learn to produce a wide variety of images even when you're limited to only one or two shooting locations.

As you shoot, move from side to side, get low and shoot up on them, and get above them and shoot down. Experiment with how your positioning changes the perspective on the couple and how different angles and focal lengths impact the feel of the images.

Share your results with the book's Flickr group!

Join the group here: flickr.com/groups/weddingsfromsnapshotstogreatshots

7

ISO 200
1/160 sec.
f/4
52mm lens

Cocktails, Dinner, and Decor

WEDDING STAGE FOUR

Without question, cocktail hour is the busiest time of the day. Between the family and couple portraits, candid coverage of the guests, and detail shots of the dinner area and tabletops, you generally have to fit about two hours' worth of work into one hour. The only way to manage it is to stay organized, maintain your cool, keep an eye on the time, and just continue working through each element as it comes. Once the guests sit down for dinner, there will be a moment to catch your breath…usually!

An aperture of f/5.6 gave me just the right softness and layered effect for the trees in the background.

I always shoot a few of these types of images in case someone is making a funny face or an awkward gesture that might distract the viewer.

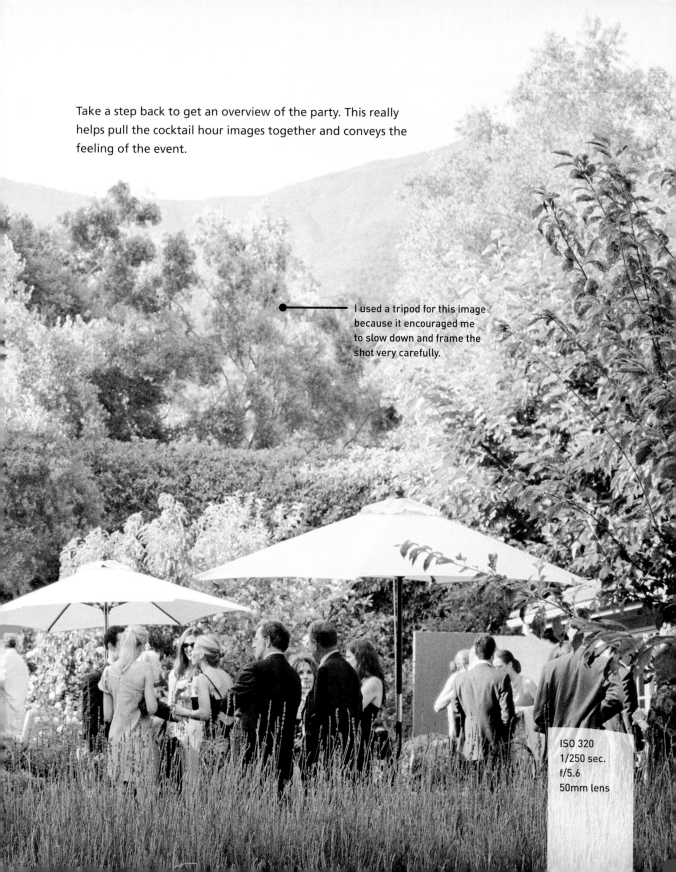

Take a step back to get an overview of the party. This really helps pull the cocktail hour images together and conveys the feeling of the event.

I used a tripod for this image because it encouraged me to slow down and frame the shot very carefully.

ISO 320
1/250 sec.
f/5.6
50mm lens

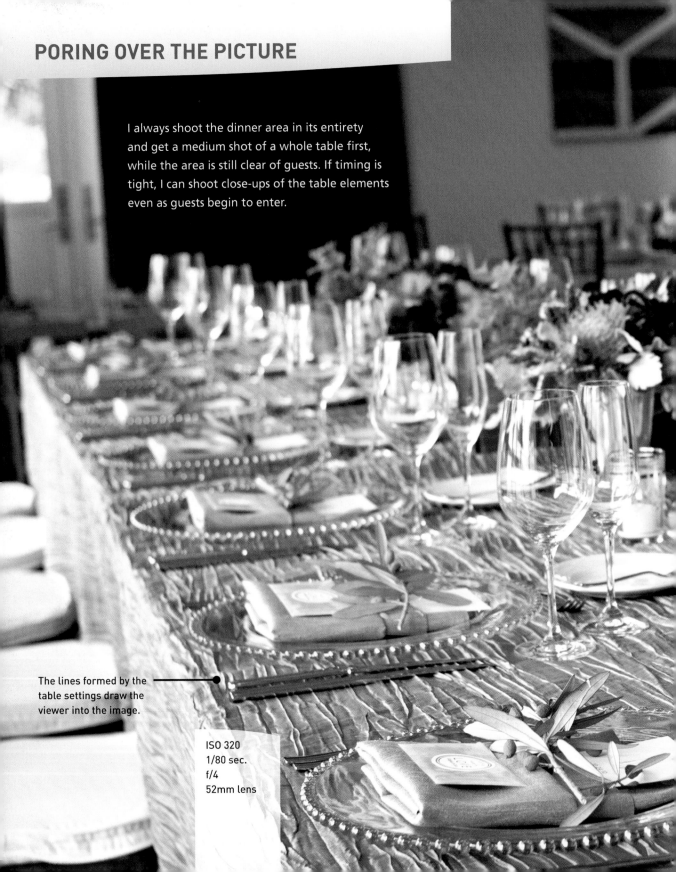

PORING OVER THE PICTURE

I always shoot the dinner area in its entirety and get a medium shot of a whole table first, while the area is still clear of guests. If timing is tight, I can shoot close-ups of the table elements even as guests begin to enter.

The lines formed by the table settings draw the viewer into the image.

ISO 320
1/80 sec.
f/4
52mm lens

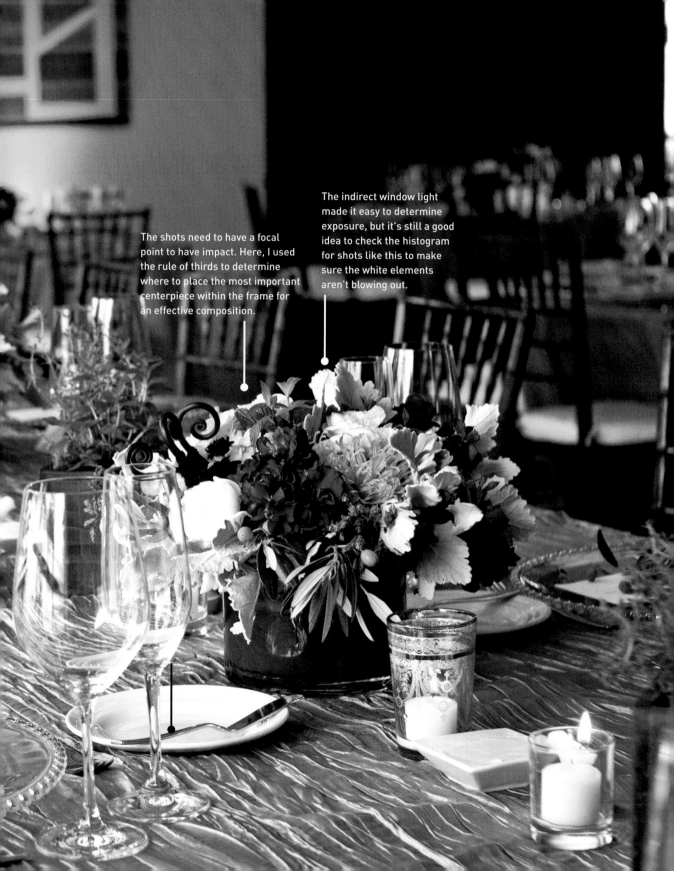

The shots need to have a focal point to have impact. Here, I used the rule of thirds to determine where to place the most important centerpiece within the frame for an effective composition.

The indirect window light made it easy to determine exposure, but it's still a good idea to check the histogram for shots like this to make sure the white elements aren't blowing out.

COCKTAIL-HOUR CANDIDS

Cocktail hour is often the best opportunity to get casual, candid photos of the wedding guests. I work very quickly and try to document everyone there. By this point in the day, I know who the key players are—family, close friends, members of the wedding party, and so forth—and I give them a little extra emphasis (**Figure 7.1**). I shoot both very natural, candid portraits and simple, straightforward party shots, where the subjects pose and smile at the camera.

FIGURE 7.1
Give a little extra attention to the family members. These images will be cherished as the years pass.

ISO 400
1/60 sec.
f/5.6
135mm lens

Every set of guests has a unique collective personality. Occasionally, the group is quite reserved, and they disregard my presence completely. In that case, I do all my shooting as discreetly as possible and I don't inject myself into the scene in any way. At other weddings, the guests are a bit looser and enjoy having their photos taken in various combinations, posed and smiling. And why not? They're in a beautiful setting, they're dressed up, and it's a celebration. If the mood is right, I'm not shy about asking guests if they'd like a photo. I look for interesting moments, but let's face it: Some of these shots simply aren't the most artful images of the day. Guests love them, though, and clients love to see everyone who was there represented in the images. I just take my cue from the crowd and try to cover everyone with the most natural images possible (**Figure 7.2**).

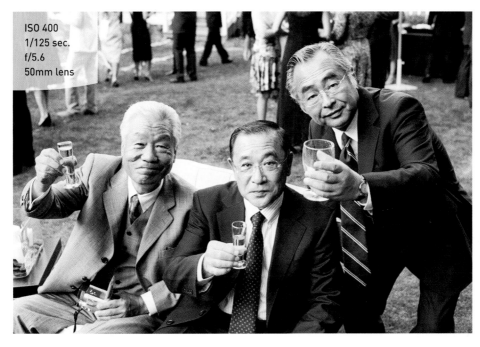

ISO 400
1/125 sec.
f/5.6
50mm lens

FIGURE 7.2
Even when asking my subjects to pose, I try to keep it interesting.

For the more discreet, candid portraits, I use a long lens and shoot very unobtrusively. Since people are busy talking and eating during cocktail hour, I often need to patiently wait a moment or two for a flattering expression—for example, when the subject laughs in the middle of conversation. Because the guests usually have no idea that they're being photographed, the resulting images are wonderfully spontaneous and often quite striking (**Figure 7.3**).

FIGURE 7.3
Sometimes, a little
patience is required
to capture truly
natural expressions.

ISO 400
1/250 sec.
f/4
200mm lens

LIGHTING

I shoot the cocktail hour with available light when possible, for all the same reasons I've described in previous chapters—to remain unobtrusive, to capture images that feel natural, and because, most of the time, I simply prefer the look. But if the light is very harsh or just plain unattractive (for example, bright midday sunlight, or green-toned fluorescent lights sometimes found in museums and other spaces), then I pull out the fill flash. Keep in mind that when using the flash, you're a little more limited in the allowable distance from the subject (too far, and the flash won't reach). And if there is anything between you and your subject (such as other people), it could block the path of the light. You need to be a little more direct in your approach, because the light needs a clear path to the subject.

As I work the area, I look for beautiful pockets of available light and interesting angles that will help transform this work from simple crowd coverage to something a little more beautiful and significant. If the cocktail hour stretches over two locations and one location has better light (for example, a hotel ballroom and an adjoining patio are both being used), I cover the whole thing but I linger in the more appealing setting, checking periodically to see if anyone new has arrived.

DON'T PHONE IT IN

You may be tempted to set the camera on Auto and simply shoot snapshots during cocktail hour, but it's worth it to put the effort into making the images something more. If you think about it, most people rarely have the opportunity to be photographed in a very candid, natural way, and these images become more significant as time passes.

Several times, a client from years before has contacted me because a friend or family member recently passed away, and the candid images I took of that person at the wedding were among the best photos the family had. Obviously, not every cocktail-hour candid will be a stunning example of portraiture, but always keep in mind that what you're doing is photographing life, and it's important!

LENS CHOICE

If there is ample space, I love to use my 70–200mm lens to shoot guests from a distance, usually without their realizing it. In this way, I capture very natural images (**Figure 7.4**). If the space is small or especially crowded, I use a wide-angle lens, such as a 28mm or 35mm (**Figure 7.5**). It can be fun to use an even wider lens for some novelty shots, but for the majority of my shooting, I avoid using too wide a lens because it can cause distortion and generally isn't as flattering to people.

FIGURE 7.4
My 200mm lens allows me to shoot spontaneous, candid images that can be quite beautiful and capture the mood.

ISO 400
1/30 sec.
f/2.8
200mm lens

FIGURE 7.5
This cocktail hour
was more crowded,
so I used a wider
lens to capture fun,
expressive images.

ISO 320
1/60 sec.
f/5
35mm lens

CAMERA SETTINGS

If the lighting is consistent throughout the space, I shoot the cocktail hour on Manual so that I have full control over the exposure.

I set my aperture around f/4 for cocktail-hour candids because it gives me enough depth of field to keep the subject sharp and softens the background in the way that I like. If the light is low, I'm comfortable shooting them at f/2.8.

Because people are talking and moving, my preferred shutter speed is around 1/125 sec. to prevent motion blur, but if the light is low, I can stretch it to 1/60 sec.

I choose the lowest ISO possible while achieving the aperture and shutter speeds that I need. I can shoot at ISO 800 or even ISO 1000 and still get great-quality images.

CAPTURING A VARIETY OF PERSPECTIVES

As with every part of the wedding, it's the combination of many points of view during the cocktail hour that really tells the story. Portraits of individuals, images of groups of people engaged with one another, and long overview shots of the whole scene come together to convey a real sense of the event. Move around a lot, use a variety of lenses (wide, normal, and telephoto), and really look for unique perspectives on the cocktail hour (**Figure 7.6**).

FIGURE 7.6
The flower girl led me to this balcony view of the cocktail hour.

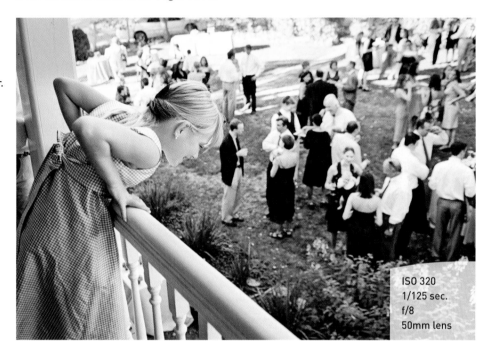

ISO 320
1/125 sec.
f/8
50mm lens

DETAILS AND DECOR

It's such a treat to photograph all the amazing decor at the wedding, and capturing beautiful images of these details is essential for several reasons. First and foremost, they're a reflection of the couple's personal style—especially nowadays, with couples individualizing their weddings in so many ways. These images are crucial to capturing the unique personality of the event. The wedding day story just wouldn't be complete without images of all the myriad details.

Second, these images showcase the work of the other wedding vendors—planners, florists, designers, cake bakers, rental companies, and so on. Taking care of your colleagues by providing them with wonderful images of their work is crucial to building relationships and establishing yourself within the industry (**Figure 7.7**).

Lastly, wedding magazines and style blogs are primarily interested in the details and decor of a wedding, so if you'd like to pursue having your work published as a way to promote your business, you need to pay attention to them!

ISO 320
1/125 sec.
f/2.8
50mm lens

FIGURE 7.7
The client, planner, and other wedding vendors will all appreciate images that highlight the wedding decor.

LIGHTING

I like to find either pretty outdoor spots or indoor areas with indirect window light for small items like invitations, favors, and bouquets (**Figure 7.8**). Be sure to avoid mixed lighting (for example, a situation where daylight from the window and tungsten from the room lights are both hitting the subject) because it creates strange color casts that are difficult (if not impossible) to correct.

If you're using window light, reflectors can be helpful to bounce a bit of light back into shadow areas, and even if you don't have a fancy collapsible reflector in your gear bag, you can improvise with newspapers, white napkins, or the paper on which your schedule is printed. Using the reflector is simply a matter of experimentation; position it in such a way that the light bounces from the reflector onto the subject, and then try moving and tilting it in various ways to get the effect you want.

FIGURE 7.8
I moved this basket
of favors to a win-
dow for better light.

ISO 1000
1/250 sec.
f/2.8
52mm lens

Obviously, you can't move things like tabletops and cakes to a more favorable light-
ing situation—you need to work with whatever is available. I use a few strategies to
improve the existing lighting. For tables in the dinner area, the first step is simply to
select the best ones to highlight. For indoor locations, if the sun hasn't set, look for
a table near a window and shoot from an angle that maximizes the daylight hitting
the tabletop (**Figure 7.9**).

If dinner is outdoors, find the table that is the most evenly lit. If it's half in full sun,
half in shade, making a nice image will be nearly impossible. Backlighting can create
a nice romantic effect, but for a crisp, clear image that really shows the details of the
floral arrangements and table settings, I prefer the light to be off to the side and
only slightly behind (**Figure 7.10**).

Pay attention to the background when selecting your table and your position. Try to
eliminate distracting elements such as speakers, band equipment, and wait-staff trays.

ISO 400
1/60 sec.
f/4
50mm lens

FIGURE 7.9
For indoor locations, select a table that is illuminated by window light if possible.

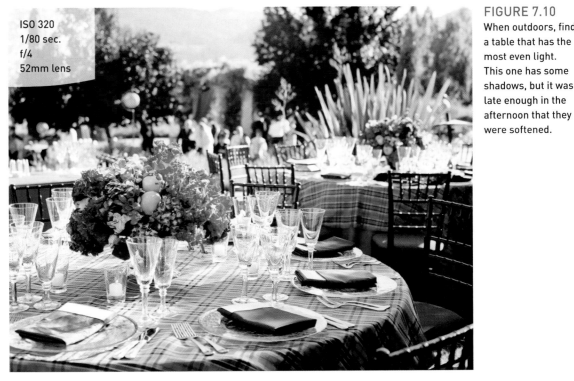

ISO 320
1/80 sec.
f/4
52mm lens

FIGURE 7.10
When outdoors, find a table that has the most even light. This one has some shadows, but it was late enough in the afternoon that they were softened.

For darker rooms, if I have enough time, I use a tripod and long exposures (often several seconds) because I can shoot with a relatively low ISO to minimize digital noise in the image. The tripod also has the beneficial effect of slowing me down a bit so that I compose things more carefully. Quite often, though, I simply don't have enough time to shoot using the tripod, so I crank the ISO up to 1000 or so and hand-hold the camera, sometimes at speeds as slow as 1/8 sec. so that I can cover things much more quickly (**Figure 7.11**). Use the same low-light shooting techniques described in previous chapters: try to lean against something, exhale, hold your breath, and shoot several shots in a sequence to get at least one that's perfectly sharp.

FIGURE 7.11
This shot was hand-held. Even a few years ago, I couldn't have expected to get image quality this good at an ISO of 1250, but digital technology has improved dramatically (and continues to improve).

ISO 1250
1/30 sec.
f/2
35mm lens

During those pre-dinner moments, my assistant is usually covering cocktail hour, so I shoot the details solo. Later on, when dinner is underway and my assistant is once again available to help me, I can use reflectors or even a video light to add some additional illumination. The video light can be especially useful if there isn't a lot of event spot lighting on items like the cake and centerpieces (**Figure 7.12**). I'll ask my assistant to hold the light off camera from the side. It pays to be on good terms with the videographer at the wedding; sometimes when shooting the dinner area, I tag along with the videographer and "borrow" his light for some of the detail work.

ISO 1000
1/6 sec.
f/2
52mm lens

FIGURE 7.12
My assistant held the video light high and to the left of the cake for a bit of additional illumination.

LENS CHOICE

The two most important features in the lens used for shooting details is the ability to open wide and focus close up. I love my 60mm macro lens, but its widest aperture is 2.8. When I need to shoot a lot of close-ups in a short amount of time, I need to hand-hold the camera, and if the dinner area is dimly lit, then f/2.8 just isn't fast enough. In this situation, I often use my 35mm lens on a non-full-frame camera because it opens to f/2.0, focuses very close, and acts like a 50mm lens.

Of course, for shots of the entire room I need something wider (**Figure 7.13**). I often use the tripod for the overview shots, because it's just a few setups and it doesn't add that much time to the process (as opposed to the many individual detail shots that would be very time-consuming to frame and shoot with the tripod). I shoot the room with my 24–70mm or, if the room is small and I need a wider lens, the 17–35mm.

FIGURE 7.13
I used a wider lens to capture the grandeur of this room and a tripod to ensure a clean, sharp image.

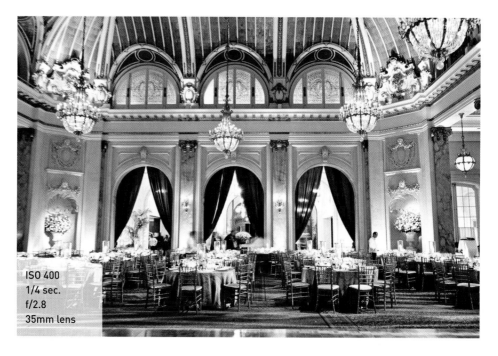

ISO 400
1/4 sec.
f/2.8
35mm lens

SEIZE THE DAY

When it comes to shooting details, shoot whatever you see, the moment you see it. Although you may plan to come back later, the schedule could change and you may not have the opportunity after all—or it may not be in the same perfect state by the

time you return. Even a quick shot as you walk by of details like the guestbook or favors is better than nothing. If you have time to come back later and compose the perfect shot, wonderful. If not, at least you have it covered.

The escort-card table in particular is always a special challenge. It's the first thing to get picked over when the ceremony is finished, so find it and shoot it beforehand if you can. If that's not possible because of the way the post-ceremony time is scheduled, and you find that the guests have, indeed, ravaged the escort card table by the time you arrive, take whatever cards remain, arrange them nicely together, and shoot them in close-up (**Figure 7.14**).

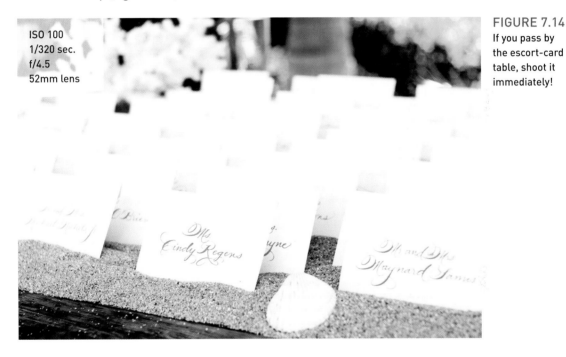

ISO 100
1/320 sec.
f/4.5
52mm lens

FIGURE 7.14
If you pass by the escort-card table, shoot it immediately!

PRIORITIZING SHOTS WHEN TIMING IS TIGHT

The dining area and table tops are usually not photo-ready until just before guests are set to enter the room, and with everything else that needs to be done during cocktail hour, you may find yourself walking into the dining area with only five minutes to shoot. In order to maximize coverage, think about shooting from large to small:

• **Shoot the entire room first.** Ask waiters and other staff to step aside for a moment so you can get a clear shot. Work quickly so as not to keep them from their jobs.

- **Next, pick the table with the best light and get a shot of the whole tabletop.** Shoot it from eye level, from table level, and from above. (I remove my shoes and stand on a chair. From that vantage, I shoot straight down onto an individual table setting; then I move the chair back a bit to shoot the entire table from that height.) Pay attention to styling: remove any unattractive elements such as salt and pepper shakers or containers of sugar packets, and adjust the table setting so that it's perfectly aligned.

- **Last, move in on the individual table elements: centerpieces, place settings, glassware, menus, favors, and so on.** You can continue to shoot the close-in details even as guests are entering. Likewise, save the cake for later. It can be shot while guests are eating, so don't use precious pre-dinner moments on it.

Some must-get details are obvious, such as the cake and table settings. Here are a few other items to watch for:

- Views from rooms where the wedding party is getting ready
- The exterior of the church or ceremony site (**Figure 7.15**)
- Bride and groom escort cards
- The bar setup
- The signature drink (**Figure 7.16**)
- The types of wine being served
- Hors d'oeuvres
- An overview of cocktail hour
- Bride and groom chair decorations (**Figure 7.17**)
- Bride and groom place cards at the table (**Figure 7.18**)
- Lounge areas
- The kids' table
- Entrees

ISO 200
1/1000 sec.
f/5.6
50mm lens

FIGURE 7.15
Get some distance from the church or reception building for a scene-setting shot of the exterior.

ISO 400
1/80 sec.
f/5.6
82mm lens

FIGURE 7.16
Be sure to shoot any special signature drinks.

ISO 400
1/90 sec.
f/2.8
35mm lens

FIGURE 7.17
Another easily overlooked detail: bride and groom chair decorations.

ISO 1250
1/20 sec.
f/3.2
50mm lens

FIGURE 7.18
Depending on lighting, the bride's table may not be the best choice for shooting the entire tabletop, but you should definitely get a close-up of her place card.

MOMENTS TO WATCH FOR

When you're shooting the cocktail hour and dinner, watch for the following moments:

- **People posing for snapshots with one another:** Hustle over and quickly shoot these setups from the side for images that are a bit more casual (**Figure 7.19**).

- **The couple as they enter cocktail hour:** Because this is usually their first chance to greet their guests, there are many nice moments—the couple hugging guests, the couple showing off their rings, and so on.

- **Kids playing:** Kids often provide some very sweet, fun images during this part of the day (**Figure 7.20**).

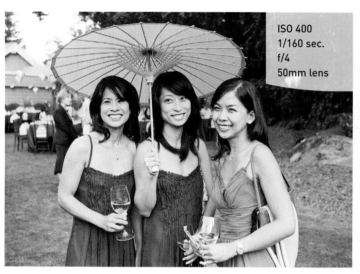

ISO 400
1/160 sec.
f/4
50mm lens

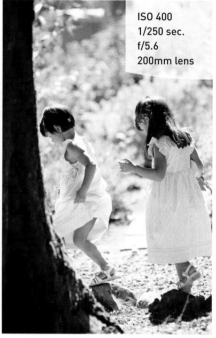

ISO 400
1/250 sec.
f/5.6
200mm lens

FIGURE 7.19
When I notice guests taking snapshots of one another, I hustle over and grab a quick shot of my own. The resulting images have a casual flair.

FIGURE 7.20
Kids often find amusing ways to entertain themselves, so be sure to keep an eye on them for photo opportunities.

Chapter 7 Assignments

Practice Party Shots

Bring your camera to any event that you can—birthdays, dinner parties, family barbecues—and simply practice shooting the guests. Shoot discreetly and get the feel of watching and waiting for that great moment. Get comfortable interacting with people to initiate the more posed party shots.

Reflect on This

There is no hard-and-fast rule for using a reflector—it's very much a process of experimentation, moving the reflector around at different angles until you see that light is bouncing back onto the subject. Try using a reflector when the light is coming from the side, from above, and so forth. If you have a collapsible photo reflector with two sides, experiment with both to see how it changes the quality of the light. In the absence of this type of reflector, you can use a newspaper, a sheet, a white napkin, or a tablecloth.

Shoot for Variety

Mock up a tabletop near a window (a simple bouquet and one place setting will do) and spend time observing it from every angle. Notice how the look and feel change as your angle to the light changes. See how much variety you can capture with this one setup by using different lenses (macro, normal, and wide) and changing your position—both your distance from the table and your relationship to the light source. You could even use this assignment as a way to build a relationship with a floral designer—ask her to create an actual tabletop to shoot, and give her images for her own portfolio in return.

Share your results with the book's Flickr group!

Join the group here: flickr.com/groups/weddingsfromsnapshotstogreatshots

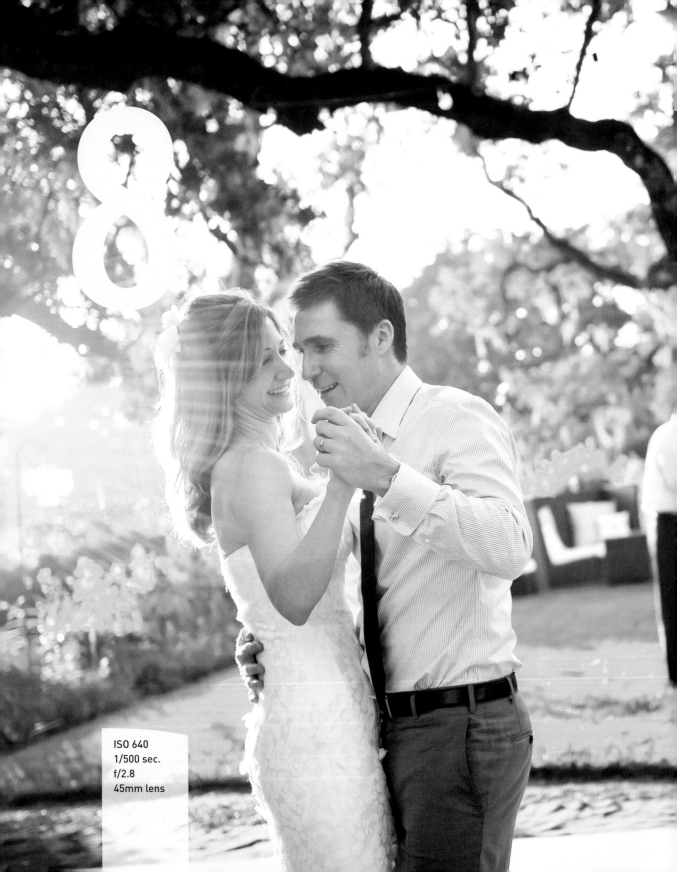

8

ISO 640
1/500 sec.
f/2.8
45mm lens

Reception and Dancing

WEDDING STAGE FIVE

Once the crush of cocktail hour is completed and guests are seated for dinner, you usually have a moment to catch your breath and reorganize for the reception. Next up are scheduled events such as toasts, the first dance, and cake cutting, as well as a whole lot of dancing. There are so many ways to get creative when shooting these moments, and so many opportunities to capture meaningful, memorable images.

Reception coverage is both very fluid (as you rove about looking for those exceptional moments that happen organically) and somewhat orchestrated (as you cover planned events, such as toasts and cake cutting). Stay in communication with the planner or catering manager about timing, because the schedule often shifts a bit. Most important, always anticipate what's coming up, and be ready for it. Take light readings; make decisions about positioning, lenses, settings, flash setup, and so forth; and prepare the gear in advance so you aren't scrambling at the last moment!

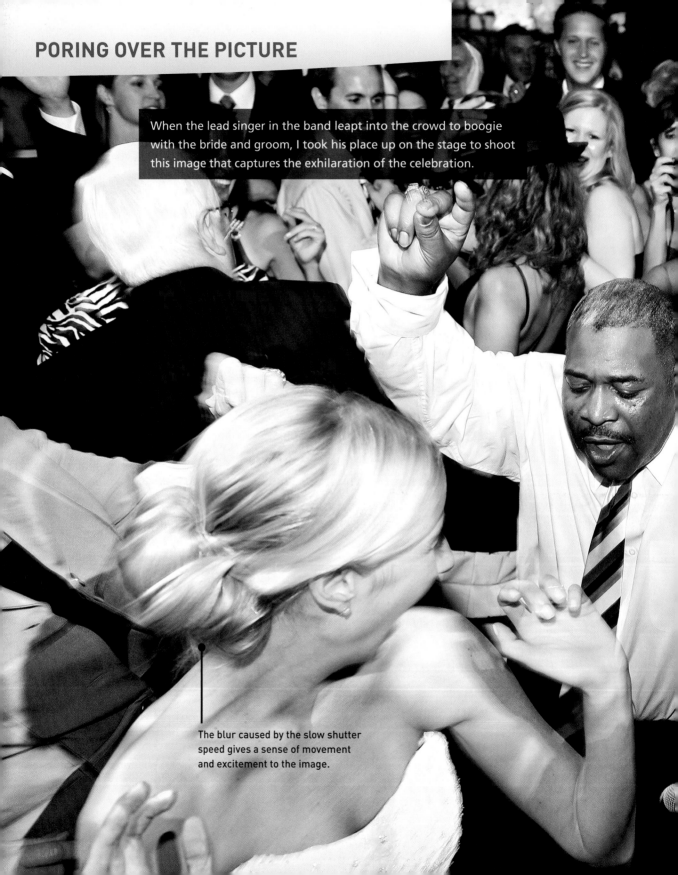

PORING OVER THE PICTURE

When the lead singer in the band leapt into the crowd to boogie with the bride and groom, I took his place up on the stage to shoot this image that captures the exhilaration of the celebration.

The blur caused by the slow shutter speed gives a sense of movement and excitement to the image.

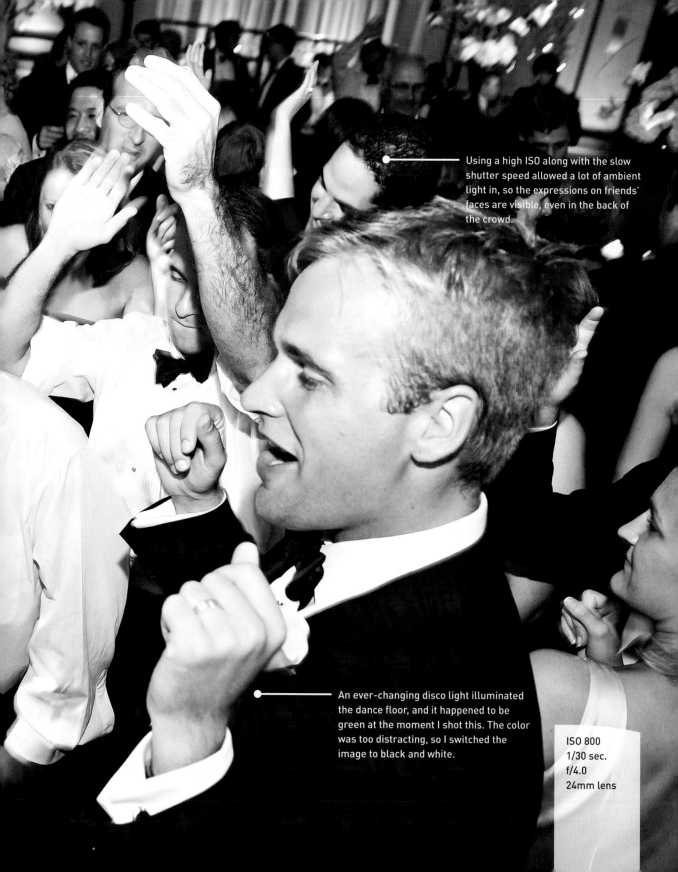

Using a high ISO along with the slow shutter speed allowed a lot of ambient light in, so the expressions on friends' faces are visible, even in the back of the crowd.

An ever-changing disco light illuminated the dance floor, and it happened to be green at the moment I shot this. The color was too distracting, so I switched the image to black and white.

ISO 800
1/30 sec.
f/4.0
24mm lens

DINNER

If you feel that you may have missed some guests during cocktail hour, you have another good opportunity to shoot candids just as they're entering the dining area and sitting down. Stop shooting individuals when they begin to eat, though—nobody enjoys being photographed while chewing!

Be sure to take a step back at some point during the dinner and shoot an overview to capture the decor and ambience of the event, as well as the crowd in its entirety. Shoot from a balcony or other elevated spot if possible; even standing on a chair will help.

When the light is low, I shoot with a longer exposure on a tripod so that the movement of people has motion blur, but the setting is totally sharp (**Figure 8.1**). Be sure that the bride and groom are actually present in the room and visible in the shot.

FIGURE 8.1
Don't forget an overview of the dinner scene.

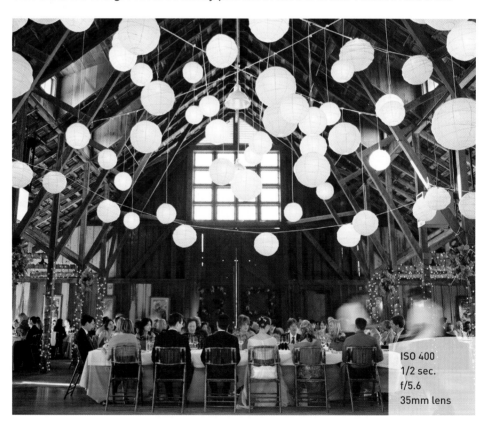

ISO 400
1/2 sec.
f/5.6
35mm lens

TOASTS

As with all the reception events, I shoot the toasts with multiple cameras, using different techniques with each. For example, for a toast that takes place at night in low light, I shoot the person making the toast in a very straightforward way, with on-camera flash (bouncing it, if possible, to soften the light). If there is enough available light, I also shoot without flash at a high ISO for a more natural look.

I wait for a moment when the speaker pauses or laughs so that I capture a flattering expression (**Figure 8.2**). I get several shots of the speaker rather quickly, so that I can turn my attention to the couple and others as they listen and react.

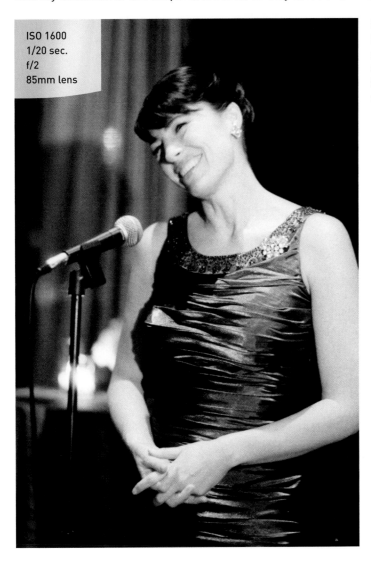

ISO 1600
1/20 sec.
f/2
85mm lens

FIGURE 8.2
I waited for this moment of laughter and shot it without flash for a very natural look.

The toasts provide a fantastic opportunity to capture completely authentic emotion as the couple reacts to the words of their dear friends and family, and the more you can stay invisible while shooting, the more real it will be. I find a spot opposite the couple, usually shooting through a gap between the people seated across from them, and I crouch there for most of the toasting so as to minimize any disruption for the couple and their guests.

I love the flexibility in focal length afforded by my 24–70mm and 70–200mm zoom lenses, and I use them if there is enough available light (**Figure 8.3**).

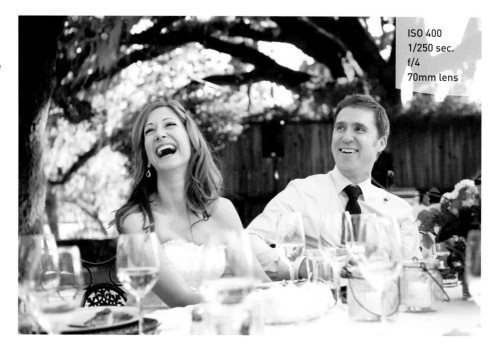

FIGURE 8.3
In a lovely outdoor daytime setting such as this, I have greater flexibility in my choice of lenses because an aperture of f/2.8 is ample for the situation.

ISO 400
1/250 sec.
f/4
70mm lens

More often than not, though, the setting is quite dark, and a maximum aperture of f/2.8 just isn't wide enough. The lens I use most for toasts is my 85mm, because the telephoto focal length gets me just close enough to the couple when I'm in position, and it opens to a wide f/1.8, allowing me to shoot in extremely low-light situations. With my crouched position, the couple is able to forget about my presence entirely, and I can capture very personal and intimate images (**Figures 8.4** and **8.5**). If the tables are very close together and I'm closer to the couple, the 85mm may be too long for me to get both bride and groom in the shot. In that case, I switch to my 50mm lens, which also opens up to f/1.8.

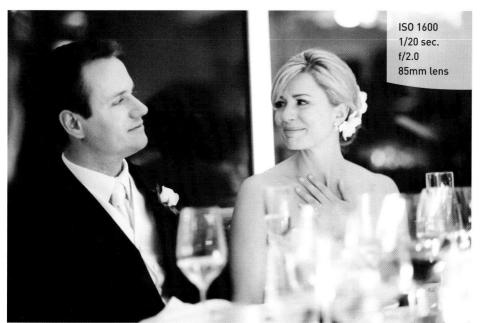

ISO 1600
1/20 sec.
f/2.0
85mm lens

FIGURE 8.4
By shooting as discreetly as possible, I'm able to capture very real moments of authentic emotion as the couple reacts to the toasts.

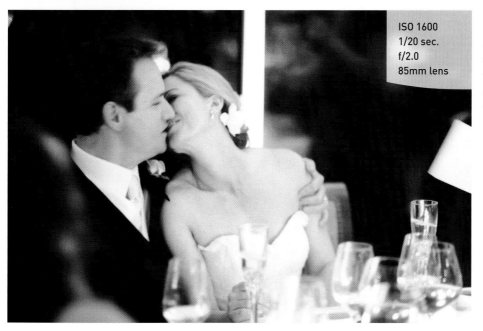

ISO 1600
1/20 sec.
f/2.0
85mm lens

FIGURE 8.5
I keep my attention on the couple throughout the toasts and capture a range of images during this time.

Take note of where key friends and family members are seated, and look for great reactions from them as well (**Figure 8.6**).

Unless it's a very pretty outdoor setting in soft, evening light (as in Figure 8.3), I tend to prefer black and white for these shots. To my eye, if the colors in the image are very bright or clashing, they can distract from the emotional impact of the moment.

FIGURE 8.6
Toasts are an opportunity to capture wonderful, authentic reactions from family and close friends.

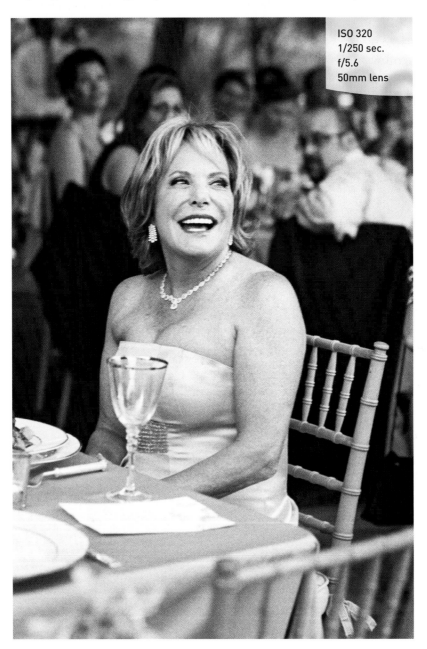

ISO 320
1/250 sec.
f/5.6
50mm lens

THE FIRST DANCE

I always make a point to discuss the first dance in advance with my clients and find out if they have anything special planned. Some couples take lessons and have an entire choreographed routine, and it's helpful to know in advance what they'll be doing. In particular, I ask if there will be a dip at the end of the dance. It seems like a small, silly thing, but it's really easy to be in the wrong place when it happens! If I know in advance that it's coming, I have a much better chance of being in the right place at the critical moment (**Figure 8.7**).

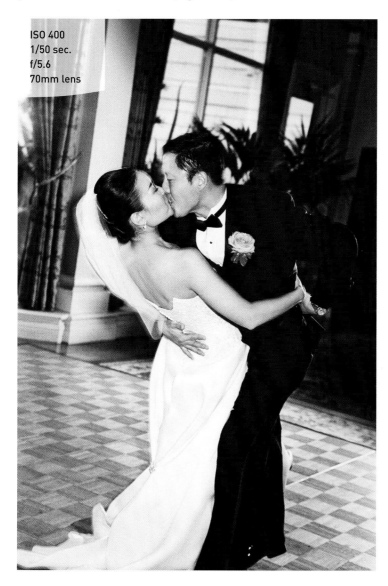

ISO 400
1/50 sec.
f/5.6
70mm lens

FIGURE 8.7
It's always satisfy-
ing when I manage
to catch the dip
from a great angle.

As with the toasts, when the couple takes to the floor for their first dance, I shoot in a few different ways. If the room is dark, I shoot with on-camera flash, bouncing it from the ceiling if it's low enough, to diffuse the light. I use my 24–70mm lens so that I have a lot of flexibility in taking wide shots that show off the room, as well as closer shots that focus on just the bride and groom. To capture as much ambient light as possible, I set the flash to TTL and the camera to Manual. With a shutter speed of around 1/40 sec. (maybe a bit faster if the couple is moving very quickly, to avoid unintentional motion blur) and a fairly open aperture of about f/4, I'm able to bring the environment into the image and often capture great reactions from guests and family members in the background.

I often experiment with dragging the shutter. I set my shutter speed to about 1/10 sec. and move the camera as I shoot, tracking with the movement of the couple. This way, I intentionally create motion blur in the background, while the flash freezes the action of the couple so that they're mostly sharp. With such a slow shutter speed, the couple sometimes has a bit of blur as well, but less than the blur of the background (**Figure 8.8**). I'll switch to these settings long enough to fire off several shots, and then return to my usual shutter speed of 1/40 sec. or so.

FIGURE 8.8
Slowing the shutter speed way down and tracking the movement of the couple creates a nice motion-blur effect.

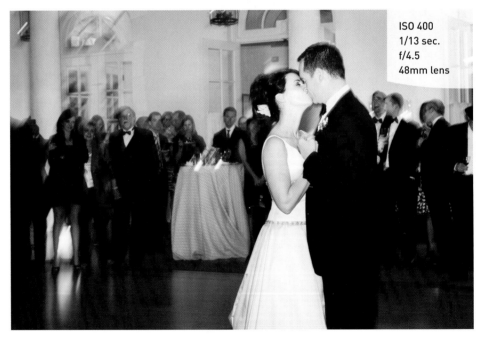

ISO 400
1/13 sec.
f/4.5
48mm lens

I often shoot without flash as well, using one of my faster lenses, such as the 85mm f/1.8. As long as there is enough available light for me to shoot with a wide-open aperture, a shutter speed of 1/30 or 1/20 sec., and a reasonable ISO that won't cause too much grain or digital noise (I usually keep it at 1600 or less—that's the ISO I use when shooting black-and-white film, too), then I'm good to go. Because the shutter speed is usually so slow, I know to expect some motion blur, and I embrace it. I like to track the movement of the bride and groom with my lens so that they'll be less blurry than the background, and I also like to get close up on details such as his hand around her waist (**Figure 8.9**).

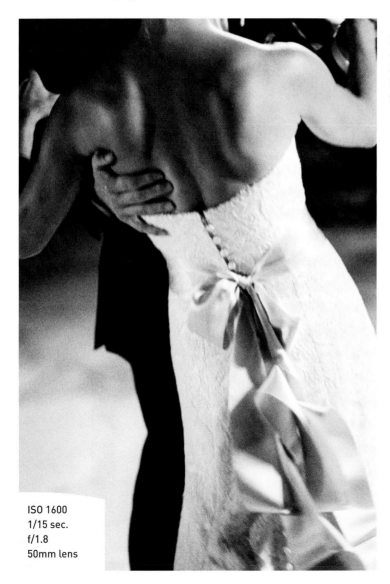

FIGURE 8.9
Back-of-the-dress details make for a beautiful ambient-light shot of the first dance.

ISO 1600
1/15 sec.
f/1.8
50mm lens

If it's just too dark to get the settings needed to shoot without flash, I'll add the video light. My assistant holds it and moves fluidly around the couple, with the predominant position being a little less than 90 degrees away from me so that the light hits the couple from the side (**Figure 8.10**). My assistant also can slip behind the couple, crouching directly behind them to create a nice, backlit glow. With the video light, I'm able to achieve the settings I need to set the flash aside for a bit.

FIGURE 8.10
The video light coming from the left side added just enough to capture this dreamlike image.

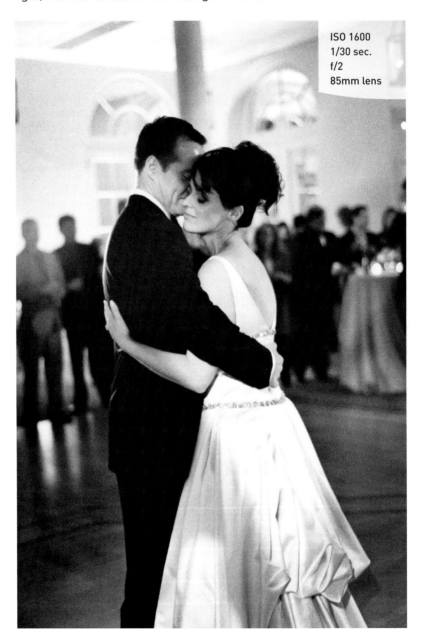

ISO 1600
1/30 sec.
f/2
85mm lens

If you don't have the video light—or an assistant to hold it—but there is a videographer at the wedding, you can "borrow" his light to get the same effect. The videographer will already be using his light on the couple, so just coordinate your movements with his so that, from your position, the light is coming from the side. Moving around in relation to the light will obviously change the way the image looks; with a little practice, you'll get the feel for it.

Be sure to consider the videographer's shot if you're taking advantage of his light. It's OK if you pass through once in a while, but it would be obnoxious to continuously cut in on his shot as you both move about.

CAKE CUTTING

I approach cake cutting much the same as I approach the toasts. I shoot in a straight-forward way with flash, using a slower shutter speed to pull in as much ambient light as I can and bouncing the flash if possible. I also shoot with available light, using the video light when necessary (**Figure 8.11**).

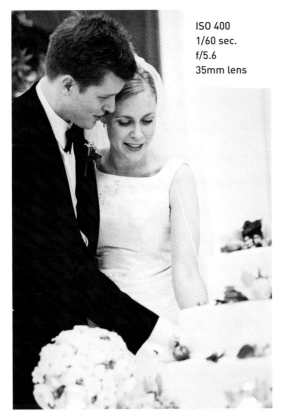

ISO 400
1/60 sec.
f/5.6
35mm lens

FIGURE 8.11
I shoot the cake cutting both with flash and without, and often prefer the more soulful look that is possible when shooting with available light.

At this time, guests often crowd around and I may be squeezed in fairly close to the couple, so I usually need a normal-to-wide lens to get everything in the shot.

The cake is often placed near a wall, and if you stand directly facing the wall and shoot with on-camera flash, you risk creating a hot spot in the image where the flash hits the wall and bounces directly back into the lens. To avoid this, simply turn a bit so that you're shooting at an angle to the wall, not directly at it.

Don't forget to turn around and grab a shot of the guests as they watch (**Figure 8.12**).

FIGURE 8.12
I used a wide lens to catch this fun shot of guests during the cake cutting.

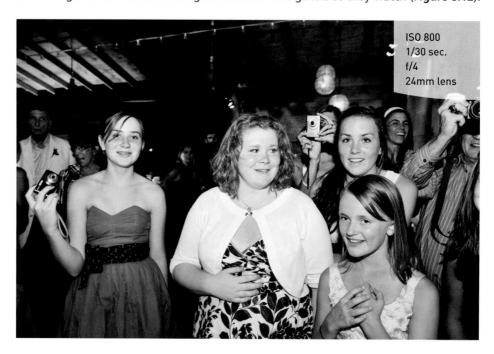

ISO 800
1/30 sec.
f/4
24mm lens

I always shoot important moments multiple ways, both for variety in the look of the images and as extra insurance. If a flash dies or a camera body begins to malfunction during the cake cutting, I always have another option for covering the moment. I ask my assistant to shoot these moments as well, as an additional precaution.

DANCING

Dancing and party shots are fun, especially if you have a soft spot for often-played classics like "Don't Stop Believin'" and "We Are Family"!

But between the quick movement of the subjects, the press of the crowd, and the typically dark lighting conditions on the dance floor, dancing shots also can be

challenging. Using a few simple techniques, you can create images that are truly head and shoulders above simple snapshots.

FLASH

At most weddings, the dancing takes place at night and in dark conditions—although occasionally I'm lucky enough to have an outdoor summer wedding where the dancing begins before dusk, in which case I shoot as much as I possibly can before it gets dark (**Figure 8.13**). Inevitably, though, the time comes to pull out my flash.

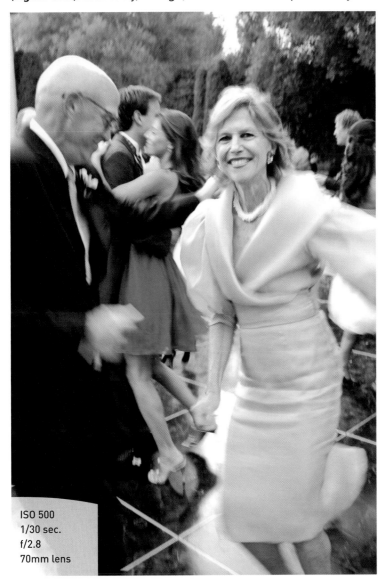

FIGURE 8.13
Whenever guests are dancing in daylight, I shoot like crazy! I was stretching it here, with a shutter speed of 1/30 sec., but the blur works in this image.

ISO 500
1/30 sec.
f/2.8
70mm lens

Similar to the technique described in the "The First Dance" section, I use my flash on the TTL setting and my camera on Manual. I use a relatively high ISO (usually 800) and a shutter speed of around 1/60 sec. so that I can pull in as much ambient light as possible without getting too much motion blur. For the aperture, it's a balancing act between opening up enough to capture ambient light in the background and ensuring that I have enough depth of field so that the subjects are sharp. This is a particular concern because of the darkness of the room (which can make it difficult for the camera to accurately autofocus on the subject) and the movement of the dancers. I usually use an aperture of about f/4.

I bounce the flash off the ceiling whenever possible to soften the light and give it a more natural look (**Figure 8.14**). If the dance floor is outside in the dark, however, there is nothing that the light can bounce off and I have no choice but to point the flash directly at the subjects. When shooting this way, I'm very aware of any people or objects that stand in the path to my subject, because they could block the flash and ruin the shot.

FIGURE 8.14
Bouncing the flash from the ceiling makes the light much softer and more diffuse.

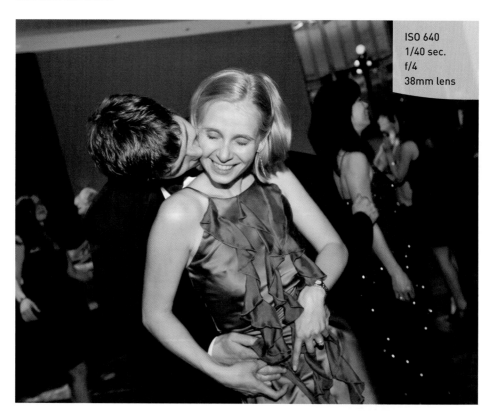

ISO 640
1/40 sec.
f/4
38mm lens

By attaching the flash to the camera using a sync cord, you can remove it from the hot shoe and shoot with the flash off-camera. You can experiment with holding the flash from various positions (from the side, from above, and so on) to create different looks (**Figure 8.15**). It takes a lot of practice to aim the flash properly with one hand while simultaneously composing the shot, focusing, and pressing the shutter with the other. In addition, flash sync cords are notoriously inconsistent, so the flash may not always fire. I recommend using this technique sparingly as a supplemental, fun "extra" until you really feel comfortable that you can achieve consistent results.

I shoot with natural light so much that I have to consciously remind myself to slow down just a bit when shooting with flash, to make sure that the flash unit has time to recycle.

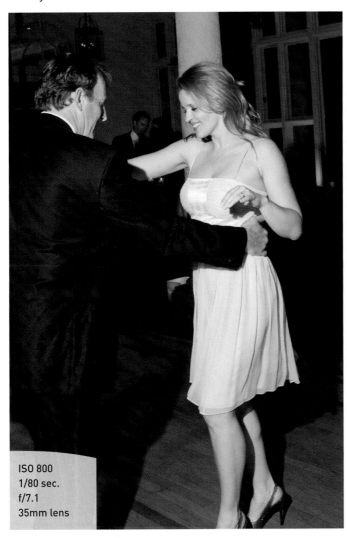

ISO 800
1/80 sec.
f/7.1
35mm lens

FIGURE 8.15
I used a sync cord and held the flash off-camera high and to the left.

LENS CHOICE

I love using a telephoto lens for dancing shots because they allow me to keep a distance from the subject and capture a more natural look. That said, telephoto lenses work well only if I'm able to shoot without flash (for example, that rare occasion when the dancing is during daylight) or when the dance floor isn't too crowded (so my flash has an unobstructed path to the subject). For shots of individuals or couples dancing, I most often use my 24–70mm on the normal-to-wide side or my prime 35mm.

I switch to a wider lens for overview shots with available light. For these images, motion blur only adds to the feeling, so when the light is low, I often shoot at very slow shutter speeds, such as 1/8 sec. Similar to overview shots of cocktail hour and dinner, an overall perspective of the dance floor is nice to have for the final album (**Figure 8.16**).

FIGURE 8.16
I took advantage of the daylight and shot this overview of the reception from a second-floor window.

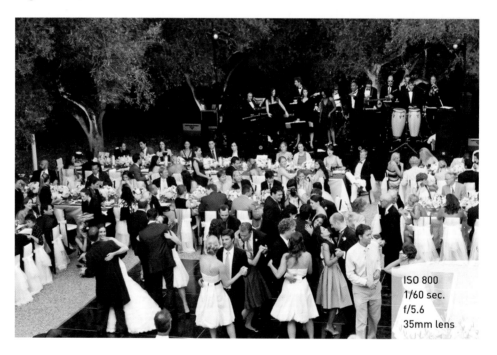

ISO 800
1/60 sec.
f/5.6
35mm lens

TIMING

Obviously, because dancing subjects are in motion, timing your shots is key. I anticipate the movement of my subjects, often just tracking them with my lens until the moment when they spin, turn, or do something that creates a desirable composition (for example, making both partners visible, or providing a great perspective on one

partner over the other's shoulder; **Figure 8.17**). I often keep my camera trained on a particular couple for a few moments until I see the opportunity, and I very consciously select my moment to press the shutter. I recommend shooting a lot of dancing images and simply weeding them out later, because you'll get a high percentage of duds no matter how carefully you try to compose!

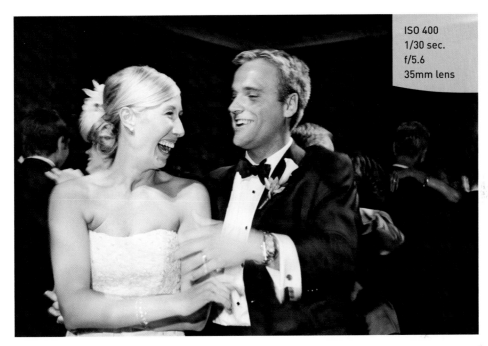

ISO 400
1/30 sec.
f/5.6
35mm lens

FIGURE 8.17
I waited for just the right moment, when he spun her and they were both facing the camera.

UNIQUE ANGLES

Always look for unique angles from which to shoot, especially for overview shots. You can get above the crowd from a staircase, from a balcony, from the band's stage (with permission, of course), from a chair, or even just holding the camera over your head to shoot. I also like to get down low and shoot from a corner of the floor with a wide-angle lens for a really dynamic image (**Figure 8.18**). Basically, anything that isn't shot from eye level will have a different—and often more compelling—look than a typical snapshot.

If there is a band and they're really getting the crowd going, it's fun to stand near the stage, turn around, and shoot the sea of guests from the front as they rock out (**Figure 8.19**).

FIGURE 8.18
Shooting with a wide-angle lens from down low captures a nice party vibe, as well as the details of the room.

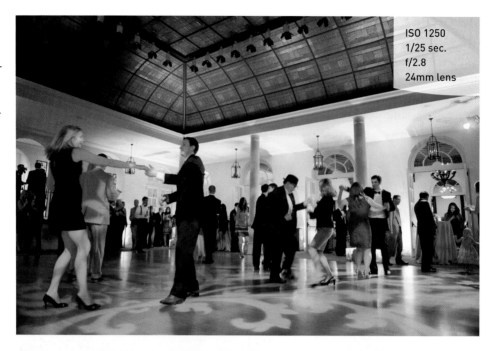

ISO 1250
1/25 sec.
f/2.8
24mm lens

FIGURE 8.19
If partiers are crowding the stage, scramble to the front, turn around, and shoot them.

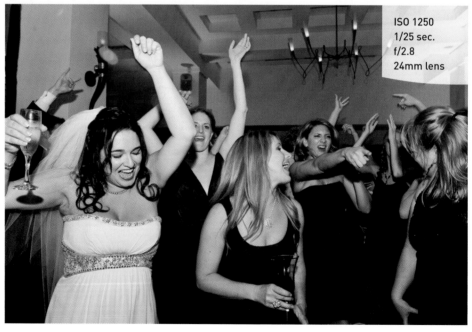

ISO 1250
1/25 sec.
f/2.8
24mm lens

DEPARTURE

If the couple is doing some kind of special departure, you need to get at least one fantastic exit shot to end the story with an exclamation point. It's always nighttime, and it's always dark, so I'm always using flash. But if there is some ambient light (say, from a streetlight or the guests holding sparklers), I ask the couple to pause for just a moment as they leave, and I shoot with a tripod (or just hand-hold the best I can). The results are worth it (**Figure 8.20**)! And don't forget to turn around and get shots of the guests' reactions as the couple goes.

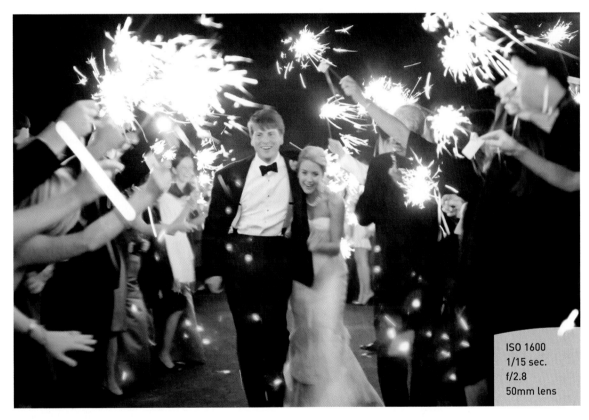

ISO 1600
1/15 sec.
f/2.8
50mm lens

FIGURE 8.20
I don't like to make too many requests of the couple as they enjoy the day, but I did ask this couple to walk very slowly for a moment so that I could shoot them by the light of the sparklers.

MOMENTS TO WATCH FOR

When you're shooting the dinner and reception, watch for the following moments:

- **Kids gathering around the cake as they wait for it to be cut:** Like moths to the flame, they just can't stay away.

- **Sweet dancing moments between:** the parents, other family members, and close friends of the couple.

- **Still-life shots of getaway car, favors, and other elements that may not be introduced until just before the evening ends:** Keep in touch with the planner to make sure you don't miss anything (**Figure 8.21**).

- **Signs of the party:** Look for shoes left behind to facilitate dancing, a splash of wine on a tablecloth, chairs sitting empty as everyone dances, and so on (**Figure 8.22**).

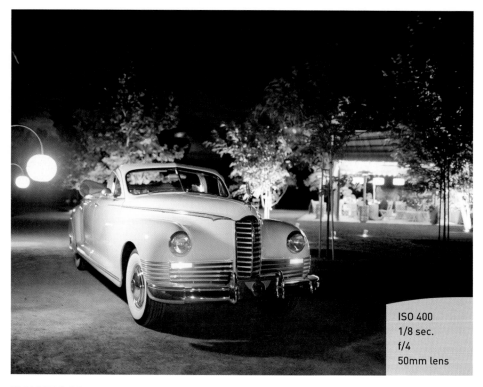

ISO 400
1/8 sec.
f/4
50mm lens

FIGURE 8.21
The wedding is drawing to a close, but you don't want to miss anything. Make sure you know in advance about any end-of-the-evening details that need to be covered.

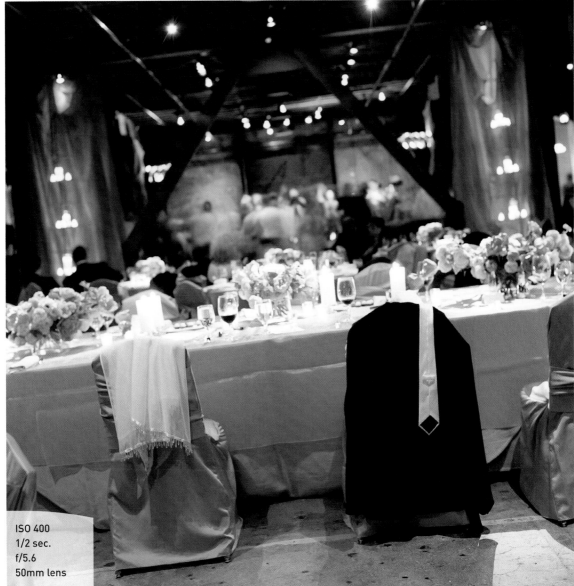

ISO 400
1/2 sec.
f/5.6
50mm lens

FIGURE 8.22
With the couple's accessories hanging on their chairs and the dance floor in the distance, this shot
says a great deal about this party.

Chapter 8 Assignments

Dancing with Light

If you plan to have an assistant hold a video light during the first dance, it's a good idea to do a little test run so that both of you can get the feel of moving around one other and the subjects. You're engaged in a dance of your own with your assistant and with the light, so stage a rehearsal. Ask some friends to pose as the couple, and simply fake a first-dance shoot. You need a fair amount of space, so you could do this outside at nighttime, and it'll really give you a sense of how the position of the light affects the look of the image.

Flash Play: Drag It

While you have some willing models, set up your flash and practice dragging the shutter. Try it out at different speeds, and try moving the camera at different rates as you shoot, as well. You'll begin to get a sense of how much blur is caused by the various shutter speeds, as well as how fast you move the camera. Pay attention to the background as you shoot, and see how elements such as lights and architectural details are rendered.

Flash Play: Take It Off

Try using a sync cord to get your flash off the camera. First, just try to hit the subject with the light—it can be more challenging than it sounds! Then experiment with holding the flash in different positions—up high, off to the side, and so forth. Notice how the different angles of light affect the shot.

Share your results with the book's Flickr group!

Join the group here: flickr.com/groups/weddingsfromsnapshotstogreatshots

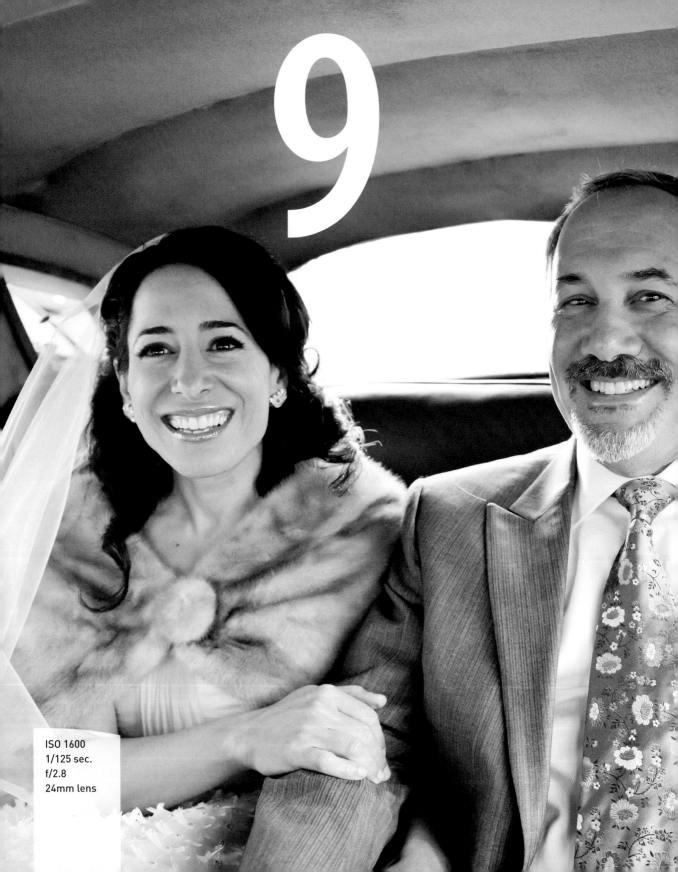

9

ISO 1600
1/125 sec.
f/2.8
24mm lens

Organizing and Presenting Your Work

IDEAS AND RESOURCES

The wedding's finished and you not only survived—you rocked it! So, your job's done, right? Wrong!

When it's all said and done, you may end up with thousands of images from the wedding, and the sheer quantity is enough to overwhelm most clients. You need to edit, organize, and present your work in such a way that the couple and their guests can easily navigate, appreciate, and enjoy the images—not to mention order prints, albums, and other items, if you choose to offer them.

Many online proofing sites feature a cover image that is the first thing the couple (and everyone else viewing the proofs) will see. Choose this image carefully, because it will set the tone for how they view everything to come. I always choose a beautiful, timeless, emotion-filled portrait of the couple.

The simplicity of the composition adds to the power and timelessness of this moment.

This image includes just enough of the setting to give a sense of the wedding itself, without detracting from the emotion expressed by the couple.

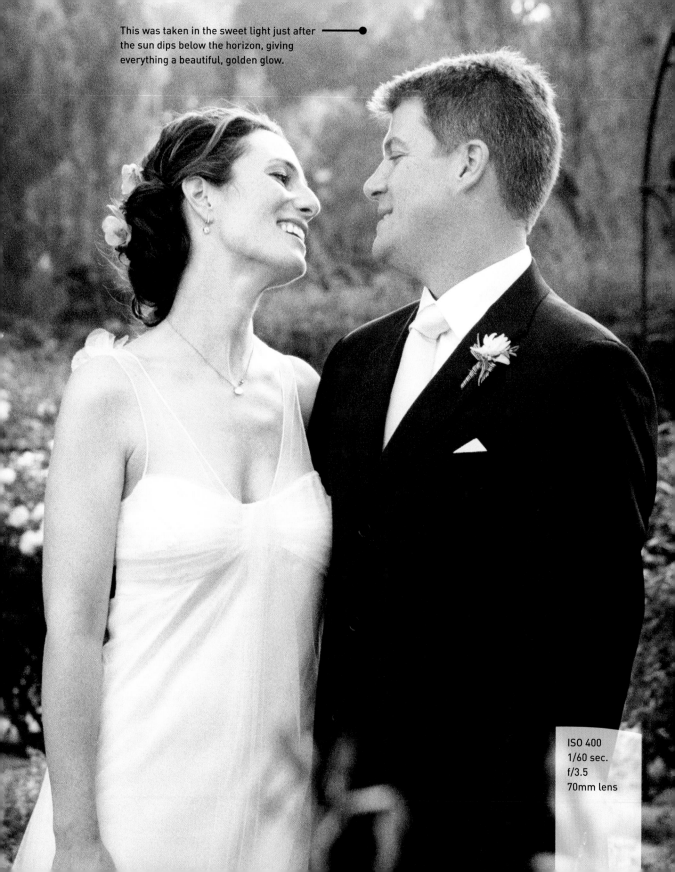

This was taken in the sweet light just after the sun dips below the horizon, giving everything a beautiful, golden glow.

ISO 400
1/60 sec.
f/3.5
70mm lens

EDITING IMAGES

Editing images for your clients is nearly as important as the shooting itself. You've no doubt captured some magnificent shots, but if they're buried in a sea of unexceptional and repetitive work, they may very well go unnoticed and unappreciated.

Think of Michelangelo, chipping away at the block of stone to discover the statue within. Likewise, you need to edit and shape your massive pile of images to reveal the narrative of the day and highlight the truly exceptional shots.

I usually end up with well over 2,000 images. Such a large number is daunting not only to clients, but to me! I generally deliver 600 to 700 images to my clients, and I have a two-step process to get to that number.

1. On my first pass, I edit in broad strokes, reducing the number of images and organizing them into categories so that I can begin to see the story taking shape.

2. On my second pass, I dig deeper and fine-tune the ultimate selection and organization of images that I'll present to the client.

In the following sections, I cover these two steps.

CHOOSING BETWEEN SIMILAR IMAGES

Quickly eliminating blinks and bloopers is easy. It's a much harder job to choose the best image among many similar images. But you need to do it, because the task is even more daunting for clients. The average person simply doesn't have the ability to discern the differences between similar images and make the best selection. You're providing a valuable service by offering a smaller number of higher-quality images for your clients.

When editing, your first instinct is best. Move quickly and go with your gut. How did you feel the first instant you saw the image? If you linger too long, you run the risk of getting too emotionally attached to images that probably aren't worthy of the love. It's like pulling off a bandage. Just do it, move on, and don't look back!

If you have a series of similar images, select a maximum of two or three to include. When choosing among them, look for emotional impact—a slight change of expression between shots can make a big difference (**Figure 9.1**).

Look also at practical concerns like subtle differences in lighting and what's happening in the background. Distracting elements may appear in some shots and not others.

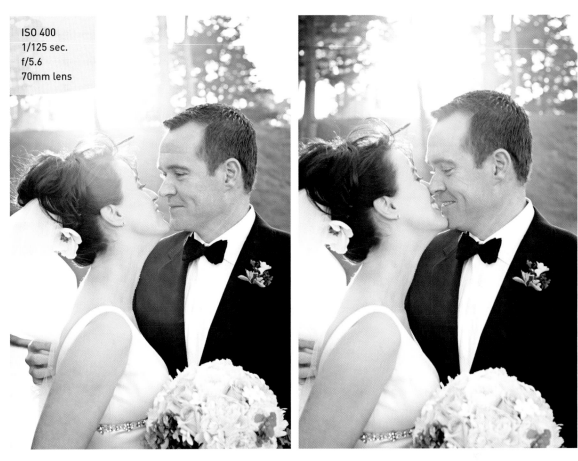

ISO 400
1/125 sec.
f/5.6
70mm lens

FIGURE 9.1
Both images are beautiful, but the groom's expression in the image on the right has more emotional impact, and the image on the left has a flare on the bride's hair. The image on the right is the winner.

CATEGORIZING IMAGES

I usually end up rejecting over half the images in my first pass. At the same time, I start putting them into smaller, more manageable piles by sorting them into categories based on chronological order. This makes it much easier to make sure I have all the bases covered and to see the story taking shape. Categorizing images is also really helpful to the client, because it divides the work into more easily digestible chunks and makes it easier to navigate.

Here is a sample list of categories that you might use:

- Highlights (see the sidebar below)
- Details
- Ladies getting ready
- Guys getting ready
- Before the ceremony
- Processional
- Ceremony
- Recessional
- Post-ceremony

- Couple portraits
- Cocktail hour
- Dinner
- Toasts
- First dance
- Parent dances
- Cake cutting
- Reception and dancing
- Family and group portraits

THE WEDDING HIGHLIGHTS

When you're categorizing images, pay special attention to the highlights category. These images are the very best, and, taken together, they tell the story of the day. Think about it: Your clients spent several months or more planning the wedding. The day went by in a blur. They waited three or four weeks to see the images. So, the first thing they want to see is a beautifully edited version of the story—their wedding day. The highlights are the last present they get to open. Later, they can dig into the rest of the images.

The highlights category is also important because it serves as a starting point for clients to begin thinking about their album. Most people don't have the sense of narrative needed to put together selections for an album, so the highlights category provides a template for them. It serves to show the client how to use the elements of the wedding day to tell a story.

FINE-TUNING YOUR SELECTION

After I've culled down the images and categorized them, I take another pass to fine-tune the presentation. During this phase of editing, I think in greater depth about how the images will ultimately come together to tell the story of the day. I'm always envisioning the final album when editing, and I make sure that all the major events are covered.

I also keep a lookout for good transitional images that signal to the viewer that the story is shifting from one segment of the day to another. For instance, a sweet

close-up of glasses clinking during a toast can help to either introduce or close out that portion of the day in the album, which makes for smoother, more fluid storytelling (**Figure 9.2**). Other images that serve this purpose include, say, guests walking to the cocktail area (**Figure 9.3**), a beautiful room shot, cocktail-hour and dinner overviews, and so forth.

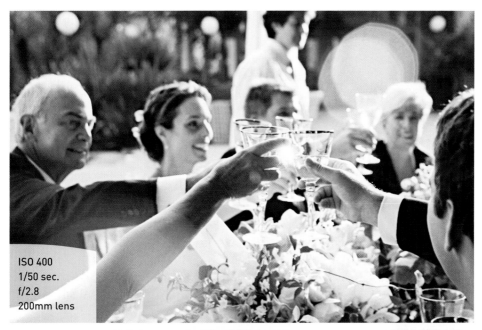

ISO 400
1/50 sec.
f/2.8
200mm lens

FIGURE 9.2
Images like this one give a feeling for the celebration and help transition between different parts of the day when designing the album.

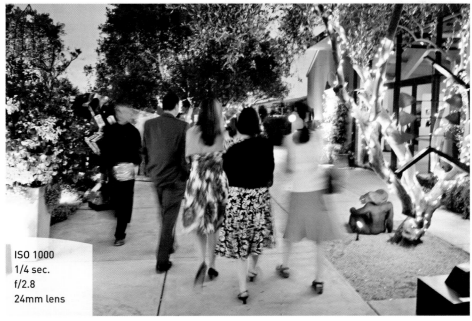

ISO 1000
1/4 sec.
f/2.8
24mm lens

FIGURE 9.3
This image features guests in motion from one portion of the day to the next, making it a natural transition shot.

I also keep an eye out for small sequences of images—usually sets of three—that would work well together to tell a little self-contained story within the story. Examples include the sequence of a kiss (before, during, and after), or a series of beautiful first-dance images (**Figures 9.4, 9.5,** and **9.6**). When I edit the images, I place these images together to help the client see the design possibilities.

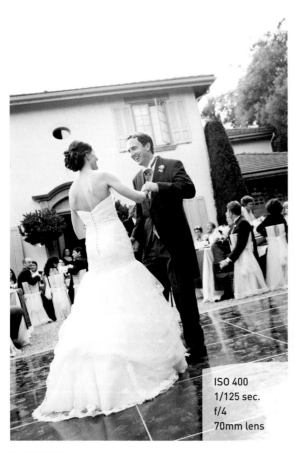

ISO 400
1/125 sec.
f/4
70mm lens

FIGURE 9.4
These images work well together to tell the story of the first dance, opening with an overview-type shot.

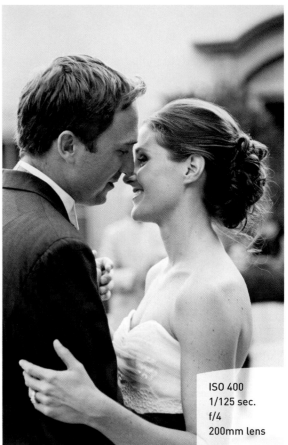

ISO 400
1/125 sec.
f/4
200mm lens

FIGURE 9.5
Next, a sweet close-up that captures the emotion.

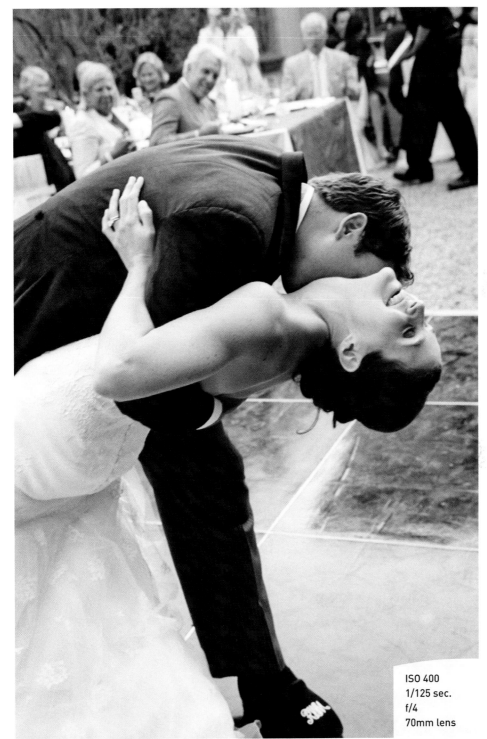

FIGURE 9.6
Finally, the dip.
By creating sets of
images like this,
you can help your
client visualize the
narrative of the day.

ISO 400
1/125 sec.
f/4
70mm lens

PROOFING OPTIONS

If you ask ten different wedding photographers how they present proofs to their clients, chances are good that you'll get ten different answers. Some photographers offer only online presentation of images, with no hard-copy proofs at all. Others provide gorgeous sets of 4x6 proof prints of every image. Still others (myself included) deliver sleek press-printed books with multiple images per page.

You'll need to do some research into what other photographers in your area offer, think about your business model (for example, if you want to sell albums after the wedding, you may not want to offer everything upfront), and get to know the needs of your own clientele (what they request when they meet with you). Whatever you decide to offer, do it with confidence and be sure to explain the benefits of your chosen proofing method to your clients when you meet with them, because most of them don't know the pros and cons of the different options.

There are far too many options and services to list them all, but I'll give an overview of the different media, some important features to consider, and some resources for further research.

ONLINE

There is no real industry standard in terms of what type of proofing products are delivered to clients, but I would argue that you really must make the images accessible online. Couples expect to be able to view and share their images in this way. Plus, it's a great way for you to expand the reach of your work, because many friends and family members will take the time to view the images.

A number of companies provide this service, and several offer related services and products as well, such as print-order fulfillment, albums, and other items both for photographer and consumer use. I did an informal survey of my colleagues, and the following are some of the more popular and reputable services:

- **PickPic** www.pickpic.com
- **Pictage** www.pictage.com
- **RedCart** www.redcart.com
- **Zenfolio** www.zenfolio.com

Each service is structured differently, so you'll need to do some research to find the best fit for your needs. Some features to compare include the following:

- **Pricing structure** Some companies charge a monthly fee for unlimited image uploads; others charge on a per-event or per-image basis; and still others charge a larger, one-time-only fee. Obviously, the option that is most cost-effective for you will depend on how many weddings you shoot and how many images you present to the client.

- **Website interface** How does it look? Is it easy to use, both for you as the photographer and for your clients? Be sure to evaluate its use from both perspectives. How much can you customize the interface, both visually (to match your branding) and in terms of the functionality you want to offer your clients?

- **Privacy** Are all events password-protected?

- **Print/product-order fulfillment** Do you want your clients to be able to order prints and other products through the site? Some companies not only host the proofing site, but also fulfill print orders and send them either directly to the client or to your studio. Others simply send you a record of the order so that you can take it to any lab you like, which is obviously more time-consuming but gives you greater choice in vendors. Think about which option fits best with your studio setup, your lifestyle, and your vision for your business.

- **Other services that add value** Some companies, such as Pictage, present themselves as a one-stop solution for photographers. They offer a number of additional low- or no-cost services, such as album design, credit card processing, community forums, and so forth. Be sure to factor these types of extras into your comparison if you would find them useful.

DIGITAL

Another way to present the proof images to the client is on a CD. I give my clients a CD with low-resolution images that are suitable for e-mailing, posting on social media sites like Facebook, and so on, but that aren't large enough to print. When discussing this with my clients, I let them know that the biggest reason I maintain control over printing the images is that I want them to be of the highest quality—after all, the work will have my name on it, so I want it to be the best it can be.

Many labs offer great CD packaging. You can choose something simple like a colorful sleeve with your logo printed on it or a deluxe foldout case with spots to attach images from that particular wedding. Putting a little effort into creating a nice presentation for the client really goes a long way toward presenting a professional image.

HARD COPY

Many clients still want their proofs in some hard-copy format—something that they can hold and touch. When I started doing wedding photography in 1997, individual proof prints were the only option for hard-copy proofs. Now, in addition to loose prints presented in either a box or proof albums, there are also great-looking press-printed books and image magazines.

Naturally, there are pros and cons to both approaches:

- Proof prints (**Figure 9.7**):

 Pros: High perceived value for some clients, easy for clients to sort and make piles when selecting images for the album

 Cons: Bulky (depending on how many images are delivered), harder for clients to carry and show friends, easy to get disorganized, easy to lose images, may depress sales of reprints and albums

- Press-printed books (**Figure 9.8**):

 Pros: Sleek, elegant look; neatly contain a large number of images; easy for client to carry and share with friends; impossible to lose individual proofs

 Cons: Can't sort into piles when selecting images for the album

Years ago, every client wanted individual proof prints. Although I do get the occasional request for prints, these days most clients see the advantages of a more streamlined presentation—especially considering the large number of images that they receive.

I provide clients with a hardcover proof book that features four images per page, categorized and numbered consistently with the proofing website. With the book, clients can easily flip through to locate specific images, and with the proofing website, they have the functionality to create virtual "piles"—folders of favorites, album selections, print orders, and so forth. Used together, the book and the site provide the client with powerful tools to manage their images.

ISO 800
1/80 sec.
f/2.8
50mm lens

FIGURE 9.7
Proof prints have many virtues, but with so many images, I find that they're easily mixed up or misplaced.

ISO 800
1/80 sec.
f/2.8
50mm lens

FIGURE 9.8
Many clients appreciate the sleek elegance and ease of use of a press-printed proof book.

ALBUMS AND THANK YOUS

Once the wedding has been shot, edited, and presented in proof form, the final step is to deliver your work in a beautiful way to the clients as well as to your colleagues. Offering gorgeous, professional quality albums is optional, but it's a service that can add a great deal of value for your clients and ensure that the final presentation of your work is all that you wish it to be.

A BRIEF PRIMER ON ALBUMS

As with proofing, there are many different approaches to offering albums. Typically, I ask couples to select their favorite images and I use those as the basis for the album design. I then give them the opportunity to review the design and make any needed adjustments before the album is actually printed. Other photographers choose to select the images themselves and present the client with a completely finished album design, sometimes at the same time that they present the proofs. Photographers who work this way make sure to discuss the album process at their very first meeting with the client, and lay the foundation well in advance so that client understands what to expect.

There are many album companies and even more types of albums, including digital flush-mount (each page is a sheet of photo paper mounted on a cardboard core), classic-matted albums, and press-printed books available on various paper types— just to name a few. Whether you want a sleek, modern look, a handmade, vintage feel, or an eco-friendly album, there is an album company catering to your needs. When selecting a supplier, you should research the quality of the albums as well as the customer service. Make sure to talk with other photographers who may have used them to get the real scoop.

Another factor to consider when selecting an album supplier is the design and order process. Some companies have their own proprietary software that must be used when designing the album, others work with third-party software such as Photojunction, and some offer the actual album design as a service—often free of charge—or feature pre-designed templates that you can use. Some companies offer color-correction of the images as an added service, and some require you to send images that have already been fully processed and prepared for printing.

The following list of album suppliers is by no means exhaustive, but it will give you a good starting point for what is available:

- **AsukaBook** www.asukabook.com

- **Bay Photo Lab** www.bayphoto.com

- **Couture Book** www.couturebook.com

- **Cypress** www.cypressalbums.com

- **Finao** www.finaoonline.com

- **Leather Craftsmen** www.leathercraftsmen.net

- **Michael Chinn Albums and Boxes** www.michaelchinnphoto.com

- **Pictage** www.pictage.com

- **Priscilla Foster Handmade Books** www.priscillafoster.com

- **Queensberry** www.queensberry.com

- **Simply Color Lab** www.simplycolorlab.com

- **White House Custom Color** www.whcc.com

There are many sources for inexpensive albums that are available to consumers as well as photographers, such as www.blurb.com and www.mpix.com. These are really useful if you are shooting a few weddings here and there for friends, or just need to create some initial samples quickly and inexpensively. If you plan to offer albums as a part of your wedding business, though, I recommend working with labs that cater to the needs of professional photographers, as you will have many more options in terms of cover materials, paper, and so forth. You will also have more "wow" power with your clients if you can offer them items that are not readily available to the average consumer.

THANK YOUS

Finally, don't forget to take care of the other vendors that worked so hard to create the beautiful décor, food, and other details that made the wedding day a success. A hand written note and a few prints—or even a well-designed press-printed album— along with a disc of images featuring the work of the wedding planner, designer, florist, caterer, site manager, lighting company, cake baker and so forth are always well-received and may just help you land your next gig!

Chapter 9 Assignments

Tell a Story

Photograph an event—say, a family vacation or a child's birthday party—with a narrative in mind. Afterward, edit your work to tell the story of the event, selecting a variety of images (details, people, overviews, and so on) that create a narrative that smoothly flows from beginning to end.

Practice Proofing

Research the available online proofing options and create a test account at one of them. Upload images from an event (like the family vacation or birthday party mentioned above), give the URL to a friend, and have him go through the process of proofing so you have experience working with a "client" on this part of the process. You'll gain familiarity with setting up the proofing site, and by discussing the experience with your friend, you can gain insight into the viewer experience of the site before you try it for real with a client.

Share your results with the book's Flickr group!

Join the group here: flickr.com/groups/weddingsfromsnapshotstogreatshots

INDEX

spot metering, 36, 37, 76
strobe lights, 130
sunlight
 bride/groom photos, 139
 full sun/dappled light, 111–112
 lens flare, 125
 using flash, 24
sunsets, 20, 21, 120, 140
symmetry, 43–44

T

table settings, 156, 157, 166–168, 172
telephoto lenses, 22, 142, 143, 194
thank-you notes/photos, 217
toasts, 181–184, 208–209
tonal ranges, 38
transitional images, 208–209
tripods
 considerations, 109, 155
 low lighting and, 141, 168, 178, 180
 reducing camera shake, 127, 131
 slow shutter speed, 20, 26
TTL settings, 129

U

umbrella setups, 130
used equipment, 15

V

vendors, wedding, 74, 95, 165, 217
vibration reduction (VR) lenses, 109
video light, 141, 169, 188–189
videographers, 169, 189

W

walking shots, 146, 147
wedding blogs, 165
wedding ceremony. *See* ceremony
wedding gown
 details, 70–72, 99, 147, 150, 187
 photographing, 70–71, 106
wedding magazines, 165
wedding officiant, 95
wedding party, 52, 83, 96, 172
wedding photographer. *See* photographer

wedding photography, viii, 1, 38. *See also* photography
wedding vendors, 74, 95, 165, 217
weddings
 destination, 62
 highlights, 208
 importance of photos, viii
 nighttime, 32
White House Custom Color, 217
wide angle lenses
 cocktail hour photos, 162, 163
 considerations, 6, 16, 142
 dancing photos, 194, 195, 196
window light, 76–78, 127, 157, 165–167

Z

Zenfolio service, 212
zoom lenses
 cocktail hour photos, 162
 considerations, 12, 15, 142, 143
 toasts, 182